The Future of
Visual Anthropolog

G000070691

The explosion of visual media in recent years has generated a wide range of visual and digital technologies which have transformed visual research and analysis. The result is an exciting new interdisciplinary approach of great potential influence in and out of academia.

Sarah Pink argues that this potential can be harnessed by engaging visual anthropology with its wider contexts, including:

- the increasing use of visual research methods across the social sciences and humanities
- the growth in popularity of the visual as methodology and object of analysis within mainstream anthropology and applied anthropology
- the growing interest in 'anthropology of the senses' and media anthropology
- the development of new visual technologies that allow anthropologists to work in new ways.

The Future of Visual Anthropology offers a groundbreaking examination of developments within the field to define how it might advance empirically, methodologically and theoretically, and cement a central place in academic study both within anthropology and across disciplines. This book will be essential reading for students, researchers and practitioners of visual anthropology, media anthropology, visual cultural studies, media studies and sociology.

Sarah Pink lectures in the Department of Social Sciences at Loughborough University. Her work focuses on gender, the senses, media, the home, and visual methodologies in research and representation. Her books include *Doing Visual Ethnography* (2001), *Women and Bullfighting* (1997) and *Home Truths* (2004).

The Future of
Visual Anthropology

Engaging the senses

Sarah Pink

Routledge
Taylor & Francis Group

LONDON AND NEW YORK

First published 2006
by Routledge
2 Park Square, Milton Park, Abingdon,
Oxon, OX14 4RN

Simultaneously published
in the USA and Canada
by Routledge
270 Madison Ave, New York NY 10016

Routledge is an imprint of the Taylor & Francis Group

Transferred to Digital Printing 2010

© 2006 Sarah Pink

Typeset in Goudy Old Style by
Bookcraft Ltd, Stroud Gloucestershire

Every effort has been made to ensure that the advice and information in
this book is true and accurate at the time of going to press. However,
neither the publisher nor the authors can accept any legal responsibility
or liability for any errors or omissions that may be made. In the case of
drug administration, any medical procedure or the use of technical
equipment mentioned within this book, you are strongly advised to
consult the manufacturer's guidelines.

British Library Cataloguing in Publication Data
A catalogue record for this book is available from the British Library

Library of Congress Cataloging in Publication Data
Pink, Sarah
 The future of visual anthropology : engaging the senses / Sarah Pink
 p. cm.
 1. Visual anthropology. I. Title.
 GN347.P57 2006
 301–dc22 2005019287

ISBN10: 0-415-35764-0 (hbk)
ISBN10: 0-415-35765-9 (pbk)

ISBN13: 9-78-0-415-35764-7 (hbk)
ISBN13: 9-78-0-415-35765-4-(pbk)

Contents

Figures

Acknowledgements

This book covers a series of different research projects I have been involved in and reviews the work of many other academic and applied researchers. To develop it I have relied on the good will, commentaries and collaboration of many people. For permission to reproduce images from their own work or archives thanks to: Malcolm Collier and the Collier Family Collection for supplying images from John Collier Jnr's fieldwork in Alaska and Peru; the New York Academy of the Sciences for the use of images from the work of Gregory Bateson and Margaret Mead; and International Film Seminars, New York for supplying the image from Flaherty's *Nanook of the North*. For allowing me to use screen captures of their work, or from projects owned by them, thanks to: Susan Tester and her research team; Rod Coover; Jay Ruby; Nelle Steele and Tracey Lovejoy at Microsoft; and Unilever Research.

My research about the sensory home was funded by Unilever Research. I especially thank Katie Deverell, Jean Rimmer, Paul Moores and Sue Stanley for their support and collaboration in these projects. My research about the Spanish bullfight was funded by the Economic and Social Research Council.

Particular thanks to: Malcolm Collier, Dick Chalfen, Peter Biella and Alison Jablonko, who supplied me with important advice about contemporary and historical uses of applied visual anthropology and the history of visual anthropology; Ana Martinez Perez, whose visual anthropological work in Spain has been an important source of inspiration; John Postill, whose comments on the text as it has developed have been invaluable; and Routledge's anonymous reader.

Responsibility for the argument and any errors in this book is, however, my own.

Preface

During the last five years I have been thinking through, writing on, and exploring through practice a series of issues related to how visual anthropology is situated (and mis-situated) in relation to mainstream anthropology and in wider inter- or multidisciplinary contexts across the social sciences and humanities. This has involved exploring four key themes: the interdisciplinary context of the use of visual methods, the implications of an anthropological theory of sensory experience for visual anthropology, the application of visual anthropology outside the academy, and digital media and the development of hypermedia anthropology. In the course of these explorations I came to see these themes as being unavoidably interconnected, both embedded in and constitutive of the contemporary context that a visual anthropology for the twenty-first century both shapes and is shaped by. This book aims to make these connections and interdependencies explicit by drawing together new work with rewritten versions of articles published elsewhere and unpublished conference papers. Not initially conceived as part of this wider interwoven argument, these ideas were pitched originally according to the aims of each individual project. In contrast this book draws together a set of related ideas and discussions into one project, making explicit the continuities and connections not evident in the separate publications.

The inspiration to do this has come from two sources. First, as I have more recently been working on the question of an applied visual anthropology I have realised that many of the issues I had already raised in my discussions of anthropological theory and visual representation, on experience and writing, and on new digital media and anthropological hypermedia continued to be pertinent in this apparently 'new' topic. Second, in November 2003 Stan Schectman invited me to contribute a paper to the WAVA conference in the USA, on the Future of Visual Anthropology. I was at the time on study leave and had just arrived in Malaysia so a trip to the USA was not possible, but I was kindly invited to contribute by e-mail. This paper, fuelled by the thoughts I had already had about the interrelatedness of the themes I had been developing in my existing work, gave me the impetus to tentatively suggest that the future of visual anthropology would depend on how visual anthropologists of the twenty-first century develop their use of new digital media, anthropological theory and applied visual anthropology. The positive

response I received to this paper, which forms parts of chapter 1 of this volume, has encouraged me to develop this argument here.

Chapter 2 is a slightly modified version of my (2003) article 'Interdisciplinary Agendas in Visual Research: re-situating visual anthropology', published in *Visual Studies*. Chapter 3 was originally conceived as a conference paper presented in a panel convened by Paul Henley and Rosie Read at the ASA conference in 2003. Chapter 4, written for this book, adapts and combines my (2003) article 'Representing the Sensory Home: ethnographic experience and ethnographic hypermedia', published in *Social Analysis* and parts of a book chapter 'Conversing Anthropologically: hypermedia as anthropological text' published in the edited volume *Working Images* (2004). Chapter 5 was first presented as a conference paper at the EASA conference in Vienna in 2004, in a panel I convened on Applied Visual Anthropology. Finally, chapters 6 and 7 were written specifically for this book.

Part I

Situating
visual anthropology

Chapter 1

Engaging the visual

An introduction

In this book I discuss the future of visual anthropology by suggesting a series of challenges, departures and opportunities for the subdiscipline as it enters the twenty-first century. I propose visual anthropology's potential lies in its engagement with a set of key interrelated contexts: the increasingly wide use of visual ethnographic methods of research and representation in 'visual' subdisciplines across the social sciences and humanities; the theoretical demands of, and shifts in, a mainstream anthropology in which the visual has now become acceptable and popular as a methodology and object of analysis; a reassessment of the aspects of human experience that images and writing best represent, and a related analysis of the relationship between the visual and other senses through an engagement with recent developments in the anthropology of the senses; the possibilities offered by digital video and hypermedia that invite visual anthropologists to develop new practices; and increasing use of visual methods of research and representation in applied anthropology. In doing so I explore how theory and practice might be combined to produce a visual anthropology that has a strong profile in and outside the academy and communicates effectively to either audience.

First, however, what does it mean to refer to the future of an academic subdiscipline? Often our discussions of the future are constructed in relation to our definitions of the past. In Britain the history of social anthropology (see for example Kuper 1996; Mills 2002, 2003) and the historical relationship between social and visual anthropology (Grimshaw 2001) have been critically documented. In the USA the historical development of visual anthropology has been discussed widely in several contexts. Many aspects of its development are charted in the Web Archive in Visual Anthropology (WAVA), which contains Jay Ruby and Sol Worth's original proposal to set up a Society for Visual Anthropology in the USA[1] as well as the society's newsletters from 1973 to 1987,[2] and in the Journal *Studies in Visual Communication* from 1979 to 1985. This history is also represented in diverse volumes focusing on particular visual anthropologists and filmmakers. Alison Griffiths (2002) explores the development of anthropological cinema in the context of turn-of-the-century visual culture, Jay Ruby critically reviews a series of twentieth-century projects (2000a), E.D. Lewis' (2004) edited volume discusses Timothy Asch's work, and the wider-ranging *Origins of Visual Anthropology* conference[3] and volume brings the work of the 'founders' of visual

anthropology to the fore (Prins and Ruby 2001–02). Although my main focus in this book is on what we might call mainstream contemporary visual anthropology in Britain, the USA and Australia, other histories of visual anthropology from across Europe – for example, France,[4] Germany[5] and Hungary[6] – and more recent developments in China[7] demonstrate how uneven the development of the subdiscipline has been internationally. Like the wider history of anthropology, which is embedded in political and power relationships, and the ambiguous relationship between anthropology and national culture and politics (see for example Eriksen and Nielsen 2001), visual anthropology theory and practice (and its relationship with applied anthropology) has developed differently in different locations.

Although these histories can be, and sometimes have been, challenged[8] we have a fairly clear notion of how visual anthropology has arrived at its present form: our history is of the practices and performances of individuals, the formation and dissolution of institutions, associations and departments, the proceedings of conferences and seminars, developing theory, (changing) research practices, the production of anthropological texts, and the appropriation of technologies for these purposes. The future of visual anthropology is contingent on similar processes – that is, on the practices of research and representation we develop, the connections we make within the discipline, the academy and outside, the postgraduate training offered, the conferences, seminars, associations and networks we build,[9] and the debates we engage in. I propose we view visual anthropologists, the creative practitioners of an academic subdiscipline, as a type of 'community of practice' – defined by Wenger *et al.* as 'groups of people who share a concern, a set of problems, or a passion about a topic, and who deepen their knowledge and expertise in this area by interacting on an ongoing basis' (2002: 4) – and the creativity, innovation and debate this inspires. It will be through our creative and innovative practice as individual agents, and in collaborative groups working in different ways and with different media and methods, and through debate and discussion that the future of the subdiscipline will form, even though much of our interaction will be mediated by written text, film, e-mail and more, rather than as face-to-face contact. This book suggests some points we might keep in mind as we engage in the practices that will shape the future of visual anthropology.

This book is not a critique of visual anthropology. However, a critical edge is intended as I urge visual anthropologists to enter areas that have previously not been sufficiently engaged. With contemporary theoretical and methodological developments originating from within and outside the academy, the beginning of the twenty-first century presents an inspiring context for considering and securing the future of visual anthropology. In the second part of this chapter I identify some themes of this contemporary context that are particularly pertinent for the future of visual anthropology, and which shape the book – the interdisciplinary context, the anthropology of experience and the senses, applied visual anthropology, and new visual and digital media. First, I discuss how their histories were interwoven in relation to the emergence of mainstream social and cultural anthropology in the twentieth century.

The historical context

Rather than writing a 'complete' history[10] here I present a series of critical insights into how visual, sensory and applied anthropology and new technology have been supported and sidelined by mainstream anthropology as it was established as a distinct academic discipline during the twentieth century.[11] The turn of the century is a pertinent starting point for a number of reasons. Elizabeth Edwards proposes that colonial photography (produced from 1860 to 1920) is 'evidence of the early years of what has become visual anthropology' (Edwards 1992: 3). During this period, not only did the 'parallel historical trajectories' of anthropology and photography overlap (Pinney 1992; Young 1998: 4), but also the colonial project entailed an initial application of anthropological methods to an interdisciplinary project with non-academic ends, and the sensorium was implicated in the early anthropological theory that informed colonialism. Moreover, methodologically this was a period of technological innovation. Early fieldworkers used multiple media to collect ethnographic materials and combined spoken words with photographs, film and sound in their public lectures. These new photographic and cinematic techniques of research and representation were employed alongside the emergence of the 'database' academic book genre that used the multiple media of writing, photographs and diagrams (Cook 2004: 60).

The 1890s to 1950s: the rise and rejection of the senses, the visual and the applied

One of the first documented academic anthropological uses of film is Alfred Cort Haddon's 1898 British expedition to the Torres Straits Islands, a large multi-disciplinary expedition to study scientifically the Islands' people, 'comprehensively equipped with the very latest scientific recording instruments'. This included 'equipment for taking [photographic] stills, movies and even experimental colour photographs' (Long and Laughren 1993; see also Griffiths 2002: 129–48), forming a multimedia project that Anna Grimshaw characterises as 'a mixture of Victorian ideas with modern innovative practices' (2001: 19). Vision was central to the Torres Straits expedition as both a method of research and its scientific approach to 'native life', which by favouring direct observation over missionaries' and travellers' reports fused the 'roles of fieldworker and theorist' (Grimshaw 2001: 20; see also Eriksen and Nielsen 2001: 42). Vision also figured in another way in Haddon's scientific project, which, David Howes reports, was concerned with the senses and sought to prove a hypothesis about the relative significance of vision in civilised and primitive cultures. It was believed that for civilised Europeans the 'higher' senses of sight and hearing were most important, in contrast associating the 'lower' senses of taste, touch and smell with animality. One task of the expedition was to test the hypothesis that '"primitive" peoples would show a predilection for the "lower" or "animal" – in short "primitive" senses' on the 'primitive' Torres Islanders. Howes notes that 'Although the data itself was inconclusive, it was

interpreted to support this hypothesis' (2003: 5). Griffiths also suggests that Haddon's filmmaking was a form of 'haptic cinema' (through which the viewer 'feels' or 'touches' the image), which would have produced a 'sensorially rich' experience that was incompatible with the scientific quest of turn-of-the-century anthropology (2002: 142–3). This early evolutionary anthropology accommodated interdisciplinarity, engaged its era's new technologies and seemingly found both a sensory approach and visual method uncontroversial.

Haddon was not the only anthropologist of his time to use film and photography. Franz Boas (see below) also used both media and Howard Morphy describes how Baldwin Spencer and Frank Gillen, who did fieldwork together with Australian Aboriginals from 1894 onwards, used innovative visual methods as part of their participant observation. Taking few portraits of the type associated with the evolutionary paradigm, they produced 'photographs of ritual events as they occurred', developed photographs in the field and used them for elicitation, and in their film footage focused not on staged events but, for example, on a fight and women arguing (Morphy 1996: 140–1). Perhaps they were ahead of their time – Morphy notes that they 'saw photography as an essential means of conveying the atmosphere and experience of the Australian rituals they witnessed' (1996: 142), like Haddon's work implying some attention to sensory experience. Both Spencer and Haddon appreciated the benefits of using multiple media in not only ethnographic research, but also in public presentations of this work in the form of the 'multimedia lecture' (Griffiths 2002: 166), which integrated film, photography and sound into spoken performance. Public film screenings also marked the early popular appeal of ethnographic film (Griffiths 2002: 283).

The work of Haddon, Spencer and others undoubtedly had a lasting influence on the development of the long-term fieldwork method as well as the use of visual methods in subsequent work (Grimshaw 2001: 51; Morphy 1996). However, it has more commonly been argued that social and cultural anthropology emerged around the time of World War I (Eriksen and Nielsen 2001: 37), usually credited to the influence of Bronislaw Malinowski, Franz Boas, A.R. Radcliffe-Brown and Marcel Mauss. Although approaches varied among these 'founding fathers', the approach associated with them advocated the long-term fieldwork method, rejected the evolutionary paradigm, was characterised in Britain by debates between functionalism and structural functionalism, sought methods for cultural translation, and was a comparative relativist discipline (Eriksen and Nielsen 2001: 37–53).[12] It saw 'anthropology as a *holistic* science' (original italics) that did not study and compare singular aspects of societies – such as rituals – but aimed 'to describe societies or cultures as integrated wholes' (Eriksen and Nielsen 2001: 51). In his interpretation of how the senses came to be excluded from twentieth-century anthropology, Howes suggests these developments led anthropology to lose interest in the sensorium by concentrating on sight and hearing (2003: 6), allowing the development of subdisciplines such as visual anthropology (2003: 7) and ethnomusicology where '"other" sensory domains are customarily eliminated or evoked only indirectly' (2003: 8). However, actually within this context we see a decline in interest not only in the sensory but also in

visual images and technologies. The notion of an observational anthropology was by no means coterminous with a visual anthropology. In fact an interrogation of the work of the observational method's two main proponents – Malinowski and Boas – reveals that, although both were prolific photographers, their approaches actually limited the potential of the visual.

Dating from 1883 to 1930, historically Boas' initial photography pre-dates Haddon's expedition. His early work with the Kwakiutl Indians, which contributed to his 'multimedia approach' to anthropometric studies (also including measurements and plaster casts of body parts) (Jacknis 1984: 20), has some parallels with Haddon's enthusiasm for new technologies. However, later Boas' interests shifted and his photographs (often taken by an indigenous photographer) covered material culture, ceremonies, temporal and spatial patterning as well as portrait and physical-type photographs of people. They were presented in museum collections, at his lectures and in two monographs. His use of film, mainly to record native dance, was to combine these materials as a source of raw data for triangulation with other sources (Griffiths 2002: 306). Although some see Boas as a 'father figure in visual anthropology' (Ruby 1980: 7, see Jacknis 1984: 51), Jacknis' analysis demonstrates that 'photography was caught in the inherent contradiction that defined Boas' fieldwork' (1984: 47). Boas believed culture could only be understood historically and he moreover mistrusted the visual because it only showed the surface. For Boas 'the study of the human mind was possible only through the medium of language', thus 'the mere act of witnessing some exotic behaviour was insufficient' (Jacknis 1984: 44). As such his approach foiled and did not promote any anthropological appreciation of the scientific value of photography. He created a legacy for his students (such as Margaret Mead), who later followed his example of using visual media, a context where the visual image was not valued.[13]

Malinowski was also an active fieldwork photographer (about 1,100 of his images are archived at the London School of Economics (Young 1998: 21)). He rejected the principles of the anthropometric photography of the nineteenth century to create a photographic record of 'living' people (Young 1998: 4), using photography extensively in his publications (1998: 21). However, while his photography was prolific (and influenced later visual practices), it was fundamentally incompatible with the fieldwork experience Malinowski advocated. In Grimshaw's interpretation Malinowski's fieldwork methodology was based in romanticism, it relied on 'the cultivation of human sensibility or passion', and repudiated 'technology, mechanical skill and the trappings of industrial civilisation' (Grimshaw 2001: 54). Likewise, his writing was 'painterly' rather than cinematic, relying on literary composition rather than montage (2001: 55–6). Grimshaw shows how Malinowski's observational approach employed experience and description to create a picture of a 'whole' society or context. The mediation of technology and specificity of photography constituted a contradiction in this work, and his wider approach left little room for visual methodology. Jacknis' and Grimshaw's respective analyses of the legacies of Boas and Malinowski suggest that although participant observation became a requirement for anthropological fieldwork, it is

incorrect to assume the consolidation of observational anthropology favoured visual over sensory anthropology. It is more likely that decreasing interest in the sensorium was, like the rejection of visual methods of anthropological research and representation, fuelled by other themes that emerged as anthropology departed from the evolutionary model to a relativist one.

The process by which social and cultural anthropology established itself as a scientific discipline is key to understanding the rejection of the visual, sensory and applied. None fitted with this scientific anthropological project. First it rejected the subjectivity of photography and film to use visual metaphors such as diagrams, grids and maps to synthesise and objectify knowledge (see also Grimshaw 2001: 67). Second, and likewise, Seremetakis suggests these 'homogenising representational strategies that privileged vision-centred consumption of ethnographic experience, the reductive mapping of cultural traits, and the narrative genre of a static ethnographic present' also excluded sensory experience (Seremetakis 1994a: 225). Third, the ethnographic footage of Spencer and Gillen, Haddon and Boas was produced in a context where these anthropologists were already aware of the commercial and popular appeal of their films (Griffiths 2002, chapters 4 and 6). This more sensory and decontextualised form of representation, along with its popular appeal, would have been contrary to the development of the scientific identity of academic anthropology. Finally, this occurred in a wider context where the applied and 'pure' strands of anthropology came into conflict. In Britain interwar social anthropology was seeking academic recognition, status and funding in a context formed by the specific politics of the interwar years, which were characterised by economic depression and social unrest at home and colonial expansion overseas (Grimshaw 2001: 67–8). During this period social anthropology was funded and effectively established by virtue of its relationship with the Colonial Office. By the 1930s British anthropologists were funded to undertake applied studies in the colonies (Kuper 1996: 101–2).[14] Indeed, the principal task of Evans-Pritchard's Nuer research – 'to discover the enduring principles underlying Nuer territorial groupings' – was 'determined by the Anglo-Egyptian Administration' (Hutchinson 1996: 30). In his preface to *Nuer Religion* Evans-Pritchard thanks the Government of the Anglo-Egyptian Sudan 'for a grant of money towards the cost of publication' (1956: ix). This period was characterised by a contest between applied and 'pure' academic anthropology (see Mills 2002) until the 1950s, when – deriving new confidence from funding from the Carnegie and Rockefeller Foundations and an identity as a scholarly profession with the establishment of the Association of Social Anthropologists of Britain and the Commonwealth (ASA) in 1946 – leading anthropologists were not interested in shaping their research agendas to meet the needs of industry[15] or colonialism. In Britain, by the 1950s applied anthropology was rejected by the emergent academy, keen to demonstrate that anthropology was an exploratory scientific and theoretical discipline, inappropriate for the problem-solving demands of applied work. In the USA during the same period applied research also contributed to cultural anthropology. In fact, even earlier, Boas' name again comes into the picture as in 1910 he published policy research that

contradicted racist ideas about the impact of immigration in the USA (van Willigen 2002: 24). A number of applied research organisations, such as the 'Applied Anthropology Unit in the Office of Indian Affairs', were established and, for example, anthropologists were employed by the US Department of Agriculture. This culminated in anthropologists working 'in support of the war effort during the 1940s' and the establishment of the Society for Applied Anthropology (which still exists at the beginning of the twenty-first century) and its related publications (van Willigen 2002: 26–8). Although applied anthropology was accepted and more strongly established in the USA than in Britain it still remained a contested practice.

By the 1950s anthropology had experimented with and rejected the senses, visual methods and technologies, and applied practice. The social and cultural mainstream was establishing itself as a scientific theoretical discipline, distinguished from others by its emphasis on long-term fieldwork, its relativism and comparative project.

From the 1940s to 1980s: a marginalised presence

Taking the development of scientific anthropology that rejected the visual, sensory and applied as context, I now focus on the advances that were made in these areas in the mid-twentieth century. After Malinowski and Boas photography and film were not entirely absent from the anthropological endeavour. For example, Evans-Pritchard's Nuer publications (see chapter 2), the electronic archive of Paul Stirling's Turkish village research, including photographs from 1949–51 fieldwork,[16] and Julian Pitt-Rivers' 1950s fieldwork in Southern Spain (Pitt-Rivers 1963). Ethnographic photography from this period was usually used as illustration rather than being conceived as an analytical or methodological tool and is now interpreted as an objectifying practice.[17] It was thus unchallenging to the contemporary anthropological project. A more ambitious project was Bateson and Mead's photography and film in Bali, coupled with Mead's conviction that visual anthropology could serve a scientific, objective anthropology (discussed in detail in chapter 2). This work, moreover, attended to sensory experience; Jürgen Streek notes Bateson and Mead's stress on Balinese 'cultivation of the tactile aspect of actions, i.e. the very subtle application of pressure by the finger-tips to the malleable substance of meat', and how, combining image and word to represent this, 'Bateson and Mead wrote of "emphasis on the separateness of the fingers and on the sensory function of their tips" (Bateson & Mead, 1942: 100)', also shown in their photography.[18] Both the successes and failures of Bateson and Mead's Bali photography and cine-film are interesting. Their success was in publishing an innovative and important landmark text in anthropology, which continues to be influential. However, this project failed to achieve its potential to persuade anthropologists of the time of the value of systematic visual research and analysis as a contribution to the scientific anthropology of the era (Morphy and Banks 1997: 10–11; see also Grimshaw 2001: 88 and Ginsburg 2003) or inspire an anthropological focus on the senses.[19]

Mead was also a champion of applied anthropology. During World War II, amongst other things,[20] with Ruth Benedict in 1941 she 'founded the Institute for Intercultural Studies ... to mobilize the behavioural sciences for public service', where she led the Columbia University Research in Contemporary Cultures project (1947–52). Mead and Métraux's research manual *The Study of Culture at a Distance* publishes examples of this work (Beeman 2000: xvi–xvii) and is interesting for several reasons. First it contests the anthropological tenet of its time that equated anthropological research with long-term face-to-face fieldwork, instead engaging anthropology in the solution of real-world problems through distance methodologies. The group's work often informed policy and/or decision-making.[21] The study of 'national characters' aimed to 'help national governments to deal with members of other nations who were also behaving nationally, as members of armies, negotiating commissions, and so on' (Mead 2000: 4). Second, they advocated the study of visual materials, including film and popular and fine art (Mead 2000: 3) and other literary media and performance genres, as a route to understanding culture and 'national character' (discussed in chapter 5). Finally, the volume attends to the senses (see also Howes 2003: 6–17). Mead notes the importance of imaginatively reconstructing the sensory experiences of fieldwork or inaccessible historical events (Mead 2000: 12) and the book includes pieces written by informants about their own sensory experiences. Although she did not explicitly link the visual, sensory and applied theoretically or methodologically, all pertained to Mead's agenda. This however did not become embedded in the mainstream anthropology of the 1950s. Perhaps partly due to Mead's willingness 'to experiment with new topics, ideas, and technologies' (Sharp 2003: 1), she did not achieve equal 'respect and recognition from the Academy accorded some of her more sober, male contemporaries' (Ginsburg 2003: 2).

Although visual and applied anthropology were contested approaches during this immediate postwar period of scientific, theoretical and objective anthropology and continued to be for at least the following three decades, this did not prevent their establishment. In the USA Ruby (2001–02: 5) dates visual anthropology's official acceptance as 'a credible scholarly undertaking' to the early 1970s, when the Society for the Anthropology of Visual Communication became established as a subsection of the American Anthropological Association. The approach to visual anthropology of the time was laid out in Gross and Ruby's framework for the journal *Studies in Visual Communication* (founded in 1974 by Sol Worth) and stated by Ruby and Chalfen as including:

> (1) the study of human nonlinguistic forms of communication which typically involves some visual technology for data collecting and analysis, (2) the study of visual products, such as films, as communicative activity and as a datum of culture amenable to ethnographic analysis, and (3) the use of visual media for the presentation of data and research findings-data and findings that otherwise remain verbally unrealised.
>
> (Ruby and Chalfen 1974)

However, during the latter part of the twentieth century the dominant practice in visual anthropology was ethnographic filmmaking, various genres of which, as well as in the USA and Britain, developed in Germany, France, the Netherlands and Australia (see Dunlop 1983; Heider 1976; Taureg 1983).

During this period, applied anthropology also became institutionally established, but remained a contested field. From 1945 to 1975, although there was no universal acceptance of applied anthropology in the USA a group of applied anthropologists emerged, their roles diversified, and anthropologists began working as agents of change in society (van Willigen 2002: 31). In Britain after the 1950s, applied anthropology developed in a troubled relationship to the mainstream culminating in outright rejection of the applied by prominent members of the academy. This was strongly contested by the enthusiasm and enduring presence of applied anthropologists in Britain (see Wright 2005) but developments were more restricted than in the USA. Nevertheless, during this period there were some important developments that linked applied and visual anthropology, unsurprisingly in the USA, which are little reported in the existing literature. In particular the work of John Collier Jnr (discussed in chapter 5) stands out. Collier, who is best known for his book *Visual Anthropology: photography as a research method* (1967), harnessed visual anthropology for applied research mainly in the field of anthropology of education. His work was practical, intended to lead to social intervention, scientific in its methodology, and informed by anthropological theory.

Visual anthropology was also applied in other ways during the twentieth century but infrequently reported. Exceptions are the 1970s and 1980s Australian Aboriginal films made by Ian Dunlop, Roger Sandall and David MacDougall, which served to bring Aboriginal issues into a public domain. These films were sometimes made at the request of their subjects and were produced to serve both the interests of their subjects and those of ethnographic filmmakers (Loizos 1993: 171). Although such films became 'famous' within visual anthropology they did not inspire a literature about the applications of visual anthropology. In fact, the innovations they are noted for in the history of ethnographic filmmaking are technological and epistemological, acclaimed for highlighting 'the ability of the film-makers to be increasingly explicit about how the films were made and the whys and for-whoms of their making' (Loizos 1993: 171). Although applied visual anthropology did not emerge as an established field its practice was developed by leading visual anthropologists. As I outline in chapter 5 Richard Chalfen (better known for his academic work on family photography and home media) has since the 1970s developed an applied visual anthropology in health research. Moreover since the 1970s anthropologists have increasingly worked in indigenous media. Some of this work (for example Prins 2002) involves applying visual anthropology to indigenous issues. Other work (for example Michaels, see Ruby 2000a) suggests anthropological approaches to producing indigenous media with and for local people. The potential of visual-anthropologically produced or informed media that lead to social interventions has long since been recognised in practice, whereas the public profile of visual anthropology associated it primarily with ethnographic filmmaking.

Until around the 1980s mainstream anthropology had largely come to reject applied interventions, the use of new visual technologies for research and representation and a focus on the senses. It had effectively become a monomedia anthropology, based on written text and verbal presentations. Within this written anthropology, however, by the 1980s some interesting debates had begun to emerge, with a developing interest in the body and phenomenology (in the work of Thomas Csordas), questions of experience (Turner and Bruner 1986), the senses (Stoller 1989), the status of text itself (Geertz 1988) and a continued insistence by applied and visual anthropologists of the value of their approaches. In the next section I analyse the significance of this context for the reassertions of the subdisciplines of visual, sensory and applied anthropologies that emerged alongside a renewed acceptance of technology.

From the 1980s: the 'crisis of representation' and the (re)establishment of visual, sensory and applied anthropologies

Although uses of visual technologies in research, visual analysis and applied visual practice were evident in twentieth-century visual anthropology these were largely overshadowed by the more 'glamorous' practice of ethnographic filmmaking (Morphy and Banks 1997: 5), experienced variously as an exciting round of international film festivals and a teaching resource that was infrequently connected to accompanying written ethnography or theory.[22] Ethnographic filmmaking developed along various strands and styles from the scientific to more recent observational and participatory cinema.[23] Its history has been written and re-written in various forms (for example, versions and fragments of it can be found in Grimshaw 2001; Heider 1976; Loizos 1993; MacDougall 1998; Ruby 2000a). I will not repeat this here. However, it is significant that by the 1980s and into the 1990s ethnographic film emerged as a subjective and reflexive genre (for example the films of Jean Rouch and David MacDougall). It had largely rejected past attempts to serve scientific anthropology (for example Heider 1976),[24] and visual anthropologists (again notably MacDougall) had begun to take on board questions of the body, phenomenology and experience, and to interrogate the relationship of film to anthropological writing. As social and cultural anthropology became more firmly established as objective (objectifying) practices up to the 1980s, visual anthropology had gradually departed from the epistemologies that informed mainstream anthropology to embody, as MacDougall has coined it, a 'challenge' to it. Curiously, though, it was eventually not the challenge of the visual that pushed anthropology into a crisis in the 1980s and 1990s, but closer reflection on the mainstay of conventional anthropological representation – its monomedia practice – the written text.

The key milestone in the development of this 'crisis of representation' or 'writing culture debate', as it has come to be called, is usually seen as led by the work of James Clifford and George Marcus (1986, for example). Its impact is summed up nicely by James, Hockey and Dawson who suggest it 'alerted anthropologists to the

need to pay closer attention to the epistemological grounds of their representations and, furthermore, has made them consider the practical import of that process of reflection, both for the anthropological endeavour and for those who are the subjects of any anthropological enquiry' (1997: 3). In the 1980s some of the ideas proposed in this work were resisted. Also some valid critiques of the approaches Clifford and Marcus, Tyler and others advocated pointed out what it had neglected (for example, Henrietta Moore (1994) notes their inattention to gender and a feminist perspective). Howes complains that this emphasis on text also subdued the anthropological interest in the senses that had emerged during the mid- to late-twentieth century (developed variously by Lévi-Strauss, McLuhan, Ong, Carpenter, Hall, and Mead and Métraux) (Howes 2003: 6–17). Howes argues that this turn to dialogic anthropology (in particular he cites the work of Tyler and Clifford) in the 1980s exacerbated problems he associates with Geertz's approach to reading culture as text, as a second focus on textualisation (2003: 22–6), which diverted attention from sensory experience. Instead he suggests that '[by] Striving to be more sensible, we would also be more inclined to experiment with our bodies and senses, instead of simply toying with our writing styles' (2003: 28). Howes' interpretation of the impact of the work of Clifford and Marcus and others and the 'crisis of representation' offers one way of understanding why anthropologists paid little attention to the senses during that period. However, as I outline below, an alternative explanation may be that Howes' own approach to a sensory anthropology was incompatible with the new 'turn' in anthropology in another way. To contextualise this first requires a brief note on the impact of this 'crisis'. The issues raised indeed made anthropologists think more carefully about how their texts are constructed; however, its impact on the experimental movement in anthropology also influenced anthropologists in other ways. As part of a critical reflection on power relations and truth claims in the wider anthropological project it inspired new forms of representing anthropologists' own and other people's experiences. Significantly, it helped to bring reflexivity to the fore in anthropology (reflexivity was already integral to visual anthropology – raised notably by Jay Ruby – and much existing ethnographic film practice (see also Ginsburg 2002a: 214)). It also raised the profile of individual subjectivity – of anthropologist and informant and in the contexts of both fieldwork and representation – which influenced new styles of ethnographic writing. Indeed, one of the most interesting late-twentieth-century experiments in ethnographic writing is Stoller's (1997) *Sensuous Scholarship*, a book that both focuses on sensory embodied experience and explores new ways of representing this reflexively in written text. Previously, in 1989, Stoller's *The Taste of Ethnographic Things* emphasised how ethnographers might learn from their own sensory experiences in fieldwork. I suggest that in this new context, where greater importance was given to experiential ethnography and individual subjectivity, it was not a sensory anthropology that was excluded, but rather the approach Howes (1991: 168–9) advocated. He was not interested in individual sensory experience, but rather in comparing how different sensory hierarchies fitted with '*whole* societies' (original italics). This sensory anthropology was not simply foiled by the crisis of

representation but by the project's clash with a related critique – the rejection of the comparative paradigm and its related notion of holistic cultures. The 'grand theories' and scientific methodologies of comparative anthropology became, as Fox and Gingrich (2002: 2) outline, increasingly unfashionable throughout the 1970s, accused of supporting European imperialism (for example by Asad 1973; Clifford 1983; Clifford and Marcus 1986) and undermined by a critique of its claims to objectivity. This was indeed a context that favoured a visual anthropology which MacDougall characterises as completely at odds with anthropology's comparative project, because rather than stressing cultural differences it reveals 'social agency' and 'recognizable patterns of social interaction' that emphasise commonalities rather than difference between individuals in different cultures (1998: 256). The premise for rejecting visual methods and visual representations of anthropology (usually ethnographic film) as too subjective became invalid, and visual anthropology was able to make its own claims to be closer and more acceptable to mainstream anthropology. By the 1990s the mainstream was also interested in the approaches to embodiment and sensory experience evidenced in reflexive and phenomenological approaches to visual ethnography and its filmic and written representation, and the emphasis on individual experience that is an enduring characteristic of observational film. Therefore I suggest that visual and sensory anthropologies started to gain popularity in the 1990s partly as a consequence of the crisis in representation, but also of course in relation to a number of other theoretical developments such as the emphasis on the body and phenomenology. This also occurred as part of a turn away from a comparative anthropology.[25]

Not only did the crisis of representation invite anthropologists to engage in experimental forms of writing, but it also inspired new ways to represent sensory embodied and visual aspects of culture, knowledge and experience. This encouraged the use of other modes and media of representation, including not only ethnographic film and photography, but also performance anthropology and exhibition. If not yet constituting a multimedia anthropology the emergent context was one where anthropologists began to recognise the validity of multiple media in anthropology. Significantly it was during the 1980s and especially the 1990s that, as academics gradually converted their office practices to the use of computers, digital media became an increasingly normal part of everyday anthropological practices of writing and communicating. It is within this context that the development of a theory and practice of hypermedia anthropology began to emerge in the 1990s (see chapter 6).

It may at first seem that the subjective reflexive strands of 1990s anthropology would also foil the development of applied anthropology. To some extent a problem-solving approach needs to accommodate a realist view of some aspects of social life and experience. However, in fact, since the 1990s applied anthropology has been increasingly recognised by mainstream anthropological institutions and practised across a wide range of non-academic sectors. There are two possible explanations for this. One is that anthropology has become so fragmented that 'anything goes'. The second and more plausible explanation is that a reflexive approach that recognises the intersubjectivity and often fragility of the grounds

upon which our assumptions are made is also compatible with an applied anthropology. As we see in chapter 5's focus on applied visual anthropology, the principles of reflexivity and collaboration and the process of undermining essential truths in favour of understanding individual locations are also integral to applied practice, and in fact applied and academic visual anthropology share many principles.

Throughout the twentieth century the strands of visual, sensory and applied anthropology were variously incorporated and rejected as anthropology moved from its 'multimedia' practices of the late nineteenth century to establish itself as a monomedia academic 'discipline of words', as Mead (1975) put it. By the end of the twentieth century the bastions of scientific anthropology were crumbling in favour of a subjective and reflexive approach that favoured experimentation, welcomed new technologies and was increasingly recognising its relevance in the wider world. In the following sections I suggest the meaning of this for a visual anthropology for the twenty-first century and outline the programme of analysis it sets in the following chapters.

A visual anthropology for the twenty-first century: opportunities and challenges

The contemporary interdisciplinary context

Between 1999 and 2001 a series of new publications across the social sciences and humanities revealed a thriving interdisciplinary interest in visual research methods.[26] In chapter 2 I outline this interdisciplinary context, which is at times plagued with amateur borrowings and misguided critiques (see also Pauwels 2000: 12–13). Some recent publications on visual methods have (misguidedly) set out to discredit contemporary visual anthropology through criticism of its colonial roots and the observational projects of its mid-twentieth-century past (for example Emmison and Smith 2000; Holliday 2001). However, visual anthropologists have also set about defining a visual research methodology with a basis in anthropology (Banks 2001; Pink 2001a). In this situation visual anthropology needs to assert its identity beyond that which is often attributed to it by virtue of its association with colonial photography and ethnographic film. It needs to ensure that its approaches and range are understood amongst these emergent visual subdisciplines, each of which appears to have academics keen to stake their claim to be the leader in visual methodology. Simultaneously this surge of interest in visual methodologies is good news: visual anthropology no longer exists in a space where its very focus on the visual is a contested project, but in a context where it is of interest to both anthropologists and other social scientists. Indeed, resistance to the visual in anthropology is now a problem of the past. This theme and the interdisciplinary agendas it involves are taken up in chapter 2, where I identify the place of visual anthropology in this emergent interdisciplinary context. I return to this context in chapter 5 to discuss applied visual anthropology practice, which often involves working with colleagues (and principles) from other disciplines and in chapter 6 to situate visual anthropological uses of hypermedia with others across the social sciences and

humanities. In the final chapter I reflect on the status and distinctiveness of anthropology as a discipline amongst the other social sciences and the role of the visual in this.

Mainstream anthropology as a context for visual anthropology

The close association of visual anthropology with ethnographic film that character-ised its position for much of the latter part of the twentieth century is diminishing. We have already gone 'beyond observational cinema': on the one hand filmmaking practices have, as David MacDougall (1998) proposed in his chapter of that title, become more participatory, and on the other we have moved towards using a wider range of visual media and technologies. Largely developments have reflected Morphy and Banks' (1997: 6) call for a broadening out of the question of what visual anthropology might comprise by referring back to the three-stranded defini-tion of visual anthropology stated in the 1970s in the work of Worth, Ruby, Gross and Chalfen. This focused on using visual technologies in research methods, the study of non-linguistic behaviour, the analysis of visual products, and visual repre-sentation (Ruby and Chalfen 1974). The reassertion of this definition implies a closer relationship or overlap between mainstream and visual anthropology (it would anyway be surprising not to encounter visual cultural forms in any fieldwork project). Indeed, visual technologies are increasingly embedded in anthropological research and greater acceptance of the visual and easier access to new media encourage both more anthropologists to take video and still cameras to the field and new experimentation with illustration and drawing (see Pink et al. 2004). Some anthropologists who develop innovative visual methodologies are not trained 'visual anthropologists', but researchers who find, once in the field, that the visual offers a route towards collaboratively produced knowledge (for example Afonso 2004; Orobitg 2004). In such contexts the visual can be both the subject of research and a medium through which knowledge is produced and not only incor-porates film and photography but also encompasses digital video, drawing, art and digital imagery. As part of this process new uses of digital video, photography, illus-tration and hypermedia are emerging (see Coover 2004a, 2004b; MacDougall 2001; Pink 2004b; Rusted 2004). This is partly because as anthropologists increas-ingly use visual methods and media in their research they seek ways to combine image and text in their representations.

The second implication of this increasing embeddedness of visual methods and media in mainstream anthropological research is to challenge visual anthropolo-gists to engage their own work and the tenets of their subdiscipline with contem-porary developments in anthropological theory. In this book I approach this question through a discussion of the question of experience, which is a significant concern for visual anthropology. Generally visual anthropologists argue some elements of human experience are best represented visually, and that the visual brings the fieldwork experience directly to the context of representation. However, they (myself included) have often tended to use the term 'experience' with little

analysis of precisely what it refers to. In this book I ask how, in the light of recent anthropological work on experience, the senses and phenomenology, we might research and represent aspects of other people's experience in ways that are meaningful to others and what the role of the visual might be in this practice. In chapters 3 and 4 I discuss how we might understand on the one hand the visual research and representation of experience, and on the other the experience of visual representation. To do this I draw from recent work developed in the anthropology of the senses, which is instructive for two reasons. First, following other recent work on the senses and my own visual ethnography of the home, I see the relationship between the visual and the other senses as key to understanding how everyday experiences and identities are constituted (Pink 2004a). Second, because the anthropology of the senses encompasses vision, it locates it in relation to other sensory modalities. As such it challenges the privileged status that vision is lent by visual anthropology, and demands we rethink the ideas of visual knowledge, experience and communication in terms of the relationship between the visual and the other senses. It seems to me that one of the most important theoretical challenges is the question of how to situate the visual within an embodied and sensory anthropology – more specifically, what the relationship is between the visual and the other senses and how might we understand the visual both as a form of 'experience' and as a medium for its representation. To add to MacDougall's (1997) comment that some aspects of knowledge can best be communicated by visual means, recent research demonstrates how other aspects are best communicated through smell, touch or sound (see Pink 2004a). A sensory anthropology also has implications for how visual anthropology might communicate transculturally – Geurts' (2002) study of the Ghanaian Anlo Ewe sensorium indicates that because people in other cultures might not use the same sensory categories as modern western anthropologists, the question of sensory representation is further complicated. David MacDougall (1998) has drawn from phenomenological anthropology, the anthropology of the body and of the senses to argue that because the individual subject takes a central role in film it has a potential for communicating about sensory experience transculturally that cannot be achieved in writing. However, my own reading of the recent anthropology of the senses convinces me there are other limitations to film's ability to achieve this that need to be acknowledged. I will suggest writing is essential to how we communicate anthropologically about cross-cultural sensory categories and experiences. By problematising visual anthropology in this way the anthropology of the senses invites us to pose both challenges and opportunities for the future of visual anthropology.

In chapters 3 and 4 I suggest how visual anthropology might be enriched by a confrontation with these problems.

The applied context

Applied uses of anthropology outside the academy are becoming increasingly popular in the public sector, industry and non-governmental organisations

(NGOs), and in other community work. In these contexts, combined with the increasing availability and accessibility of visual media and technologies, visual methodologies and representations are already in use. In some cases innovations in methodologies of research and representation have developed when visual anthropology that has not been tried in academic visual anthropology practice is used in applied work. This might be due to a range of factors, such as different funding opportunities, freedom to innovate without the restrictions of existing anthropological conventions, and different audience expectations. The existing work I have encountered tends both to draw from established visual anthropology methodologies and theories and to present new practices that could well also serve the aims of academic visual studies. In chapter 5 I reflect on the nature of recent and historical developments in applied visual anthropology to situate them at the intersection between visual anthropology, applied anthropology and other anthropological or interdisciplinary influences. Indeed, applied visual anthropology tends to be embedded in interdisciplinary work, which leads me to reiterate the point made above that visual anthropology needs to establish itself as a unique subdiscipline with a specific history and contribution to make on a (sometimes competitive) interdisciplinary stage.

Academic anthropologists have traditionally tended to be sceptical about the status of applied anthropologists and rejected the idea that applied practice has much to contribute to the academic discipline. Elsewhere I have argued (Pink 2005) that this is a mistaken view. In fact applied work can contribute to anthropology theoretically, ethnographically and methodologically. The same applies to applied visual anthropology, as I demonstrate in chapter 5. The projects I examine represent innovations in business, NGO, public-sector and community-based research that are not simply part of an applied endeavour that draws *from* anthropology but constitute research that can also contribute *to* mainstream and visual anthropology. There are important differences between applied and academic visual anthropology. They have different briefs, aims and methodologies. However, this does not mean that there is an insurmountable gulf between these practices as in fact they also have much in common. First they are both informed by anthropological theory, and while some methodological practices necessarily differ they tend to be based on the same principles (of reflexivity, collaboration and participation). In particular, like academic visual anthropologists, those who undertake applied work are also in the business of researching and communicating about other people's experiences, and the same issues that I raise concerning the anthropology of the senses and the anthropology of experience are as pertinent to applied as to academic visual anthropology practices. Applied visual anthropologists also create experiences for their audiences in the process of preparing representations that potentially lead to social intervention of some kind. Again, as in the academic context discussed in chapters 3 and 4, applied visual anthropologists are finding that new digital technologies can support this process. In chapter 6 I take this up to discuss the implication of new visual and digital media for applied visual anthropology alongside more mainstream digital innovations.

The more practical dimension to this context is that there is a niche for visual anthropologists to work on applied projects, participating in the development of theoretically informed 'applied visual anthropology'. This may provide important directions for a future in which visual anthropology has a more prominent public profile and engages with what some have argued is our responsibility to promote a public anthropology that comments on and intervenes in issues of public concern. It additionally creates employment possibilities for visual anthropologists in a context where tenured academic posts in anthropology departments seem increasingly scarce and employment possibilities for PhD anthropologists are limited.

The new media context

Visual and digital technologies and media are becoming more economically accessible and 'user-friendly'. Related to this, visual methodologies are more widely used by anthropologists and thus visual anthropology and the theoretical and empirical concerns of mainstream anthropology become more firmly wedded. Visual anthropologists have argued that the way forward would be both to integrate the visual into mainstream anthropology and to incorporate anthropological aims into ethnographic filmmaking. This would give the visual a critical role in revising the categories through which anthropological knowledge is produced (Grimshaw 2001: 173; MacDougall 1997: 292) by introducing the visual as an alternative way of understanding, and route to knowledge about, social phenomena. Moreover, a new agenda for digital ethnographic video-making has suggested the production of films according to anthropological, rather than broadcast television, agendas (MacDougall 2001; Ruby 2001). The future of this relationship should be a two-way process through which mainstream anthropology comes to accommodate visual knowledge and ethnographic film comes to accommodate anthropological concerns. In this book I suggest that we need to create a visual anthropology that no longer simply defends itself against the mainstream, but that responds to developments in anthropological theory that might themselves shape visual anthropology in some ways. One way this is already achieved is by accommodating theoretical developments in anthropology within visual projects – for example, to make theoretically informed visual representations. Another is to develop new forms of visual representation that can communicate theoretically, and thus will be conversant with theoretical debates in mainstream anthropology in ways that film is not. This might involve producing not only new forms of ethnographic film, but hypermedia texts that combine word and image. More broadly this involves examining the potential of a digital ethnography for the development of an anthropology that re-situates the visual and in doing so encourages innovative forms in anthropological fieldwork and representation.

Moves to new media are increasingly represented in the practice of established visual anthropologists such as Peter Biella and Jay Ruby, postgraduate training in visual anthropology,[27] and international workshops.[28] In chapters 4 and 6 I propose that opportunities to work with new visual and digital media – especially digital

video and hypermedia – suggest two important types of engagement: first, with mainstream anthropology and its methodological and theoretical currents; and second, with digital work developed in other disciplines, arts practice and theories of representation and communication. In chapter 6 I review existing hypermedia innovations to discuss the interdisciplinary context of hypermedia representation that is developing and identify the implications of these emergent genres for a visual anthropology for the twenty-first century.

Opportunities and challenges

This book develops the idea of *Engaging the Visual* via four related contemporary opportunities and challenges for visual anthropology: an interdisciplinary stage where visual methods are increasingly popular; developments in anthropological theory; the demand for applied visual anthropology; and new possibilities for digital media in research and representation. These themes are not the only basis from which to discuss the future of visual anthropology. Rather they provide a point of entry to begin to survey the possibilities. It is frequently noted in conference discussions and conversations that visual anthropology itself might now be seen as a contested concept. Part of my aim here is to examine how the subdiscipline can proceed in the twenty-first century with a renewed identity that recognises and departs from the contradictions and ambiguities that the contexts outlined above reveal.

As the book unfolds I explore each context chapter by chapter, examining as the argument progresses how the themes and issues they raise are also inevitably interwoven. Finally in chapter 7 these themes lead me to reflect on the wider contribution an engaged visual anthropology might make. Here I consider the role of visual anthropology in a renewed comparative anthropology, as a conduit of the public responsibility of anthropologists, and as a unique player in an interdisciplinary social science.

Interdisciplinary agendas
(Re)situating visual anthropology

Introduction

At the beginning of the twenty-first century visual anthropology and the cognate practice of visual sociology are established academic subdisciplines, represented by professional organisations and taught in some universities. Other academic disciplines – including cultural studies, queer studies and cultural geography – as well as applied practitioners in consumer and design research, participatory development, arts practice and other fields are increasingly using visual methods and are developing approaches that are discipline-specific and that borrow from existing examples in visual anthropology.

As the visual has gained this more established role in academic and non-academic social science research and representation, qualitative researchers from different disciplines have interrogated the existing literatures of visual anthropology and sociology to develop and inform their work. However, as Luc Pauwels warns, the path of interdisciplinarity is 'not at all an easy road to take' because '[w]hen crossing borders of disciplines the danger of "amateurism" is always lurking. This may manifest itself in a quick (and dirty) exchange or borrowing of ideas and techniques without grasping the full implications' (2000: 12–13). Moreover, some interdisciplinary exchanges have been obtusely critical and badly informed. Sometimes this involves condemnations of previous work that are the result of misguided and misinformed interdisciplinary borrowing supported by too little background reading. Often the critiques form a narrative strategy designed to prove the superiority of the author's own approach. This chapter explores two questions about the academic sphere of this context (whereas applied visual methodologies are discussed in chapter 5). First, I examine how recent interdisciplinary exchanges have portrayed the founding disciplines in visual research and representation through a focus on visual anthropology (and to a lesser degree visual sociology). Although these critiques emphasise disciplinary uniqueness they also indicate mutual interests. Therefore, second, I critically survey the common aims and interests of the academics promoting visual methods from/for their disciplines. As we delve into the 'new' visual research literature it becomes clear that contemporary visual researchers from different disciplines have common interests:

reflexivity, collaboration, ethics and the relationship between the content, social context and materiality of images.[1] Maybe I will also be guilty of promoting my own discipline, social anthropology. Nevertheless I shall argue for a more collaborative interdisciplinary approach to visual research whereby disciplines might learn from each other without seeking narrative foils to assert the supremacy of their own discipline at the expense of others.

Critiques of visual anthropology: evaluating the twentieth century

The process by which the ideas that informed anthropological uses of the visual gradually shifted from an emphasis on realist visual recording methods in the mid-twentieth century to later incorporate contemporary approaches that engaged with subjectivity, reflexivity and the notion of the visual as knowledge and a critical 'voice' is well documented in recent literature (Grimshaw 2001; Pink 2001a). This has included the incorporation of critical perspectives and new theories of representation, reflexive and collaborative ethnographic methodologies, awareness of the materiality and agency of the visual, and recognition of the ambiguity of visual meanings. These changes have taken place as anthropology has developed as a discipline that critically reflects on its own practices and theories and in which anthropologists have made critical arguments and taken innovative measures to develop new practices and approaches.

In this section I discuss three cases that are well referenced in the 'history' of the development of the theory and practice of visual research and its representation in the form of printed text, photography and film: Robert Flaherty's film *Nanook of the North* (1922); Gregory Bateson and Margaret Mead's photographic study of *Balinese Character* (1942); and E.E. Evans-Pritchard's use of photographs in *The Nuer* (1940). By examining how they have been characterised in recent interdisciplinary debates I outline how they have been interpreted and reinterpreted from different theoretical and methodological perspectives, and how these discussions reflect the contemporary concerns with ethics, objectivity/subjectivity, realism and truth, and reflexivity.

Flaherty and Nanook of the North: self-aware or self-evident?

Robert Flaherty's *Nanook of the North*, an early documentary film about Inuit culture, was released in 1922. Although Flaherty was not an anthropologist,[2] the film has gained a status in anthropology that merits its discussion here. The film represents knowledge about an 'other' and 'unknown' culture by using the narrative devices of cinema. It was based on Flaherty's experience of Inuit life as much as on his observation of it (Grimshaw 2001: 47) and in common with early twentieth-century Malinowskian anthropology it shared a humanist approach and a 'romantic impulse that shapes their engagement with the world' (Grimshaw 2001: 46). *Nanook* has had a changing presence in visual anthropology. Banks was 'shown

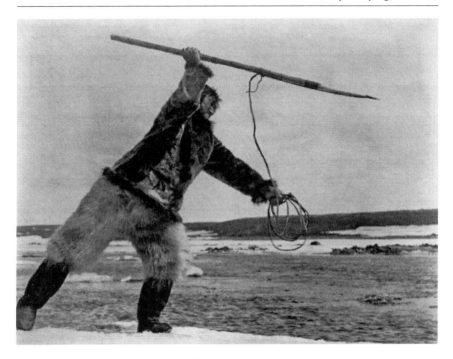

Figure 2.1 Still image from *Nanook of the North.*
Reproduced courtesy of International Film Seminars, New York.

Flaherty's *Nanook of the North* as a student in the 1970s, not as an example of early documentary film style, or even to raise issues of other-cultural representation, but as an apparently unmediated window into native Alaskan culture' (2001: 148). As a master's student in 1989–90 I viewed *Nanook* under different circumstances, as the first ethnographic film, and with concerns about questions of representation, reconstruction and film style. In this context *Nanook* was an example of a reconstruction – a style that in the early 1990s, when realist approaches carried more weight, visual anthropologists were unsure about.

At the time of its making *Nanook* had another significance and was advertised as: '*Unusual! Thrilling! Dramatic!*'. Viewers were invited to 'See the battle for life in the frozen Arctic' and 'See Nanook spear the seal, fight to get it and then eat raw flesh'; they were advised that '*You'll not even wink your eyes.* So much interest, so much heart throb, so many pulse-quickening sensations, you'll sit as if you were hypnotized. It's a rare drama, great story, thrill action with a stupendous human punch. *You'll see it twice and talk about it forever*' (from a poster advertising the film, reproduced by Gaines (1999: 9)). This sensationalising 1920s advertising discourse might well tempt an interpretation of the film as an exoticising project that plays on both the familiar and the shocking to portray cultural difference. This reading has been proposed by Rony, who claims that *Nanook* is '"a cinema of romantic preservationism" dedicated not to anthropological knowledge but to the

production of indigenous peoples as trophies and to the capture of their ways of life in nostalgic fiction' (Rony (1996: 102) cited by Gaines 1999: 6). Gaines describes how Rony borrows Haraway's concept of 'ethnographic taxidermy' to argue that the film uses artifice to produce 'a reality that improves on the event before the camera, creating an enriched and supplemented real that invites us to take it as true' (1999: 7). However, whilst *Nanook* might produce a 'supplemented reality', Gaines shows how Rony's comments are unjustified because they neglect Flaherty's 'genuine quest for knowledge about the totally unknown and familiar'. Above I noted how the advertisements appeal to the familiar and the shocking, as Gaines puts it 'the public fascination with likenesses' which can also promote 'the function of resemblance as a route to knowledge' (1999: 7). In this way Gaines redeems Flaherty's narrative strategy as a way of communicating knowledge about the unknown by creating resemblances to the familiar, thus offering audiences a framework through which to understand and incorporate new knowledge.

Gaines argues that *Nanook* is not an attempt to convince the audience that they are viewing the unmediated reality of Inuit life. Referring back to the advertising discourse she claims that 'Here audiences are attracted both *to* the hoax and *by* the very success of the hoax – by the ability of the maker to produce a perfect illusionistic imitation' (1999: 8). The flaw in Rony's analysis is that her focus is on the film as text. By concentrating on its content rather than the wider context of its production and its audiences Rony interprets it through the narrow prism of an academic discourse that misguidedly labels anthropological representations of other cultures as objectifying truth claims. However, Gaines' own discussion also lacks an important dimension, as she does not engage with the process by which the film was produced or the intentionality of its makers.

Ruby's research into the production and form of the film, and Flaherty's methods and intentions, indicates the importance of attending to how visual representations are produced. Ruby also criticises Rony, pointing out that 'Rony's chapter on Flaherty and *Nanook* is filled with unsubstantiated assertions' about the practices involved in the filmmaking process that undermine her thesis. Seeing this as an example of an attempt to 'be critical of anthropology and ethnographic film without having sufficient knowledge of either to be able to make a credible argument' (Ruby 2000a: 283 n2), Ruby writes off Rony's work as 'politically correct Flaherty bashing' (2000a: 69). Instead, Ruby describes *Nanook of the North* as 'a narrative film' in which Flaherty interweaves 'a dramatic story with actuality' (2000a: 71). Like Gaines, Ruby applauds the use of narrative as a route to knowledge, emphasising that narrative is not only a property of fiction film, but a documentary device with a role in ethnographic film. He identifies parallels between Flaherty's production methods and those advocated by contemporary ethnographic filmmakers, arguing that Flaherty was 'a pioneer in participatory and reflexive cinema' (2000a: 83). For example, Ruby's analysis of Flaherty's and his wife's diaries and correspondence, shows how Flaherty worked closely with Nanook, his protagonist, to create a film that was based on their shared construction of Inuit everyday lives and dramatic events.

The *Nanook of the North* debate is exemplary of how contemporary attempts to define the history of visual anthropology focus on questions of reflexivity, constructedness, realism and ethics. While Rony appropriates a popular post-colonial critique of objectifying truth claims, Ruby argues that Flaherty's was a self-aware project where he collaborated with his film's subjects to produce a film that represented their everyday lives to a wide audience by portraying how dramatic events were played out. Ruby thus situates Flaherty's as an ethical project that accounted for the views of his subjects, and was overtly constructed. *Nanook* played on ideas of realism but because it intended to *represent* everyday life it did not claim to be an objective recording of reality lived in real time, and it was probably not taken to be so by audiences.

Mead and Bateson in Bali and Evans-Pritchard's Nuer: uniquely innovative or exoticising and offensive?

Margaret Mead's work with photography and film and her efforts to promote the visual in social science research have had a lasting impact on the development of visual anthropology and visual sociology. Writers in both disciplines often cite her written and visual work and her call for the use of images in what she famously referred to as a 'discipline of words' (1975).[3] Mead argued that the visual could be harnessed to support the objectives that existed for the social science research of her time: namely the realist recording of 'objective' data that could be analysed to the ends of anthropological inquiry. This exemplifies what we might call the 'observational' approach, as Banks puts it: the assumption 'that simply to watch someone is to learn something about them' and in doing so to generate 'knowledge that can be later analysed and converted into intellectual capital' (Banks 2001: 112). Banks is referring to Mead's chapter in Hockings' 1975 *Principles of Visual Anthropology* (1995). The observational approach was an important characteristic of social research methods in Mead's era, and she sought to employ the visual to serve this agenda. Situated in the historical development of 'ways of seeing' in anthropology, this was a period in which 'much energy was expended in seeking to legitimate ethnographic film as an acceptable scientific endeavour' (Grimshaw 2001: 88). Over 25 years later it 'seems hopelessly outdated' (Banks 2001: 112), because most anthropologists would regard the processes by which knowledge is produced during research as the outcome of the relationship and negotiations *between* the researcher and informants, rather than of the former's objective observation of the latter. Visual anthropology has certainly moved on. Yet some recent misreadings of the history of ideas in visual anthropology have characterised Mead's 1975 proposals as if they were dominant ideas in contemporary visual anthropology. For example, Holliday (2001) represents Mead's argument (reprinted in 1995) as an objective approach characteristic of visual anthropology at the end of the twentieth century. Any critique of Mead's work needs to situate her work historically; as she died in 1978 her ideas do not represent those of a visual anthropology of the 1990s (see Pink 2001b).

Mead and Bateson's earlier work with photography in Bali published as *Balinese Character* (Bateson and Mead 1942), an example of the use of the visual as an observational recording device, has also become a topic of contemporary discussion. Banks (2001: 120–1) comments on this to discuss how social researchers have used semi-covert research techniques to produce unselfconscious images of their informants. Although informants are aware the researcher is photographing they are not conscious of precisely what. As Banks writes:

> Gregory Bateson ... sometimes used a stills camera with an angular viewfinder in his quasi-ethnological work with Margaret Mead on Balinese body styles, apparently allowing Bateson to identify and frame a shot 'when the subject might be expected to dislike being photographed at that particular moment' (Bateson and Mead 1942: 49). The example he identifies, Plate 29 of their joint work, is a series of eight photographs entitled 'Eating meals' and is prefaced by the caption that 'The eating of meals is accompanied by considerable shame. Those who are eating usually turn their backs toward anybody who may be present' (Bateson and Mead 1942: 112).
>
> (Banks 2001: 120–1)

Banks correctly situates Mead and Bateson's project in an anthropology of 60 years previously. Noting that few contemporary researchers would countenance fully covert research for ethical reasons (2001: 120), he does not explicitly judge the strategies used by Mead and Bateson. The historical slant is crucial. In the hope of collecting objective visual data Mead and Bateson would not have wanted their images to be affected by their informants' consciousness (or unwillingness to be photographed). As they were working to the agenda of a scientific anthropology with its own ethical requirements, it would be more appropriate to critique the theoretical and methodological beliefs informing this approach than their ethics. Moreover Mead (Bateson and Mead 1942) actually trained her local Balinese assistants to act as critics of the film materials she and Bateson made about them (Banks 2001: 120), showing her openness about the images they produced and her collaboration with informants to understand them.

Other writing about Bateson and Mead's Bali project has concentrated on representation. Chaplin (1994: 232) discusses Mead's innovative use of image and text in the layout of *Balinese Character*. Chaplin offers a constructive analysis of how these images are used to represent knowledge. However Emmison and Smith's (2000) analysis is less sympathetic. Similar to Rony's critique of Flaherty, they use a discourse on colonialism to criticise Bateson and Mead's (1942) and Evans-Pritchard's (1940) work and to characterise visual anthropology as a whole as a misguided and not particularly useful project, arguing that their own observational approach to visual research signifies the way ahead. They criticise visual anthropology on ethical grounds for having taken an 'affirmative position on the need for visual materials to be incorporated into its texts, even those which might be considered highly offensive'. As examples they cite images in Bateson and Mead's (1942)

Figure 2.2 A strip for Plate 91: Exhumation II from Bateson and Mead's *Balinese Character: A Photographic Analysis* (1942: 236–7).
© 1942, New York Academy of the Sciences.

Balinese Character depicting 'ritual self-wounding ... the disinterring of corpses for ceremonial purposes ... and a dog consuming the faeces emerging from a crawling infant'. They suggest such uses of photography are a strategy of giving readers 'a feel for the kind of society they are dealing with' in a context of a colonial discourse that allowed anthropologists to represent their objects with little fear of censure from those depicted. Moreover, '[d]istance in terms of geography, culture and race allowed the ethnographic photograph to be positioned as a neutral and scientific document rather than as pornographic or voyeuristic, exploitative or potentially corrupting'. In particular they note close-up pictures of naked Nuer women and men that reveal their genitalia in Evans-Pritchard's (1940) work (Emmison and Smith 2000: 15).

Emmison and Smith's critique is not totally misguided, but neither is it completely new. In fact more sophisticated critiques of the visual discourses of colonial photography (that they do not cite) had already been developed within visual anthropology (for example Edwards 1992, 1997). In his (1990) discussion of Evans-Pritchard's Nuer photographs, Hutnyk also noted how one image shows two full-frontal nude males, to suggest that 'These anonymously foregrounded natives are species "Nuer" undifferentiated, ready for comparison' (1990: 90). Hutnyk demonstrates how this use of photographs sets up a set of general types of Nuer – man, boy, youth, and so on (1990: 90–1) – thus photographically creating 'a simple model of a complex entity' which can easily be used for comparison, and using captions that employ 'the symbols of colonial and anthropological lumpen categorization' with labels such as 'boy' and the 'contextual racism' that the term carries (1990: 95).

The critiques on which Emmison and Smith base their rejection of visual anthropology have already been made. Moreover, as Loizos has already demonstrated in his response to Nichols' (1991) comparison of pornography and ethnography, the analogy just does not work (Loizos 1993: 206–7). However, as developed from within anthropology, the existing critiques have, unlike Emmison and Smith's commentary, not stopped at criticism, but have been incorporated as a point of departure and basis for exploring how appropriate photographic representations of other cultures should be produced, both by anthropologists and in collaborative projects with local people and by indigenous photographers. A good example of collaboration between anthropologists and photographers that has developed critical responses to these approaches using visual media is the *Visible Evidence* (1995) project developed by the Royal Anthropological Institute and the Photographers' Gallery. Ignoring the many recent developments of this kind, Emmison and Smith disregard any work that has been done after 1942 and fail to situate the work of Bateson and Mead and Evans-Pritchard either historically or theoretically. Effectively they write off anthropology's claim to be a reflexive ethical visual discipline without engaging with the last 60 years of its development and self-critique, or with the fact that much anthropology is now done either 'at home' and/or by anthropologists who are themselves not from modern western cultures (see Moore 1999a).

One of the key problems with the critiques of anthropology directed through discussions of Flaherty, Bateson and Mead and Evans-Pritchard is their failure to

situate early anthropological visual images and practices in the historical contexts of their production and viewing. Moreover, Emmison and Smith's and Rony's dependency on a critique of colonialism to support their arguments is self-limiting. More recently, Edwards' (2001) discussion of a series of examples of historical photographs demonstrates that the question of 'how photographs and their making actually operated in the fluid spaces of ideological and cultural meaning … cannot always be encapsulated precisely through the mechanisms of reception theory, semiotics or post-colonial deconstruction' (2001: 3). Instead she recommends a historical focus on specific acts of photographic practice and experience.

Contemporary perspectives on visual research: a new interdisciplinary field of visual methods?

Above I have emphasised interdisciplinary competition; there will be more of this later. Nevertheless, a multidisciplinary area of interest that centres on uses of visual methods of research and representation in social research is developing, represented in publications and conference meetings. Van Leeuwen and Jewitt's (2000) *Handbook of Visual Analysis* is a multidisciplinary edited collection with examples of visual research methods from psychology, semiotics, cultural studies, anthropology, and media studies that suggest visual researchers might want to combine not only different methods but also different disciplinary insights. Rose's (2001) *Visual Methodologies* also dedicates each chapter to exploring the merits and pitfalls of a different disciplinary approach to analysing images. Discussions between visual researchers of different disciplines have been facilitated by the *Visual Evidence Seminar Series* (2000–01).[4] This suggests that visual researchers from different disciplines share some perspectives and that, in the future, visual research may develop as an *interdisciplinary* as well as *multidisciplinary* field, with greater collaboration between disciplines. In this section I discuss two aspects of this: 1) the claims to originality of recent texts on visual methods; and 2) the common themes that are embedded in their arguments and critiques: the relationship between the content, context and materiality of images; reflexivity and ethics; collaboration and subjectivity/objectivity.

Interpreting visual images

I would argue that in any project a researcher should attend not only to the internal 'meanings' of an image but to how the image was produced and how it is made meaningful by its viewers. Indeed, not attending to all of these areas was one of the pitfalls of Rony's critique of *Nanook of the North* (page 24). These three areas are also emphasised by writers on visual methods. For example, Banks (an anthropologist) summarises that 'In broad terms social research about pictures involves three sets of questions: (i) what is the image of, what is its content? (ii) who took it or made it, when and why? and (iii) how do other people come to have it, how do they read it, what do they do with it?' (2001: 7). Rose (a cultural geographer) draws from

disciplines that engage in the study *of* visual images and texts (photography, psychology, visual cultures, cultural studies and media studies) rather than from anthropology and sociology that concentrate more on social uses of images. However, she is concerned with the social as well as textual and insists on a 'critical' visual methodology, advocating an approach that 'thinks about the visual in terms of the cultural significance, social practices and effects of its viewing, and reflects on the specificity of that viewing by various audiences' (2001: 32). She proposes a three-tier analysis that might focus on one or more sites where the meanings of images are made: production; the image; and 'audiencing'. Within these three sites Rose identifies three modalities: the technological, the compositional and the social. She proposes that through this model one might also understand theoretical debates about how to interpret images, which she suggests are 'debates over which of these sites and modalities is most important in understanding an image' (2001: 32).

Rose's critique of existing approaches, and her claim to originality, lie in her insistence that the 'social' aspects of visual meanings deserve more attention. Anthropologists have actually argued this for some time. Indeed, Banks offers a model by which the relationship between the social context and the content of an image might be understood. Rejecting the idea that an image might be 'read' as if it contained an internal message that we may 'listen to', he argues that to 'read' images we must attend to their 'internal and external narratives'. The image's content is 'its internal narrative – the story, if you will' and 'the social context that produced the image and the social relations within which the image is embedded at any moment of viewing' is its external narrative (2001: 11–12). Banks insists that the social relations of visual images are key to understanding their meanings – for example, 'all films, photographs and art works are the product of human action and are entangled to varying degrees in human social relations; they therefore require a wider frame of analysis in their understanding', which in Banks' terms means 'a reading of the external narrative that goes beyond the visual text itself' (2001: 12). Although these ideas are quite established in visual and media anthropology, Rose notes that the existing approaches she reviews neglect what she refers to as 'audiencing', a term borrowed from Fiske (1994) referring to 'the process by which a visual image has its meanings renegotiated, or even rejected, by particular audiences watching in specific circumstances' (2001: 5). Rose builds on the work of Moores (1993), Morley (1992) and Ang (1985) to propose that to study audiencing one might consider

1 'how audiences react to a visual image ... to produce a particular understanding of that image'; and
2 'how different audiences react to the same image ... to demonstrate the complexity of the decoding process', using different types of one-to-one and group interviews (2001: 193–7).

These would form 'ethnographies of audiencing' (2001: 197) for which 'an ethnographic approach would involve the researcher observing an audience in

their home over an extended period of time, and talking with them about their viewing but probably also about many other things' (2001: 197–8). I will return to this in the next section.

Cultural studies has an increasing presence in visual methods texts. Emmison and Smith outline what they see as a cultural studies interdisciplinary 'tool kit' of concepts for visual interpretation (2000: 66–9), and Rose draws from the field of 'visual cultures' (2001: 9–15). Making a similar argument that 'it is seldom, if ever, possible to separate the cultures of everyday life from practices of representation, visual or otherwise', Lister and Wells (2001: 61) have undertaken to outline a cultural studies approach to visual analysis – a 'visual cultural studies' (2001: 62). Their essay constitutes a key statement about methods and approaches in visual cultural studies which is more useful than previous comment from outside cultural studies, including my own (Pink 2001a). Cultural studies methodology is eclectic (Lister and Wells 2001: 64; McGuigan 1997) and well known for borrowing from other disciplines to use 'ethnographic, psychoanalytical and critical textual methods' (Lister and Wells 2001: 63). Its analytical project is coherent. Lister and Wells' visual cultural studies approach focuses on 'an image's social life and history'; 'the cycle of production, circulation and consumption through which [images'] meanings are accumulated and transformed'; the material properties of images and how their materiality is linked to social and historical processes of 'looking'; an understanding of images both as representation through which meanings might be conveyed and as objects in which humans have a pleasure-seeking interest; and the idea that 'looking' is embodied – 'undertaken by someone with an identity' – and that visual meanings are thus both personal and framed by the wider contexts and processes outlined above. These themes, succinctly summed up by Lister and Wells (2001: 62–5), resonate with the ideas of Rose and Banks outlined above, indicating that across the social sciences and humanities critical approaches to the interpretation of images have departed from the positivist 'truth-seeking' and objectifying approaches that have been so strongly critiqued and possibly signify a new approach across disciplines that interpret images.

To sum up, in contrast to Emmison and Smith, who take a largely observational approach to the visual, recent approaches to the interpretation of visual images in anthropology, cultural studies and cultural geography have in common emphasised four key areas. They insist that the research pay attention to

1 the context in which the image was produced;
2 the content of the image;
3 the contexts in and subjectivities through which images are viewed; and
4 the materiality and agency of images.

Perhaps most importantly, the arguments developed above have shown that, for the social researcher who is interested in understanding the relationship among people, discourses and objects, it would be important to focus on each of these areas of visual interpretation, as the visual meanings that she or he seeks to understand

will often lie at the intersection of these different areas of interpretation, rather than being 'revealed' by just one approach.

Reflexivity and an ethical visual methodology

Reflexivity is a key concern in most recent literature on visual research, indispensable to any contemporary research project and often cited as *the* virtue that distinguishes between good and bad research – a view that I agree with in principle (see Pink 2001a). Nevertheless, to understand how reflexivity figures in recent debate, we need to distinguish between the different claims to and uses of reflexivity. In the increasingly growing body of literature on visual methods, including anthropology (Banks 2001; Pink 2001a; Ruby 2000a), sociology (Emmison and Smith 2000), geography (Rose 2001), queer studies (Holliday 2001) and multidisciplinary approaches (van Leeuwen and Jewitt 2000), reflexivity is seen as essential. In some cases this almost resembles a race to be the *most reflexive* – a race that has inspired some to define visual anthropology as an unreflexive, unethical and objectifying practice. Such accusations are partially products of the competitive spirit of intellectual jousting whereby to knock down opponents it is usual to seek a means of discrediting them (see also Pink 2001b). They are also based on inadequate understandings of visual anthropology, its historical development, and the debates and discourses that exist within the discipline. Below I first discuss recent calls for reflexivity in visual methods. Then I interrogate some recent critiques of visual anthropology.

Reflexivity is a sub-theme in Rose's (2001) *Visual Methodologies*. Each chapter assesses the reflexivity of the approach to visual analysis under discussion. Rose shows how reflexivity is incompatible with some visual methodologies: scientific content analysis (2001: 67) and the strand of semiology that claims 'to delve beneath surface appearances to reveal the true meaning of images' (2001: 98) claim to produce 'objective accounts' that do not deem reflexivity necessary; reflexivity as a 'kind of autobiography' that explains how the author's 'social position has affected what they found' is impossible in psychoanalysis because psychoanalysis claims that the self-knowledge necessary for such reflexivity is impossible (2001: 130); and Foucaldian discourse analysis that explores the discursive formation, and ideas of power and truth embedded in text also 'refuses to be reflexive'(2001: 142), since the analyst's discourses can be no more objective than that she or he is analysing (Rose 2001: 160). Rose rightly argues that because these methodologies are not reflexive they are incapable of being critical visual methodologies. To counteract this lack of reflexivity she advises always remaining conscious of the power relations in which both the images we analyse and those we as researchers participate and are implicated in, to 'make sure your account acknowledges the differentiated effects of both an image's way of seeing and your own' (2001: 203).

Rose makes appropriate arguments and critiques, but she has set herself a difficult task because her interdisciplinary survey prevents her from attaching the models for visual research that she offers to a particular discipline or project. As Banks notes, 'the study and use of visual images is only of value within broader

sociological research enterprises, rather than as ends in themselves, to that extent then the overall theoretical frame of the research project will influence the orientation towards any visual images encountered or produced' (2001: 178). For example, in her discussion of audiencing Rose characterises ethnography as a form of participant observation in which the ethnographer observes and talks to informants. Here her emphasis on reflexivity is lost since she does not link her discussion with the reflexive concerns of the disciplines that use ethnography to suggest that researchers are aware of how they look and understand when doing ethnography as well as when they look at images. Instead, Rose's emphasis is on the idea that images exert their own power and agency, and that meanings are thus constructed in negotiation between image and viewer; calling this 'audiencing', she suggests it is this process we should be investigating. I would agree with this perspective. Rose rightly laments the lack of reflexivity in existing approaches, making helpful suggestions as to how students might counteract this. However, from an anthropological perspective I would suggest her discussion of the social context of image interpretation and research would have benefited from an engagement with the concerns of visual anthropological approaches to reflexivity. This approach would extend the concern with the relationship between image and viewer to the relationship between researcher and image or researcher and informant. Indeed, when interviewing informants about or with images, one should consider how the images or material objects implicated in the interview mediate the relationship between researcher and informant. Banks shows the importance of such awareness very well through an example from his anthropological fieldwork. He describes how, when he first undertook research with South Asian migrants in their homes in Britain, he found the constantly switched-on television distracting as he tried to concentrate on interviewing. However, he realised later that television might be not 'an irrelevant and irritating intrusion' but 'a social interlocutor' – in his more recent interviews in India with informants in their homes, with their televisions on, he came to see these as 'three-way informal interviews, with the staff from the CNN Asia News desk mediating conversations between myself and my informants concerning recent economic change in the town' (2001: 14). Banks also indicates how a reflexive approach might help develop such awareness since he attributes his previous disregard of television as significant to the interview to his own middle-class upbringing where it was considered inappropriate to have the television on when receiving visitors.

Other approaches to reflexivity have also been proposed. Emmison and Smith suggest that becoming 'more reflexive' and 'methodologically skilled' in using visual data should 'enhance the quality of our research' (2000: x). However, their take on reflexivity differs from that of visual anthropologists such as Ruby (2000a) who insist that to be ethical visual research and representation ought to be collaborative, reflexive, and to represent the 'voices' of informants. Instead Emmison and Smith appear to interpret reflexivity as a question of 'validity' rather than as an ethical issue. In contrast, visual anthropologists have been very active in developing approaches to reflexivity in visual research. This is at least partially linked to

the development of the reflexive style in ethnographic filmmaking, usually initially credited to the 1970s and 1980s observational cinema of David and Judith MacDougall in a context of epistemological innovations where filmmakers were 'increasingly explicit about how the films were made and the whys and for-whoms of their making' (Loizos 1993: 171). MacDougall has insisted that visual anthropologists should take reflexivity to a deep and integral level. Following Clifford (1986), he argues that 'A concept of "deep" reflexivity requires us to reveal the position of the author in the very construction of the work, whatever the external explanations may be' (1998: 89). This means that reflexivity – as an explanation of the motives, experience and conditions of the research – is not enough. Instead, what is required is a recognition of the constantly shifting position of the fieldworker as the research proceeds and as she or he experiences 'differences in levels of understanding as well as the shifts of mood and rapport characteristic of fieldwork'. This experience, MacDougall argues, should be embedded in the film and can reveal more about the researcher or filmmaker's (shifting) perspective(s) than can simple after-the-event reflection (1998: 89). Given the relative sophistication of the discussions of reflexivity that have developed in anthropology in the work of MacDougall (1998) and Ruby (2000a), it is therefore surprising that commentators from other disciplines have accused visual anthropology as a whole of being unreflexive. For example, Emmison and Smith do not use the term un-reflexive for visual anthropology but characterise it as having (along with visual sociology) 'failed to connect with wider currents of social theory in these disciplines' (2000: 5) and using photographs as merely illustrative documentary or archival materials, rather than treating them analytically. This description falls far short of MacDougall's reflexive approach discussed above as well as the well-known analytical work on colonial photography of Edwards' (1992) volume. More directly, Holliday has critiqued visual anthropology to highlight the reflexivity of, and the potential for, the visual in queer studies.[5] Her critique of some key anthropological texts, decontextualised from the long-term theoretical debates of which they form a part, argues that reflexivity of the anthropological kind 'becomes a mere buzz word generated within a pseudo-positivist approach still concerned with gaining greater degrees of "truth" and objectivity' (2000: 507). Although Holliday does not cite enough specific examples for her argument to convince, she is not totally incorrect in that some twentieth-century visual anthropology was unreflexive in the way she describes. Nevertheless, there are some significant problems with Holliday's rendering of visual anthropology. First, like Emmison and Smith, she neglects the issues and debates that have been raised in the development of visual anthropology's theory and practice since the early 1980s. Quoting Mead's introduction to Hockings' 1975 text (published in a second edition in 1995), Holliday suggests that in visual anthropology 'artistic film and text stand accused of undermining the "scientific rigour" of such studies' (2001: 505). These comments do not situate the work she criticises historically, leading her to characterise visual anthropology as a subdiscipline that, maintaining an art/science dichotomy, strives to produce 'objective', 'scientific' anthropological films that avoid the artistic subjectivity of cinema.

As I have noted for some of the critiques of visual anthropology discussed above, such analyses are not completely incorrect in that unreflexive work and uses of images as objectifying illustrations can be found in (especially earlier) visual anthropology. Their problem is that they have failed to recognise that leading visual anthropologists have already developed an established critique of such work. Ruby in particular has been offering an alternative vision since the early 1980s, which the critics of visual anthropology cited above have bypassed (see Ruby 2000a). Moreover, a review of the literature indicates there are many visual anthropologists in Europe and the USA who are working with video and photography in ways that are clearly reflexive and subjective (for example, Ferrándiz 1998; Lutkehaus and Cool 1999; Pink 1999; Pink, Kürti and Afonso 2004). More recently that the art/science dichotomy is being truly broken down is clearly evident in collaborative work between visual anthropology and arts practice (see Afonso 2004; Grimshaw and Ravetz 2005; Ramos 2004; Silva and Pink 2004).

To sum up, reflexivity is a key theme in recent texts on visual research. However, while authors agree that it should be a fundamental element of any project, academics from different disciplines tend to have different takes on how reflexivity might be achieved and on the ethical implications of it. Across the different approaches reflexivity has commonly been coined as a need for understanding 'where the researcher is coming from' and how this impacts on the knowledge produced. Some leave this at a question of validity and research quality control. However, most visual anthropologists take a quite different tack to argue that reflexivity should be integrated fully into processes of fieldwork and visual or written representation in ways that do not simply explain the researcher's approach but reveal the very processes by which the positionality of researcher and informant were constituted and through which knowledge was produced during the fieldwork.

Observation or collaboration: the objectivity/subjectivity debate revisited?

The objectivity/subjectivity debate forms an important stage in the history of visual anthropology but has, to some degree, now been left behind in visual anthropology texts. However, recent visual methods texts revive subjectivity/objectivity as a question that an interdisciplinary field of visual methods would need to account for. In this section I review these developments.

Van Leeuwen and Jewitt's (2000) edited *Handbook of Visual Research* is not critical of visual anthropology. They refrain from being critical at all, with the worthy intent to represent a range of different disciplines and their approaches. In doing so, they neglect to represent the differences, debates, and historical developments in theory and methodology that affect visual practices in those disciplines. They represent visual anthropology by Malcolm Collier's chapter 'Approaches to Analysis in Visual Anthropology', which describes different methods of visual analysis encompassed by the approach, developed in Collier and Collier's (1986) *Visual Anthropology* – which, as I noted in chapter 1, has been criticised as a manual of

'method and analysis working within a largely unmediated realist frame' (Edwards 1997: 53; see also Biella 2004). Such realist approaches to visual anthropology have encouraged both critiques of the discipline as an objectifying practice and characterisations such as van Leeuwen and Jewitt's description of visual anthropology as 'concerned with the use of visual records for the description of the present and past ways of life of specific communities' (2000: 2).

Emmison and Smith use 'voyeuristic' and 'pornographic' to describe the serious work of social scientists working within a positivist paradigm (see page 26). Such sensationalist terminology seems unnecessary. Analysis of both the processes by which these images were produced and their intended audience situates them as part of academic production rather than for the popular audience of pornography. Instead, to be useful, any critique of such positivist work should be directed at the observational, realist approach to the visual that informed such work. However, this critique on methodological rather than ethical grounds would be impossible within Emmison and Smith's argument because their own methods are based on an observational approach. Emmison and Smith are concerned with observable human interaction as visual data, seeing the study of interaction as 'a study of people as bearers of signs which mark identity, status and social competence' (2000: 190). They suggest that researchers use unobtrusive observational methods as 'the great bonus of these visible sources of information is that they allow us to explore social life covertly' and thus mean that 'the normal problems of normative responding (telling the researcher a socially acceptable answer) are not present'. They propose that 'we can often get by without it [interviewing]', although it might be advisable to allow informants 'to explain the significance of objects and their locations, permitting the researcher to augment explanations and test whether speculative inferences are valid' (2000: 110). This method prefers note-taking to visual recording methods (in other words, photography and video are considered unnecessary). For example, in one exercise they recommend that researchers approach strangers in the street and try to strike up conversation with them, while a second researcher takes notes on their response. The researcher–informant interaction here is not designed to account for the informant's point of view, but to test her or his response. Such qualitative methods are very different from visual anthropological approaches to the production of knowledge (they contrast directly with the video ethnography methods discussed in chapters 3, 4 and 5). Although they may be suitable for practitioners of unobtrusive research, from an anthropological perspective they appear naïvely unappreciative of the idea that things become visible because of how we see them rather than simply because they are observable. It is in this sense that it is inappropriate for Emmison and Smith to propose that theirs should be *the* way forward for visual research and claim it is superior to their out-of-date and inaccurate portrayal of visual anthropology.

In contrast to the approach proposed by Emmison and Smith, visual anthropologists have long since departed from pure observation to emphasise the intersubjectivity and collaborative aspects of the production of photography and video. As Banks notes, 'All image production by social researchers in the field,

indeed all first-hand social research of any kind, must be collaborative to some extent' because 'the researcher's very presence amongst a group of people is the result of a series of social negotiations' (2001: 119). Even Mead's observational photographic study in Bali involved her collaboration with informants as critics. Indeed, seeing research as a collaborative process goes hand in hand with a critique of a purely observational approach. This is, first, because the latter implies doing research about or on people, treating them as objects, whilst the former implies working with informants, attempting to understand and represent their points of view and experiences. Second, whereas an observational approach depends on assumptions about the accessibility of information about 'reality' through what is visible, a collaborative approach demonstrates how many aspects of experience and knowledge are not visible, and even those that are visible will have different meanings to different people (see Pink 2001a: 23–4). Finally, visual anthropologists view image production and the negotiations and collaborations that this involves as part of a process by which knowledge is produced, rather than as mere visual note-taking. Collaboration is important in any project that involves people and images; both on ethical grounds and as a way of recognising the intersubjectivity that underlies any social encounter. As Banks sums up 'Swooping god-like into other people's lives and gathering "data" (including "visual data") according to a predetermined theoretical agenda strikes me as not simply morally dubious but intellectually flawed' (2001: 179; see also Pink 2001a: 36–46). Collaboration might not go beyond the idea of the researcher asking informants to collaborate with her or him in order to achieve the ends of a social research project, but it also may involve projects in which informants are empowered through the production of images that will serve to represent them and further their own causes.

Conclusion

In the introduction to this chapter I proposed that the 'new' visual methods, as represented from different disciplinary perspectives, have common interests in reflexivity, collaboration, ethics and the relationship between content, context and the materiality for images. Nevertheless, they diverge in their definitions and uses of these to achieve particular disciplinary aims. Here lies one of the difficulties of interdisciplinary critique. Although I feel that Emmison and Smith's critique of visual anthropology is misinformed and inappropriate, I would also recognise that it has been made by researchers who have a very different agenda to that of contemporary visual anthropologists. I have suggested that a visual anthropological approach to the intersubjectivity through which ethnographic knowledge is produced would enhance Rose's perspective on how one might research how meanings are created through the negotiations between human and image agencies and 'audiencing'. My critique is made as an anthropologist with a particular approach to ethnography and reflexivity, which has quite different concerns from those who study audiencing. Interdisciplinary critique and collaboration are complicated and provoke all kinds of sensitivities. Our shared concerns could

mean a future of collaboration and mutual learning. But this requires both a certain openness and that we are well informed about the history of ideas in one another's respective disciplines and their historical development. For instance, visual anthropology has a long and established history of theoretical and methodological innovation. During the twentieth century, when anthropology was establishing itself as a scientific academic discipline, visual anthropologists initially attempted to find a place for the visual in its positivist realist project. However, towards the end of the twentieth century, especially with the innovative work from filmmakers such as Jean Rouch and the MacDougalls (see Grimshaw 2001), visual anthropologists began to break away from the scientific paradigm to produce works that were subjective, reflexive and that offered new visual routes to ethnographic knowledge that challenged those of mainstream written anthropology. As we have moved into the twenty-first century, the crisis of representation of the 'writing culture' debate and the insistence on subjectivity and reflexivity that go with it, a new willingness to engage with both the visual and new types of anthropological narrative and new technological developments have given the visual an increasingly prominent place in anthropological research and representation. In this new climate, visual anthropologists have continued to produce new, innovative, reflexive and theoretically informed projects using photography, video, drawing and hypermedia (see Pink 2001b; Pink, Kürti and Afonso 2004). This new work has developed not out of thin air but as the outcome of a subdiscipline that has emerged from a difficult relationship with the scientific anthropology of the past to take an increasingly critical role in the formation of contemporary anthropological theory and practice. Visual researchers from other disciplines would do best to engage with this new work and the recent history of theoretical and methodological innovation in visual anthropology represented in the written and visual work of MacDougall, Edwards, Ruby, Grimshaw, Banks, Morphy and others, by firmly locating visual anthropology's earlier twentieth-century past in its historical context.

Part II

Visual anthropology and the mainstream

Chapter 3

New sensations?
Visual anthropology and the senses[1]

Introduction

In my book *Doing Visual Ethnography* I suggested visual experience, knowledge and images acquire anthropological interest because of their relationships to other sensory experiences, knowledge and representations (Pink 2001a: 5). There, like most other visual anthropologists, I acknowledged the importance of other categories of sensory experience and action but did not discuss the significance of this. In this chapter and in chapter 4 I explore some implications of theorising the relationship between the senses for the use of audiovisual technologies in anthropological research and representation. First I discuss how anthropologists have treated the notions of experience and the senses theoretically and methodologically. A consideration of experience is relevant for two reasons: first, because how we conceive experience and sensory experience has implications for how we think we can use visual methodologies to research and represent them; second, because more generally a sensory as opposed to a visual approach to anthropology challenges the centrality that the idea of a visual anthropology gives the visual by suggesting it is resituated in relation to other elements of sensory experience. This – like the issues of reflexivity, ethics and collaboration I raised in chapter 2 – are of relevance not only to visual anthropology but also to other visual subdisciplines. Indeed, a sensory approach is becoming increasingly important across the social sciences and humanities (see Howes 2005), in applied consumer science (see chapter 5) and in intercultural cinema (Marks 2000).[2]

 As I noted in chapter 1, the anthropology of the senses originated in the comparative work of scholars such as David Howes and Constance Classen. Howes (1991) was interested in comparing the meanings and hierarchies of senses in other cultures with our (modern western) cultural uses of the senses, and Classen's (1993) work on the cultural history of smell takes its reader on a cross-cultural and historical tour of the varied places smell has occupied in different cultural systems. Recent critiques of this approach have called for: a rethinking of the relationship between the visual and the other senses in both modern western and other societies; attention to the embodied and biological nature of sensory perception; and a focus on the senses as they are implicated in individual experience and agency

rather than solely as expressive of the wider values and beliefs of holistic cultural systems. These approaches suggest we look behind assumptions that the visual is necessarily the dominant sense in modern western cultures to explore how the relationships between categories of sensory experience figure in informants' lives (Ingold 2000; Seremetakis 1994a). Additionally, recent ethnography focuses on the nature and significance of sensory understandings and experiences as ways of understanding specific context-dependent experiences not only in other cultures (for example Desjarlais 2003; Geurts 2002) but also in modern western cultures (for example Pink 2004a; Rice 2003). The resulting publications demonstrate that a revised form of cross-cultural comparison (Geurts 2002)[3] and any micro-study of human culture as it is lived and of how individuals are located in particular cultural contexts (Desjarlais 2003) benefits from a sensory approach. Yet visual anthropologists (myself included) have given only cursory acknowledgement to the other senses in their arguments for a visual ethnographic methodology (for example Banks 2001; Pink 2001a). Those who have discussed the senses have argued for the potential of ethnographic film to represent other sensory experience (MacDougall 1998, 2000; Ruby 2000a), the ability of film to invoke sensory experience in its audience (Grimshaw 2001; Stoller 1997), the use of innovative methodologies in visual anthropology to represent sensory experience (Grimshaw and Ravetz 2005)[4] or the materiality of visual artefacts and their sensory qualities (Edwards 1999). Moreover, visual anthropologists have paid little attention to the question of what experience *is*. Nonetheless, anthropologists have long since been interested in the question of 'experience' – as an empirical, theoretical and methodological concern. How do we experience, what is experience, how can it be understood theoretically and how might we go about researching and representing it? I cannot respond to this full array of fundamental philosophical, psychological and anthropological questions here. Such a project would take a whole volume in itself. Rather, my aim is to re-think the potential role of audiovisual media in researching and representing sensory ethnographic contexts. In doing so I draw from my photographic and media research on the Spanish bullfight, my video research about gender and home in England and Spain and some insights from intercultural cinema theory. However, first I pose two theoretical questions: first, what is experience? and second, what is sensory experience?

The anthropology of experience

Victor Turner is credited with being a founder of the anthropology of experience (Bruner 1986: 3). He is particularly well known for (following Dilthey) (Bruner 1986: 3; Throop 2003) distinguishing between 'mere "experience" and "an experience"', to argue that 'mere experience is simply the passive endurance and acceptance of events' whereas 'an experience' is circumscribed with a beginning and end (1986: 35) and thus a defined event. During the same period Clifford Geertz, in contrast, and in line with the argument that culture might be read as text, proposed that 'mere experience' does not exist, but experience is always interpreted – that is

'an experience' (Geertz 1986: 380, discussed by Throop 2003: 226). In fact Bruner (1986: 13) and Geertz (1986: 375) both note how the contributors to Turner's (1986) *Anthropology of Experience* did not tend to concur on either the theory or subject matter of experience. Moreover, according to Jason Throop's review of the anthropology of experience, those anthropologists who have more recently been interested in the issue have also expressed dissatisfaction with existing approaches for diverse reasons (2003: 222). In response to these contradictory approaches that have been used to define experience in anthropology, Throop suggests that, rather than being *either* found in the relationship between an incoherent flow and its reflective definition *or* always being interpreted, experience might be less predisposed to such rigid definition. In fact it might encompass the 'entire definitional range' of 'the indeterminate, the fluid, the incoherent, the internal, the disjunctive, the fragmentary, the coherent, the intersubjective, the determinate, the rigid, the external, the cohesive, the conjunctive *and* the unitary' (2003: 227). Throop[5] argues for a phenomenological model of experience that works to integrate the 'immediacy of temporal flux and the mediacy of reflective assessment' (2003: 233). As such, experience need not be defined as either undetermined narrative or interpreted event and there may be variation in ways and when experience is reflected on. Throop suggests the methodological implication of this is that some methods, such as interviewing and questionnaires, are more likely to reveal 'those explicit reflective processes that *tend* to give coherence and definite form to experience'. Others such as 'video-taping and/or systematic observation of everyday interaction' can 'capture' the '*often* pre-reflective, realtime unfolding of social action' (2003: 235).

Throop's ideas are interesting, first, because his attempt to develop an all-encompassing model of experience invites us to acknowledge a range of varieties of experience; second, because he suggests a methodological issue that provokes questions, if such varieties of experience might be found, not only about how we might research them, but also how they might be represented. Before discussing these methodological issues in the context of debates in visual anthropology about the ability of film to represent experience, I first note another approach to experience – phenomenological anthropology as developed by Thomas Csordas. Katz and Csordas note how usually 'any anthropologist concerned in the least with the category of "experience" is likely to claim to be doing, or be identified by others as doing phenomenology; and the adjectives experiential and phenomenological are in effect synonymous' (2003: 277). The cultural phenomenology they describe focuses on difference in the form of both 'the sense of encounter with other people(s)' and 'otherness in the sense of cultural difference that is alien, strange, uncanny'. At the same time it emphasises 'embodiment as the common ground for recognition of the other's humanity and the immediacy of intersubjectivity'. As such the phenomenological ethnographer uses both body and intellect as research instruments and might understand personal experiences of cultural concepts that are otherwise untranslatable though her or his own embodied experience. Such cultural phenomenology can, Katz and Csordas show, be conducted at different

levels of experiential specificity, such as: interactions between individuals (including the ethnographer); the experiences of a series of individuals in 'comparable social positions and struggling with the same category of affliction'; or phenomena 'relevant to the collective memory and identity of an entire people' (2003: 278).

The implication of this work is that experience, as anthropologists use the term, often remains undefined. When it is defined it tends to be an elusive process that is actually culturally and situationally context dependent. Theoretically, however, experience can occur at different levels of human consciousness and be evidenced at different levels of individual, group or cultural specificity. Methodologically, experience, at the different levels the ethnographer encounters it, might in different forms be accessible through interviews, participant observation, video recording and attention to the embodied forms of consciousness and learning that are part of fieldwork. In the next section I consider how this interpretation of experience relates to anthropological perspectives on sensory experience. Then I draw from both bodies of literature to evaluate theoretical and methodological approaches to sensory experience in visual anthropology.

Multisensory worlds

In this section, I briefly sum up how the relationship between the visual and the other senses has been treated in existing anthropological work. Although as I have noted in chapter 1 there was an interest in the senses in the early anthropology of Haddon and the Torres Straits project, what has become known as the anthropology of the senses was developed largely in the 1990s by Stoller (1989), Howes (1991, 2003), Classen (1993) Seremetakis (1994a, b), and Classen, Howes and Synnott (1994). Three interrelated themes resonate throughout this literature: cross-cultural comparison and the oculocentricity of the west, the sensory as embodied experience, and the interconnectivity of the senses.

The 1990s anthropology of the senses compared modern western with 'other' cultural expressions of sensory experience (for example Classen 1993; Howes 1991) in contexts that were inevitably 'multisensory'. Here 'individual differences in sensory mixes' were not of interest, because 'differences amongst individuals ... only take on meaning against the background of the culture to which they belong and thus the anthropology of the senses is a subdiscipline concerned with the classification of how '*whole* societies [original italics] might be more "tasteful" or more orally or visually orientated than others'. This meant comparing the meanings and hierarchies of senses in other cultures with our (modern western) cultural uses of the senses (Howes 1991: 168–9).[6] In doing so it usually confirmed existing theories of the dominance of vision in the modern west while in other cultures knowledge might be objectified though other sensory modalities, such as smell or sound. The ethnographic evidence certainly indicates that different cultures express knowledge and describe experience by using different mixes of sensory metaphors. However, these differences are not, as Ingold points out, to be understood as

'natural' differences in the 'balance in each [culture] of a certain sense or senses over others' (2000: 281). Rather they are instances of different cultural systems of classification of sensory perception. This is rather different from Howes' concept of 'multisensory'. For Howes, the idea that all cultures have 'multisensory modes of constructing and experiencing the world' (2003: 45) focuses on the social aspects of sensory experience and is tied up with the notion that 'the senses operate in relation to each other in a continuous interplay of impressions and values. They are rendered into hierarchies of social importance and reordered according to changing circumstance' (2003: 47–8). Drawing from biological theories of perception, Ingold argues that different modalities of sensory experience are actually inseparable, and therefore there cannot be any biological or natural basis for the dominance of vision in our actual everyday embodied sensory experience in modern western societies. Recent ethnographic studies in modern western societies support this, showing the importance of sound, smell and taste in how people experience, construct their identities and remember in the context of modern western homes (for example Hecht 2001; Pink 2004a; Tacchi 1998) and hospitals (Lammer forthcoming; Rice 2004).

Anthropologists drawing from other academic traditions also suggest the inseparability of different modalities of sensory experience in processes of perception. For example, Taussig (1991) draws from Walter Benjamin's notion of the everyday tactility of knowing to argue that our everyday perception can only be understood through tactile appropriation. Therefore, 'To the question' How in our everyday lives do we perceive a building?, Benjamin answers through usage, meaning to some crucial extent, through touch, or better still we might want to say by propioception, and then to the degree that this tactility constituting habit, exerts a decisive impact on optical reception' (Taussig 1991: 149). Like recent ideas about embodiment, this suggests a fusion rather than the separation of vision and thought from sensory physical experience. Seremetakis, who criticises Benjamin for not attending to the 'diverse temporal and perceptual consciousness' that might be found in other non-modern western cultures (1994b:22) claims that such embodied knowledge of 'alternative perceptual epistemologies' is already part of rural Greek culture. She emphasises the impossibility of separating different sensory experiences referring to the 'tactility of smells' and how 'each smell generates its own textures and surfaces' in her sensory memories of childhood in Greece. She describes 'the oregano bunch hanging over the sheep skin containing the year's cheese; the blankets stored in the cabinet which combine rough wool with the humidity of the ocean … the fresh bread in the open covered with white cotton towels' (Seremetakis 1994a: 218). This work advocates seeing the senses as unavoidably interconnected and treats touch, taste, smell and sounds as well as vision as repositories of knowledge and memory. This approach does not preclude cross-cultural comparison. However, it reminds us that we are comparing how individuals in specific cultural contexts classify and represent the actually inseparable interconnected sensory qualities of their everyday lives. We might take what Turner would call 'mere' experience and Throop redefines as the 'immediacy of temporal flux' (2003: 235) to be

coterminous with sensory experience as embodied sensation that is interconnected and inseparable and (as yet) undefined through culturally constructed sensory categories. Then what in Turner's sense would be 'an experience' would involve the coherence-making process of reflecting on embodied sensation of 'temporal succession', and using culturally constructed categories of sensory experience to 'make sense' of it by defining it in terms of vision, sound, touch, smell or taste.

Sensory fieldwork

In chapter 2 I discussed contemporary approaches to visual methodology. This work, as I have noted above, tends to acknowledge but largely disregard non-visual sensory experience. However, another literature describes ethnographic experience and routes to knowledge as embodied and sensory. This work is concerned with reflexivity and ethnographers' self-awareness of the sensory experiences though which they come to comprehend other people's lives and experiences. Here comparison comes by reflecting on one's own sensory experience and expectations. For example, Seremetakis has described her sensory experiences in rural Greece to argue for a 'reflexive anthropology of the senses' that accounts for the 'material and sensory reciprocities' of other cultures (1994a: 226). Judith Okely also discusses the sensory nature of anthropological experience and knowledge, describing how during fieldwork in France she understood her elderly informants' comparisons of their lives in the municipal institutions they inhabited with their previous lives in their own village homes, through her own sensory experiences of village life. The village banquets and farmhouse meals Okely experienced were 'culinary experiences not just associated with banquets, but part of everyday consumption and commensality'. In their institutions the elderly had 'lost relative autonomy, revelry and familiar, loved tastes in retirement exile'. It was only after Okely had 'absorbed something of the conditions of their past existence through living in their former locality and experiencing its tastes, sounds, smells and sights' that she could understand their loss (1994: 58–9).

Stoller also recommends ethnographers attend to 'the sensuous body – its smells, tastes, textures and sensations' because in non-western societies perception 'devolves not simply from vision (and the linked metaphors of reading and writing) but also from smell, touch, taste, and hearing', and in many societies these 'lower senses' are 'central to the metaphoric organisation of experience' (Stoller 1997: xvi). Like Okely's discussion of taste, Stoller demonstrates how in Niger diverse sensory experiences both inform and can be seen as knowledge that is local and anthropological, showing how experience and knowledge (anthropologists' and informants') is embodied and sensory. Recent discussions of phenomenological ethnography (Katz and Csordas 2003) also insist that embodiment is 'the common ground for recognition of the other's humanity and the immediacy of intersubjectivity' where the body becomes the ethnographer's research instrument (2003: 278). Kathryn Geurts' approach is particularly suited to a sensory ethnography. Geurts describes how, by engaging in her informants' embodied practice of

curling up her body at the end of tellings of their migration myth, and probing to uncover the sentiments that formed this action, she learnt how Anlo Ewe identity was *felt* rather than simply *thought* (Geurts 2003: 386). The visible observation that Anlo Ewe people curled up their bodies was insufficient. It was the feeling and the culturally specific sentiments it entailed that mattered (2003: 386).

However sensory fieldwork entails not simply trying to 'feel' other people's experiences, but also learning about the categories that constitute their sensorium and possibly the differences between these and those of the anthropologist. For example, while a North American anthropologist's and Anlo Ewe experience both involve inseparable and interconnected sensory experience, there were distinct differences between Geurts' own modern western sensory categories of vision, smell, taste, sound and touch and the Anlo Ewe sensorium. The latter (to dramatically simplify Geurts' discussion) emphasises audition, balance, kinaesthesia, synaesthesia, tactility, orality, and the relationships between on the one hand seeing and tasting, and on the other olfaction and hearing (Geurts 2002: 37–69). These are all interrelated in ways unconventional to those who are not Anlo Ewe. By emphasising the relationship between practice and sensory meanings, Geurts demonstrates how understanding other people's sensory experience and knowledge is not at all a straightforward matter. Because our routine practices are shaped by culturally specific meanings assigned to certain smells, sounds, touches, taste, and so on (2002: 235), culturally constituted sensoria can affect 'the very basic features of our abilities to judge each other'. For example, Geurts could never 'really grasp … the precise odor that those around me were aware of when they decided someone was marked by [a certain local stigma]' (2002: 236).

Routes to understanding other people's sensory experience are complex, require cultural knowledge, may be difficult to access, and are not always dominated by vision – either in modern western or other cultures. Okely's, Stoller's and Geurts' routes to understanding their informants' sensory experience and meanings were based on long-term participation in their lives, attempting to access aspects of pre-reflective experience as it is lived as well as the meanings placed on it. Desjarlais (2003) suggests a phenomenological methodology also encompasses spoken narration because 'the phenomenal and the discursive, life as lived and life as talked about, are like interwoven strands of a braided rope, each complexly involved in the other, in time' (2003: 6). He advocates an interview-based ethnography in which we might comprehend informants' experiences through their spoken narrations and gestures rather than through participant observation. This approach allows the researcher access to informants' voiced interpretations of their pre-reflective experiences and tries to imagine and empathise with these (in the sense that Okely did before experiencing similar events in the village; see page 46). However, his emphasis on talk[7] leads Desjarlais to elevate words problematically over other ways of representing experience. Later in this chapter I suggest the visual has an important role to play in such methodology. By adding video to the process of telling or talking to, through a method of showing-touring and embodied enacting, our collaborations with informants can involve not simply spoken

narrations of their sensory experiences but also visual display, exposure to sounds, smells and textures, thus bringing the ethnographer closer to the sensory, pre-reflective experiential context.

The discussion in this and the previous section implies that it is problematic to separate the visual from the other senses, whether in terms of biological perception, cultural theory, ethnographic experience or local epistemologies. Indeed the visual may fit into the sensorium of the culture an anthropologist researches in ways that are different from those of a modern western academic. It also suggests that rather than simply assuming that the visual is the dominant sense though which we make sense of our own and other people's everyday experience in modern western cultures, we might benefit from attending to how the other senses and their relationship to the visual are involved in this. This is the problem or question visual anthropology needs to resolve: how might a 'visual' anthropology engage with the other senses? And how might we research and represent visual and non-visual aspects of sensory experience?

To examine this I first review claims made within visual anthropology regarding the ability of ethnographic film to represent and evoke the sensory embodied experiences of other people audiovisually. Then I examine two ethnographic contexts from my own work where the relationship between the visual and the other senses was a concern both for my informants and for my research. From these examples, and drawing from some insights from Marks' (2000) work on intercultural cinema, I suggest some limits and possibilities for researching and representing sensory experience audiovisually and suggest how these might be overcome.

Visual anthropology and the senses

Visual anthropology has embraced the senses to some degree. For example Taylor's (ed.) 1994 *Visualizing Theory* has a loose brief that does not recognise 'any one hierarchy of visual or sensuous knowledge' (Taylor 1994: xiii). It goes beyond ethnographic film to explore the visual *vis-à-vis* ethnography and cultural theory and includes Seremetakis' reflection on the tactility of smell, Taussig on the embodied and mimetic experience of the visual, and Stoller on the films of Rouch (see page 52). Banks and Morphy (1997) also opened up visual anthropology to look beyond film and photography and see the visual as 'an important component of human cultural cognitive and perceptual process' that can be relevant to all areas of anthropology (Morphy and Banks 1997: 3), but do not engage with the relationship between the visual and the other senses either in theory or cognition and perception. Other recent work also acknowledges the senses. For example, Grimshaw notes how 'anthropologists have sought to escape the tyranny of a visualist paradigm by rediscovering the full range of human senses' leading to 'the development of sensuous perspectives towards ethnographic understandings' (2001: 6). Banks engages with the anthropology of the senses, following Classen to note that 'like all sensory experience the interpretation of sight is culturally and

historically specific'. Nonetheless, neither Banks (2001) nor Grimshaw (2001) takes this further in these books that focus on the visual.

Jay Ruby, David MacDougall and, in her later work, Anna Grimshaw (2005) have made more coherent calls for a visual anthropology that engages with sensory embodied experience. Building on the work of theatre anthropologists in ways that parallel Turner's (1986) view of experience, Ruby suggests culture might consist of 'a series of screen plays'. However, these cultural performances are 'more like improvisational theatre than a play' because 'the reduction of culture to text systematically excludes the embodied and the sensory knowledge that is at the core of culture' (2000a: 246). Ruby advocates a reflexive, non-realist, anthropological cinema that represents culture as it is performed in social dramas and the experiential sensory and embodied knowledge that pertains to them.

MacDougall has been the main proponent of a sensory-embodied approach in ethnographic filmmaking. Taking as a key issue the differential abilities of language and images to communicate anthropological knowledge he sees visual anthro-pology as particularly suitable for representing sensory and embodied approaches to anthropology. He suggests visual representation can offer pathways to the other senses and resolve the difficulties anthropologists face in researching and commun-icating about 'emotions, time, the body, the senses, gender and individual identity', by providing 'a language metaphorically and experientially close to them'. Because the visual has a 'capacity for metaphor and synaesthesia' he proposes that 'Much that can be "said" about these matters may best be said in the visual media' (1997: 287) as opposed to using the written word, because the former can facilitate the 'evocation' (Tyler 1987: 199–213) called for by the emphasis on the experiential in anthropology in the 1980s and 1990s (MacDougall 1997: 288). In addition to its synaesthetic capacity to evoke sensory experience MacDougall suggests the visual also offers a second route to sensory experience. Similar to Ingold and Seremetakis, he stresses the inseparability of the senses, drawing from the work of Sobschack and Merleau-Ponty to approach the senses 'not simply as separate facilities capable of some form of synaesthetic translation, but as *already* interconnected – in fact as the entire perceptive field of the body' (1998: 50). In particular, it is the interconnect-edness of seeing and touching (see also Taussig 1991) that MacDougall suggests underlies the filmic communication of sensory experience. Noting studies of blind people who on recovering their sight are unable to recognise objects visually until they have touched them (1998: 50), he argues that touch and vision 'share an experiential field' since '[e]ach belongs to a more general faculty'. Therefore, 'I can touch with my eyes because my experience of surfaces includes both touching and seeing, each deriving qualities from the other' (1998: 51). He describes how this might be done in practice through a discussion of his work in the Doon School (India), a school world that in his analysis is lived through 'the creation of an aesthetic space of sensory structure' that has 'a particular structure of sense impres-sions, social relations and way of behaving physically' (2000: 9–10). The question is how to film 'something as implicit and all-pervasive as social aesthetics'.

MacDougall suggests this 'could only be approached obliquely, through the events and material objects in which it played a variety of roles' (2000: 12). For example, the boys' daily contact with the school's stainless-steel tableware – 'The strength and obduracy of this material cannot but be communicated as a direct sensation to the boys and to inform the whole process of eating with an unrelenting utilitarian urgency' (2000: 14). For MacDougall the Doon School project aims to lead anthropology to 'forms of knowledge not envisaged before' (2000: 17). He insists that 'To describe the role of aesthetics properly (its phenomenological reality) we may need a "language" closer to the multidimensionality of the subject itself – that is a language operating in visual, aural, verbal, temporal and even (through synaesthetic association) tactile domains' (2000: 18).

MacDougall's approach to the senses is tied into his wider argument about the potential of film for the transcultural communication of human experience.[8] Seeing ethnographic film as a challenge to the twentieth-century anthropological project of cross-cultural comparison, MacDougall suggests that while 'cultural evidence is clearly not absent in visual depiction, nor is the evocation of physical presence absent in written ethnography' (1998: 254); film can represent the more general commonalities of human experience that are not containable in written descriptions thus creating affinities that defy cultural boundaries (1998: 245–6). He subsequently argues for a downplaying of culture in a visual anthropology that focuses on creative social actors, rather than cultural constraints (1998: 271) and involves 'studies of the experience of individual social actors in situations of cross-cultural relevance' (1998: 272). Grimshaw and Ravetz (2005) follow MacDougall to propose a 'more radical visual anthropology' that involves collaboration with art practitioners to depart from the limits of the visual to 'investigate ways of knowing located in the body and the senses' (2005: 1–6). This opposes an anthropology that depends on cross-cultural expertise by emphasising the experiential. Also, by creating new forms of anthropological representation based in arts practice, it directly challenges text-based ways of knowing (Grimshaw 2005: 27–8). The approach advocated by MacDougall (1998) and Grimshaw (2005) has two limitations. First, Geurts' (2002) work discussed on page 46 shows how our understanding of the creativity of social actors is contingent on our knowledge of their cultural context. This also applies to film; as Marks emphasises for intercultural cinema, we should not assume that viewers can simply 'reconstruct the sensuous experiences represented in a work' (2000: 230). Second, as Henley (2004) has pointed out, without being anthropologically framed such filmic representations (and, I would add, other forms of arts practice) cannot communicate anthropologically about cross-cultural difference.

Ruby, resonating Turner's (1986: 39) emphasis of social drama as a unit of experience, and MacDougall, taking a more phenomenological approach, both acknowledge the importance of the senses in anthropology, suggesting that the visual rather than language might best represent the sensory and embodied aspects of culture and experience. Such a visual anthropology would be reflexive and subjective, attend to the visual, sensory and embodied, and challenge the truth

claims of the scientific anthropology of modernity. Comparing the abilities of the visual and of language to adequately represent the embodied and sensory experience of being an individual in a specific cultural context, they argue that some embodied and sensory knowledge might only be accessible visually and cannot be equally represented in words.

Film certainly can represent aspects of sensory experience visually through metaphors for that experience and willing the viewer to comprehend the film subjects' sensory experience empathetically or comparatively through his or her own resources of experience. Certainly these aspects of sensory experience and sensory qualities associated with them cannot be equally represented in words and especially not in scientific writing. This is not to say however that sensory experience cannot be represented in certain styles of ethnographic writing (see MacDougall 1998: 262). For example, in his book *A Sensuous Scholarship* Stoller (1997) explores in some detail how this might be achieved. Geurts' (2002) sensory anthropology of the Anlo Ewe also provides an excellent example of how writing can be used not only to describe the anthropologists' own and her informants' sensory experience, but to also make those descriptions meaningful anthropologically. Another view is expressed by Howes, who suggests that while film might be more evocative and able to 'convey sensory impressions' of 'dance dynamics' in a film of an olfactory ritual the image would '"overshadow" the aromatic evocations'. He recommends that the advantage of writing is that 'no sensory data are directly represented by the medium itself', which 'creates a kind of equality among the senses', so an olfactory ritual might be described 'primarily in terms of its aromatic elements' (Howes 2003: 57). In disagreement with Howes, I would argue that film offers an alternative way of representing sensory experiences and qualities, it tells us new things and its potential to open 'more directly onto the sensorium' than written texts and create 'psychological and somatic forms of intersubjectivity between viewer and social actor' (Howes 2003: 57) should not be ignored. However, emphasising the merits of film for this venture obscures some of the inadequacies of audiovisual media for representing sensory experience. To what degree does ethnographic film make embodied, olfactory and tactile sensations and their concomitant emotions accessible? In what ways? And, returning to my discussions of how we might understand sensory experience theoretically, what varieties of experience might film communicate about and in what forms? Certainly, seeing an object's surface or an emotion expressed in a film might be evocative of the texture of that object and the 'feelings' of the emotion, but if ethnographic film audiences do touch by seeing, do they feel the same textures and are they touched by the same emotions as the film's subjects? Finally, do existing modes of presenting ethnographic film provide us with an anthropological understanding of these sensory experiences, or do they only offer us the chance to empathise based on our own particular experience as individuals and anthropologists?

Before exploring these questions ethnographically I shall add to the above by reviewing how the senses have been portrayed in visual anthropology in terms of the viewer's experience.

Ethnographic film as sensory experience

I have reviewed arguments that ethnographic film can *represent* other people's sensory experience. However, these perspectives are not based on research about how this sensory experience is received by ethnographic film audiences. Research into ethnographic film viewers has largely been limited to understanding the ideological and moral perspectives that students use to interpret films about other cultures (for example Martinez 1994). Other anthropologists have theorised the question of ethnographic film audiences and the senses by analysing Jean Rouch's films to suggest that film evokes knowledge through the viewer's own sensory experience. Stoller borrows Artaud's concept of a 'Theatre of Cruelty' whereby 'the filmmaker's goal is not to recount *per se*, but to present an array of unsettling images that seek to transform the audience psychologically and politically'. Defining Rouch's ethnographic films as a 'cinema of cruelty' Stoller reminds us how cinema's 'culturally coded images can at the same time trigger anger, shame, sexual excitement, revulsion, and horror' (1997: 125). In Rouch's case this involves using humour and 'unsettling juxtapositions to jolt the audience' (Stoller 1997: 126). Grimshaw similarly sees Rouch's work as involving 'romantic techniques' that 'appeal to the sensibilities, to the emotions and to the body' and in which the camera acts as 'a transformative agent' (2001: 119). She describes Rouch's filmmaking as built around the notion of 'play'. Rouch the filmmaker is 'provocative' and 'has fun' – the filmmaker is a player within the film himself (2001: 118). Moreover, his characters and audience are invited to join in with this play. As Grimshaw describes it, 'playing the game with Rouch means accepting certain rules; but equally it involves exploiting spaces or cracks'. She argues not only that the viewer's experience of Rouch's films is cognitive, but also that the viewer experiences sensual pleasure by participation in the 'game' of his films (2001: 119). Thus 'in a darkened auditorium something strange can happen: but only if participants are willing to play the game, to become players. For cinema offers itself as a primary site for disruption and transformation' (2001: 120).

According to Stoller and Grimshaw, Rouch's films (although he is perhaps an exception amongst ethnographic filmmakers in doing so) create a visual anthropology that plays with the emotions and the senses. It has a transformative effect on the audience, because the sensory experience of viewing jolts the viewer onto a path to knowledge via the self-reflections it inspires. While this approach neglects detail of how exactly people appropriate images or visual narratives, it is suggestive for the question I am dealing with here. For it implies that visual images – or more precisely the audiovisual medium of ethnographic film – have some agency to evoke embodied sensory experience and as such communicate anthropologically through this. In this equation the relationship between the visual and the other senses is one in which the visual is employed for its transformative potential – to evoke sensory experience that will jolt viewers who are willing to engage with the playful provocation of the filmmaker into reflecting on their own understandings, on the basis of which a reflexive viewer might produce ethnographic and self-

knowledge. However, although film might evoke embodied sentiments, it does not satisfactorily communicate the sense of (or non-visual sensory experience of) being there or indeed that of the film's subjects. Stoller's and Grimshaw's analyses of the viewer's side of the screen still do not tell us why the visual, and especially ethnographic film, might be good for communicating about the film's subjects' embodied sensory experience and knowledge that cannot be communicated verbally.

Laura Marks, writing on intercultural cinema, suggests a theory of spectatorship that emphasises these limitations. The cultural specificity of sensory experience is a key theme in Marks' analysis of the multisensory nature of intercultural cinema. Drawing from cognitive and neural research, she stresses how our sensoria vary individually (2000: 195, 203), are 'formed by culture' and create 'the world "subjectively" for us', yet are not fixed, since one can also 'learn a new configuration of the senses' (2000: 203). Intercultural cinema's appeal to sensory knowledge and memory is rooted in the limitations of the visual to represent experience. Different from observational ethnographic film it relies on voice-overs, dialogue (2000: xv) and particular styles of camerawork (for example, including close-ups, still image and more) that together 'create a poignant awareness of the missing senses' (2000: 129) – touch, smell and taste. However, intercultural cinema is ambivalent about its ability to represent 'the traditional sensory experience' (2000: 197). Implicit in this is a critique of ethnographic film's claim to represent, through distanciating vision, the sensory experience of individuals in one cultural context to those of another. As Marks emphasises throughout her book, this ambivalence is rooted in the premise that 'it would be wrong to assume that audiences will be able to reconstruct the sensuous experiences represented in a work' (2000: 230).

Sensory public and media events

In the previous sections I discussed visual anthropologists' claims that ethnographic film can both represent and evoke non-visual sensory experience. The problem is that film doesn't necessarily represent and evoke the same sensory embodied or emotional experience. It does not transmit what people on one side of the screen experience to those on the other. I have examined this in terms of the potential for the communication of sensory experience between cultures. In this section, I examine whether audiovisual representations can satisfactorily communicate about or evoke sensory embodied experience though an ethnographic example of communication within a single cultural context. In the absence of any audience research about how ethnographic film audiences understand sensory embodied experiences of film subjects I am hoping that an example from my work on the televised bullfight might provide some clues. Elsewhere (Pink 1997) I described the live Spanish bullfight as an embodied sensory experience represented by my informants as a context that had *ambiente*, a Spanish term referring to a specific atmosphere created when a bullfighter performs well. The *ambiente* is composed of sensory and emotive aspects of the performance that are

unquestionably partially visual but necessarily involve sound, smell, taste, tactility and the feeling of being there, of participating in creating the event. The live Spanish bullfight is a contemporary modern event – not, as some would have it, a pre-modern ritual that has continued in the modern west. It is a regulated and competitive event, managed according to commercial concerns, as part of which contracts with TV companies are important for bullfighting business. The televised bullfight is an integral aspect of Spanish bullfighting culture, dominating several TV channels on weekend afternoons. One can normally view TV bullfights daily during the season. Despite the popularity of the TV bullfight, Spanish bullfight *aficionados* do not regard it as a satisfactory replacement for the live event because it has no *ambiente* (Marvin 1988; Pink 1997: 179–80). As an audiovisual representation the TV bullfight offers opportunities unavailable live: slow-motion replays of key moments; close-ups of action that reveal details inaccessible to the naked eye in the arena; and expert commentary. However, this additional visual and verbal information does not adequately represent, or reproduce, the experience of being there – it is devoid of *ambiente*. An audiovisual televised representation of this public performance cannot satisfactorily evoke the sensory embodied experience of the bullfight in the bullfight *aficionado*'s own living room.

The bullfight example refers to the opinions of people who are experts on a particular cultural performance about the potential for that performance to be represented televisually by people who are also experts in this field. In my interpretation their criticisms are aimed at the inability of television to represent the sensory embodied experience of attending the event, an important aspect of which is not only soaking up the sound, smells, taste and tactility of being in the audience, but the possibility of empathising with the corporeal experience of the bullfighter himself as he performs with the bull. Ethnographic film does not have the same objectives as televised bullfighting, but there are some parallels: it is made by experts in a field and represents sensory embodied experience. However, it is most likely to be viewed by other anthropologists, students or a popular audience who may have no first-hand experience of the social context and cultural referents represented filmically and who cannot comment on its ability to faithfully convey experiential knowledge visually. The example of the televised bullfight would suggest that visual anthropologists might be hard pressed to satisfactorily represent filmically the embodied sensory experience of being there and the embodied sensory knowledge required for an insider understanding of a cultural performance.

Everyday sensory lives

The second problem I suggested above was that ethnographic film does not communicate anthropological theories of sensory experience and perception nor elaborate anthropologically on how film subjects are using sensory metaphors to classify sensory experiences. It similarly does not tell us what, anthropologically, the filmmaker intends to mean by 'experience'. In this section, I discuss an example from my fieldwork about sensory experiences of home[9] to highlight the

interweaving of sensory experience, representation of senses and anthropological theory that combines to produce an anthropological understanding of ethnographic (research) video footage.

In 1999 I interviewed Maureen, a retired English woman in her 50s, as part of a video ethnography project. The study focused on housework and home decoration as practices through which informants engaged with the material and sensory elements of their homes and in doing so constituted and performed their gendered identities. Maureen enjoyed her housework. For her, maintaining a clean and tidy home entailed constantly recreating a particular sensory environment. Visually, she told me, 'I get satisfaction out of [the housework] because as I say I like to see it clean and tidy, you know. So I like the finished article, when you look I think you get a lot of satisfaction out of it'. Olfaction was also a priority because she treated the smell of her home as an index of its cleanliness: 'I feel the house has been cleaned and it won't be cleaned if I just dusted it, as far as I'm concerned. It would need to have, to smell fresh when you go into it'. This included burning oils and joss sticks to respond to other olfactory agencies in each room. For example:

MAUREEN … out in the hall I've got two that I put on which is a jasmine and a lily of the valley together which are nice …
SARAH … What do you put in the kitchen then?
MAUREEN The one I've got, I can't think what it's called, it's a musk but it's an oil I use in there … yes, a sea oil. And even where the dog sleeps in the utility room … I even have those sticks, the joss sticks

Her olfactory strategies constituted engagement with other agencies of the home, for example dust, dog hair and odour, cooking odours, the mustiness of curtains and the 'smell' the house has after she has gone away and left it closed up.

The metaphors Maureen used interweave the visual ('when you look'), olfactory ('to smell fresh'), tactile ('I feel') and emotional ('satisfaction'). She also described her relaxation at home in terms of sensory experience. She plays the piano, a tactile and aural experience, and knits, a tactile and rhythmic activity that, like touch-typing, should not require vision for a good knitter. Her relationship with and uses of these material objects are mediated by activities that she speaks of in terms of non-visual sensory experience. This is not to say that she would not visually read piano music or knitting patterns or glance down at her stitches. However, the textures, sounds and smells of her home are elements that she is articulate about.

These sensory elements of home are not fixed, but often temporary and transient. The use of sound to create particular atmospheres of home that are expressive of both mood and self-identity and are consciously used to create moods and inspire particular activities was common amongst my informants. Music might be used to create a temporary atmosphere of self and home at particular times of the day. Smell is transient and uncontainable. As such, Maureen's interactions with the sensory aspects of her home were activities or processes in which different sensory elements were perceived to varying degrees at different points. For

example, when she cleaned her home she played music and often listened to her *Celtic Reflections* CD. As she explained, 'it is Irish, I mean I'm not Irish, this is Irish music but I like this sort of thing, you know. I think it's just soothing, you know, and I can work better to music as well'. She sometimes varied this, also enjoying Scottish music and Gilbert and Sullivan. She left music playing in the kitchen so she could hear it 'in the background' when she cleaned upstairs, and listened to it when she ironed in the kitchen. She combined this with creating an olfactory environment by burning candles with flowery smells. 'If I do my cleaning I always have that. I've always got smells, candles and whatever going':

> Say if I was going to clean this morning ... I will put them [candles or oils] on even if, because I like the smell of it myself, it's something different and I used to use the Shake n Vac but now I've got the other hoover that you're not supposed to use Shake n Vac. So I'm not using that. And that, you see, made a nice smell on the carpets. So I will have to have something to replace that smell, you know what I'm saying? That's me. So I've either got stuff that you spray on the settee and it makes a nice smell. So that's what I put in the room – the kitchen as well. Of course obviously when I'm cooking I have some [candles or oils] on the go, you know, but I don't like the smell of cooking.

This formed part of a wider process of olfactory transformation for Maureen. Although she 'didn't mind' the smells of detergents, after using them she would always 'put a candle in or something just to finish the job off'.

Through housework Maureen consciously created an environment with a balance of sound and smell that was satisfying. She simultaneously experienced the texture and sight of domestic surfaces and objects that in some instances she transformed. In our interview Maureen's verbal descriptions separated the different sensory aspects of her experience of housework, which she connected to the dog and different material objects and technologies. This does not mean that her embodied experience of each element was necessarily singular. They combined to constitute her experience of and relationship with her environment, as (using Turner's 1986 terminology) mere 'experience' but were separated by the linguistic metaphors through which she expressed her experience as 'an experience'.

Our interview was not simply verbal. Its second half was an hour's video interview in which Maureen showed me her home. We discussed her decorations, the rooms and objects in them (candles, oils, perfumes, the dog basket). Maureen showed me the material props of her sensory engagement with her home, and as we browsed through her house I also experienced smells, visions and textures she had spoken of. As Okely has noted about embodied sensory knowledge in anthropological fieldwork, where 'the anthropologist has no choice, but to use body and soul in addition to intellect, as a means of approaching others' experience. Linguistic utterances might provide a clue, but they cannot be depended upon. There is also the full range of

bodily senses' (Okely 1994: 61). Video is an audiovisual rather than visual medium, and Maureen was aware of this as the video camera became part of our communication. She played a track from her CD of Celtic ballads for me, using it as a prop that was evocative of the sensory atmosphere she did her housework in. By exploring these aspects of her home I gained an idea of the sensory embodied experience of Maureen's housework. This helped me begin to imagine how these different sensory elements would unite with the physical work she described to produce the emotions of feeling 'soothed' by the ballads, or 'satisfied' by the final result. Like Okely's, Seremetakis' or Stoller's fieldwork sites, the worlds I entered when I researched my informants' modern western homes were not dominated by visual linguistic metaphors for experience, neither were their embodied actions that 'showed' me their experiences of home, nor my own embodied sensory experience of the fieldwork. Video framed our encounter. In the tapes, Maureen, knowing that we were using the visual (the camera) and the verbal (our recorded conversation) simultaneously, told me about her sensory experiences of home and housework using the available resources and technologies. She and my other informants were aware of the limits of video. Sometimes they referred to obstructed or faint sounds or sights when, although they recommended I try, they doubted I could 'get it on the video'.

Therefore on the videotapes embodied sensory experiences were represented variously, including: visual images of embodied actions (enacting processes or touching or stroking objects); verbal utterances and descriptions; visual images of objects and processes that are metaphors for sensory experiences (such as candles, oils, perfumes and spaces); and facial expressions. This variety of modes of representing sensory experience also served to define it in different ways: for example as 'mere experience', defined experience, and experience reflected on verbally. The use of video here allowed me to develop a sensory methodology that went beyond the interview, talk-based approach to phenomenological research proposed by Desjarlais (2003). However, when we represent sensory experience on video (as ethnographic documentary), whether this is a direct observation of cultural performances as they actually take place, or an interview-led film that involves more overt collaboration with an informant, we rely on visual metaphors, sound and verbal utterances to represent sensory and emotional experience. The first limitation of such representations is that they do not theorise the relationship between the senses. Ethnographic filmmaking can be based on theories of the senses. In MacDougall's example we see that his Doon School films are informed by theories of the relationship between vision and tactility – that one can touch by seeing. My ethnographic videotapes tell me about Maureen's relationship with her home and because my understanding of them is informed by a theory of the interconnectedness of sensory experience I can interrogate them to examine how she separates out and describes different aspects of her sensory experience of cleaning in relation to different material and technological aspects of her home. However, as standalone audiovisual documents such films and videotapes do not offer us an anthropological perspective on everyday sensory experience. Their second limitation is that they do not situate this experience in terms of local culturally specific knowledge.

Film and video clearly take us part of the way to representing other people's sensory experience, but how might we create audiovisual representations that acknowledge the relationship between the visual and the other senses both ethnographically and theoretically?

Anthropological representations of sensory experience

To represent the sensory, embodied experience of both fieldwork and informants, anthropologists have two established modes: images and language. In this chapter I have reviewed existing literatures about the senses, writing about film, my own video research and the views of Spanish bullfight *aficionados*. I have argued that film or video alone cannot represent the complexity of human sensory experience; neither, visual anthropologists have argued, can writing. Ruby criticises existing responses to the 'writing culture debate' or 'crisis of representation' as being timidly based in written texts (2000a: 259–60), complaining that 'The sound ethnographies of Steve Feld … the experiments with performing ethnography … poetry, nonfiction novels, painting, let alone digital multimedia in which the senses are stimulated in a variety of ways are almost never discussed' (2000a: 260). Other sensory modalities also have limitations. As Howes has noted, 'most odours are "untranslatable"; i.e., impossible to describe or categorize' (1991: 131). As such he is suggesting that they cannot be converted into ethnographic description or be used to represent theoretical ideas in academic anthropology. A more likely answer is that neither of these media is really satisfactory and that participatory sensory workshops or performance anthropology in which spoken, visual, olfactory and tactile experiences are incorporated would offer a fuller representation. However, this latter suggestion does not fall within the tradition of creating the permanent anthropological publications we disseminate in the form of film or writing. Its representations would have difficulty in contributing to existing anthropological debates. Partly because, as Howes notes, 'anthropologists don't know how to communicate the kinds of things we want to communicate through smells, tastes and textures we lack the necessary codes not to mention techniques' so that 'spraying of perfumes or sampling of foods would still have to be accompanied by a more customary written or verbal exposition' (2003: 58) to become anthropologically meaningful.

I suggest the most viable solution is to explore further how writing and video might combine to represent sensory experience theoretically and ethnographically. This would involve producing multimedia texts that use both metaphor and theoretical argument to make anthropological statements about sensory experience, knowledge and memory that take advantage of the benefits both of ethnographic film and anthropological writing to represent sensory experience and make explicit the anthropological theory that informs our understanding of this. In the next chapter I discuss this with reference to my own video ethnography about the sensory home.

Visual anthropology and anthropological writing

The case of the sensory home[1]

In this chapter I discuss, as a case study, the relationship between the visual and written anthropology of the home, drawing largely on my own video ethnography about gender, identity, and the sensory home in England. I aim to highlight and unite three themes of this book. First, in chapter 3, I suggested that visual anthropology might consolidate its ability to represent other people's experiences by defining the possibilities and limitations of film and writing for communicating theoretically and ethnographically about (sensory) experience. Here, through this case study, I examine disjunctures between written and filmic anthropologies about the same topic. Second, I demonstrate an example of the relationship between applied and academic visual anthropology discussed in chapter 5. Third, I introduce an example of hypermedia anthropology, which is discussed more broadly in chapter 6.

Researching the sensory home

In 1999 I undertook a project in applied visual anthropology for Unilever Research. The project focused on the relationship between 'cleaning, homes and lifestyles' and was informed by the aims of the business, my experience as an anthropologist of Spain and England, and of gender, and my work in visual anthropology. The research also drew out three themes of particular academic interest for me – gender, the home and sensory experience.

I interviewed forty men and women in their homes in England and Spain.[2] This involved a tape-recorded interview exploring identity and lifestyle, a 'video tour' of each home and often additional visits or overnight stays in informants' homes. The research was guided by my checklist and anthropological objectives, but I encouraged informants to describe and show me what mattered to *them*. I asked each informant to collaborate by showing me around their home, talking about their 'decorations' (which were not only visual but olfactory, involved music or radio sound, and tactile), looking in their fridges and wardrobes, and explaining how they cared for their homes and contents. Together we explored these material and sensory contexts (Maureen's interview discussed in chapter 3 is an example). I used a Sony domestic digital video camera with a foldout screen, which allowed me to

see both what the camera's viewfinder circumscribes and the wider context (see C. Wright 1998). By revealing my face it permitted eye contact and a more intimate encounter than do the larger professional cameras, and thus closer relationships between anthropologist and informant. I aimed to access a sense of their experience through their talk (as Desjarlais (2003) has advocated), their embodied and visual performances and my own experience of their sensory homes.

My notion of the 'sensory home' draws from the anthropologies of the senses and the home. It refers to the modern western home as a domain that is simultaneously a pluri-sensory 'mere experience', understood as composed of the cultural categories of smell, touch, taste, vision and sound, and created by human agents through manipulation of these sensory elements. Most anthropological studies of the home have focused on material, and subsequently visual, aspects of home decoration (for example Clarke 2001). Nevertheless, the home is certainly a sensory domain and approaches that depend predominantly on the visual are surely inadequate for researching how home is experienced. For instance, Tacchi shows how domestic soundscapes are 'established and re-established continually in each domestic arena, through each individual instance of use' (1998: 26) and Hecht's (2001) biographical approach demonstrates how informants' memories of home evoke and are evoked by sensory metaphors and experiences of smell, touch and taste. Sensory themes constantly emerged in my interviews. However, as I outlined in chapter 3, the question of how we might research others' sensory experiences is complex. In this context of an applied visual anthropology there was no time for long-term participation in my informants' lives. My research allowed me to attend to informants' words in tape-recorded interviews, which in Desjarlais' (2003) sense were evocative of their lives as lived. Additionally, the video tours invited informants to represent their sensory experiences on camera using sound (playing music, taking me to 'noisy' places), smell (spraying perfumes and household products in the air, inviting me to stick my nose and camera in 'smelly' cupboards) and touch (running hands over surfaces or massaging a 'creamy, smooth' product into a sponge), as well as vision. In short they used their whole bodies and sensory repertoires to enact, represent or reconstruct their experiences of home. Because the senses are 'mediated, interpreted and conceptualised', we cannot claim to have had precisely *the same* sensory experiences as others, but we should also use our sensory experience to empathetically and 'creatively construct correspondences between' ourselves (Okely 1994: 47). The reflexive awareness of the embodied and sensory dimension of fieldwork Okely urges us to engage with also highlights the broader role sensory knowledge and experience plays in informants' lives. It raises questions of how informants might communicate this to anthropologists, and how we might represent this anthropologically.

In my analysis of these materials, following Ingold's (2000) argument that we should stand back from the idea that vision is necessarily dominant in modern western everyday experience, I have regarded vision and its use as inevitably embedded in and interdependent with other senses. Modern western paradigms that privilege vision are not only inappropriate for studying other cultures but

equally unsuitable for studying modern western cultures. In my videotapes, vision and speech were the main intentional and conscious modes of communication, yet they were used in relation to other sensory metaphors and experiences that composed my informants' sensory homes, and thus the research contexts. My aim was to understand which sensory categories and metaphors they used and why. I cannot reproduce the tapes here, but I use transcripts and description to evoke something of this research context.

During the video tours it soon became clear that visual home decoration was not the only way people create home, as Holly's example demonstrates. Holly was 23 and shared her cousin's one-bedroom London flat when I interviewed her. She had little personal space, sleeping on the sofa bed in the living room, keeping her bedding in a cupboard, and sharing areas in her cousin's bedroom for clothes and make-up. Holly's cousin had decorated the flat and although some displays also represented Holly's family she had not added any personal photos. Instead Holly's visual contribution consisted of a couple of photos and postcards stuck on the kitchen fridge. Holly liked the flat's style but if it were hers she would have created a brightly coloured, 'crazy' futuristic design reflecting her 'wild' personality. Her cousin did not feel that design would work. In this situation Holly used different strategies to create 'home' within her cousin's flat. These can be understood by conceptualising home not simply as a static material, physical and visual environment, but as a feeling and atmosphere that might be temporary and involves other sensory experiences. For example, I asked Holly if sharing space with her cousin was problematic.

> Not really. We don't really … bump into each other because we go at different times, you know. She goes at 8 o'clock in the morning; I go at half 11 in the morning, so we miss each other. You know it's not a fight to get in the shower or anything we, you know, have our space. Our own space. And she, you know, we very rarely, we do see each other a lot but I'm always out or she's like working late or she's gone out, maybe gone out for a drink with some work-mates or something. But yes, we don't get in each other's way.
>
> (Holly 1)

Holly described how she used sensory strategies to create her own sense of space and self in her cousin's material home, mainly using sound.

> I get up about half 8. As soon as I get up I stick music on, which consists of Aretha Franklin, Guns 'n' Roses, everything. If the kitchen's a mess, I'll just tidy it up. You know, watch TV for a bit but basically sing, dance all over the place, get ready for work and I'm normally fine. If I've got a hangover it's always a bit, bit different but normally I'm fine, I mean, you know, in the morning it's just, it's the best time I think in the morning. You see I've got time to myself then and stick on music. That gets me going. Sort of lifts me up in the morning.
>
> (Holly 2)

With all my informants we explored material manifestations of the sensory home (for example open windows, perfume bottles, cleaning products, air fresheners, radios, and CD players). Conscious of the audiovisual medium we were using for our shared task, they often reminded me that I must 'get that on the video', including images, sounds and smells, even though they could not be reproduced on video. Virginia showed me the exterior of her country cottage, describing the agencies that composed her home and their sensory elements:

> Sometimes we'll sort of sit out at night, you know, as it gets dark and just watch the sun go down, 'cos the sun goes down over that direction. And it's just really beautiful, it's actually quite funny because we discovered, the other week, we realised that we had a lot of bats living in the area but we couldn't quite work out where they were coming from. When we actually worked out – we sat out one night until it was quite dusk and we watched and counted about forty bats coming out from underneath all the wood cladding, so it was really bizarre. And they live under here and you can hear them. You hear that squeaking? That's the bats waking up to come out. Stuck in between all the gaps and that's what all the little squeaky noises are. Hear it?
>
> (Virginia 1)

We did hear them squeaking. Doubting we could 'get it on the video', we nevertheless tried.

Some informants described their olfactory worlds in words during the tape-recorded interview and also invited me to share their olfactory experiences on video, using smell to communicate sensations and ideas. They sprayed scents and products into the air for me to smell and expressed their pleasure or distaste at the odour of their homes and products. I inhaled the smells they referred me to (as such directing me to a pre-reflective experience on the basis of which I attempted to empathise with theirs) and we endeavoured to represent this communication on video. I experienced each home as a 'world of smell', inextricable from my informants' relationships to other sensory, material and social elements of their homes. The creative practices they used to interact with their olfactory homes were developed in relation to the possibilities and constraints of the olfactory environments they inhabited. Likewise, we discussed sound. Informants played CDs and described how radio formed part of their everyday narratives at home. Housewives' uses of radio are well known (for example Gil Tebar 1992; Oakley 1985), and Tacchi describes how radio 'contributes greatly to the creation of domestic environments' – it 'creates a textured "soundscape" in the home within which people move around and live their daily lives' (1998: 26). My informants associated particular sounds with spaces and activities, notably radio in the kitchen, and upbeat music for housework. For example:

VIRGINIA I put the radio on when I'm having a shower and what happens really, it's quite interesting, my partner turns it over to Radio 4 during the day – 'cos he'll

have a long soapy bath and he'll listen to Radio 4. I automatically turn it back to music stations. So once I've come back up here after I've had my breakfast in a morning, I switch that one on and it gets me going, you know, a music station as opposed to Radio 4. I might listen to Radio 4 downstairs when I'm having breakfast, but, you know, by the time I get up here I want to really wake up. I know I've got to wake up 'cos I'm on my way to work, so yes.

SARAH But what about when you're cleaning, do you use it then?

VIRGINIA Yes, I do actually, quite often. Actually I don't have to do it; I don't have it on as much as I used to. I used to have it on all the time …

SARAH Do you choose specific music for the mood?

VIRGINIA Yes, yes I do. I suppose I listen to classical if I'm feeling a bit melancholy. And some sort of other, I don't know, pop bands … but then I will choose more, you know, different sort of types … I will listen to more sort of upbeat music if I'm, perhaps if I'm cleaning and stuff, and if I want to get ready for work or do whatever, then yes, it's got to be more upbeat music.

(Virginia 2)

To represent their self-identities and homes informants employed multiple sensory modes: music, images, smell and touch. This reproduced neither everyday life nor the role of sound, smell, touch or vision in it. Nevertheless, the video tour encouraged informants to draw on a repertoire of props and experiences using sensory media to represent their lives in their homes through knowledge that was neither exclusively visual nor verbal. These ethnographic videotapes can be interpreted largely within the terms that MacDougall discusses for the reflexivity of film and its focus on the individual and consciousness rather than on culture as a system. They represent 'deep' as opposed to explanatory reflexivity. The former inscribes the relationships through which the video was produced whereas the latter takes place after the event and is more common in reflexive ethnographic writing (1998: 89). Simultaneously, the tapes represented my informants' individual views and experiences of their home decoration and housework and the specific strategies they employed to undertake these gendered practices. Subsequently, my set of videotapes, interview transcripts and fieldnotes communicated different aspects of the research and different types of experience and knowledge in different ways. Much of the knowledge produced through these encounters was represented visually. To attempt to translate it into words would reduce its quality as knowledge and redefine the type of experience being represented. Next, to contextualise this and reveal some of the limits of both video/film and writing, I discuss how other anthropologists and ethnographic filmmakers have researched and represented the home.

Visual and written ethnographies

In chapter 3 I discussed the potential of anthropological writing and ethnographic film to represent sensory experience in terms of their abilities to communicate

individual experience and theoretical and methodological contextualisation. Here I explore this through a case study by comparing how the experience of home and social and material relations in it have been represented in anthropological writing and film. Henley distinguishes between ethnographic film and writing, characterising the former as describing particular cases but inevitably informed by anthropological theory and the latter as explicitly 'concerned with general theoretical issues about human culture and society' but usually referring to particular cases in doing so (2000: 217). In observational ethnographic cinema anthropological theory remains implicit whereas in anthropological cinema it frames the film as a guiding voiceover. Likewise, ethnographic writing is mainly descriptive but informed by theory while anthropological writing engages directly with theory, employing ethnographic examples. These are good working definitions, although in reality not clear-cut (see Henley 2000: 217). They imply two questions: can film and writing be equally anthropological? And how do film and writing communicate anthropological and ethnographic knowledge differently? Some visual anthropologists suggest unsatisfactory dichotomies between ethnographic film and writing: Hastrup (1992) argued writing was potentially reflexive while film was not; Barbash and Taylor (1997) saw written text as concerned with 'intuitive abstractions' and film as 'a quintessentially phenomenological medium' with a 'unique capacity to evoke human experience'. Devereaux (1995) suggested film focuses on experience and the particular, but writing 'takes hold of the abstract, that enemy of experience'; and MacDougall (1995), more usefully, proposed that, where ethnographic writing can subdue the individual and the particular, film cannot. Most such distinctions are problematic: written words have for centuries been used to represent the particular and human experience, and abstract ideas can be communicated on film by diagrams, maps and voiceover. Therefore, what is of interest is not so much the essential natures of film and writing, as how anthropologists use these media. It is more appropriate to examine how film and writing have been used to communicate anthropological and ethnographic ideas, the benefits of each, and the relationships they bear to practices and discourses conventionally defined as anthropological and ethnographic.

Filmmaking, writing and the anthropology of the home: a case study

The late-twentieth-century 'crisis of representation' encouraged new styles and focuses in written ethnography that responded to 'uncertainties about anthropology's subject matter (traditionally "the other"), its method (traditionally, participant observation), its medium (traditionally, the monograph) and its intention (traditionally that of informing rather than practice)' (James et al. 1997: 2). Written and filmic ethnographies of the home have both responded to these critical perspectives, involving a departure from previously established fieldwork and observational filmmaking styles that Henley describes as 'a judicious mixture of observation and participation' and share a 'belief that understanding should be

achieved through a gradual process of discovery, that is through engagement within the everyday lives of the subjects' (Henley 2000: 218).

Contemporary studies of the home in written anthropology and material culture studies have engaged with methodological issues and new subject matter. Edited volumes and articles about home predominantly (but not exclusively) in modern western societies in anthropology (for example Birdwell-Pheasant and Lawrence-Zúñiga 1999; Gullestad 1993; Miller 1998, 2001a) and sociology (for example Silva 2000) centre on the social and material lives and agencies that intersect in the houses and apartments in which people live. For many researchers this involves doing ethnography 'at home' (in one's own culture), implying new relationships between researchers and informants, and departing from 'traditional' ethnographic methods. Ethnographers might spend only short periods of time with informants in their homes, and may find informants do not know who their neighbours are, rather than sharing a sense of community with them (Miller 2001c: 3). Although neither theoretical concepts nor people's experience of locality-based community should be abandoned (many people *do* see themselves as living in 'communities' (Moore 1999a)), Miller claims: 'In industrial societies, most of what matters to people is happening behind the closed doors of the private sphere', arguing that 'if this is where and how life is lived, it is very hard to see a future for an anthropology that excludes itself from the place where most of what matters in people's lives takes place' (2001a: 3). The 'crisis of representation' has also affected how such ethnography is written, encouraging a reflexive recognition that ethnographic writing is 'the final outcome of a complex process of liaison between the informant and the researcher' (James *et al.* 1997: 11). Some ethnographers of the home therefore recognise how, in exploring what is private, researchers and informants become involved in collaborations and negotiations over what is revealed (for example Silva 2000), use biographical approaches (for example Hecht 2001) and draw from their personal experiences of home (for example Miller 2001b). Miller particularly recognises the intrusive nature of the ethnography of the home, justifying this because 'we need to understand through empathy' the intimate relationships between people and their homes (2001a: 1).

Written essays on the home often begin with introductory, theoretical and empirical review sections, followed by case studies, and a discussion/conclusion (for example Clarke 2001; Daniels 2001; Garvey 2001; Gullestad 1993; Marcoux 2001; Silva 2000). These essays tend to separate theoretical and ethnographic writing, restricting the latter to case studies sandwiched by theory and discussion. Neither is such work usually overly concerned with representing informants' embodied sensory experiences of home, focusing more on (the nevertheless important anthropological question of) the expressive nature and emotional import of how informants talk about and decorate their homes. Drazin shows how wood in Romanian homes contributes to an 'emotional landscape ... in which care and caring are embodied' (2001: 197) and Clarke uses her informant's own words to express how her decoration makes her 'feel comfortable' (2001: 35). However, the effect is to represent informants' *feelings about* rather than *experience of* their homes. Miller

does reflect on his experience of his own home, as in his feelings of being 'haunted' by the agency of past occupants felt through his dislike of and embarrassment with its existing decoration. He appeals to the reader's sensibility because 'it brings us down to a level that most people can relate to in some degree within their own experience' (2001b: 110). However, Hecht's work is perhaps the exception in discussing how sensory experience figured in her research. Quoting her informant's descriptions of the experience of heat and cold, dark and light, and a sunny room (2001: 126), she notes how her narratives 'recapture and convey the *sense* and *essence* of her experience' (2001: 130) also by mimicking accents, showing images (2001: 131–3) and using smell and touch to evoke past experiences (2001: 136–9). Hecht effectively describes how her informant used sensory categories to express her memories and communicate sensory embodied experiences that are both visual and non-visual.

Sometimes such case studies are illustrated with realist photographs of objects and arrangements (Clarke 2001; Daniels 2001; Drazin 2001; Hecht 2001; Marcoux 2001), with captions descriptive of the objects and in whose home and room they are located. Whilst not redundant, these photographs actually objectify the material agents they represent in a way that mimics the objectification of human 'others' in conventional ethnographic monographs (discussed in chapter 2). The photographs express little about material agency, the relationship between people and objects or their own materiality as photographs. However, visual representation is not the priority of this anthropology of home. Moreover, this literature does not, to my knowledge, refer to representations of home in visual anthropology.

Nevertheless, there is nothing new about ethnographic film about houses or homes. Flaherty's (1922) *Nanook of the North* involved a house-building project. Recent films continue the theme, such as Engelbrecht's excellent *Building Season in Tiebele* (2000). Mourao's *The Lady of Chandor* (2000) presents an intimate portrait of the relationship between an elderly lady and her Goan palace. Moreover, many ethnographic films enter people's homes as we follow their lives. Rosie Read's *Domov* (2000) reflects on the meaning of home on a number of levels as her informants are deprived of, reunited with or re-make their homes. Read's reflexive observational cinema[3] style takes us with one film subject, Dana, as she leaves prison to recreate 'home' in a new apartment, documenting Dana's emotions and achievements through their conversations and Dana's expressions and actions as she gradually compiles the material and human (her children) elements that will make that space a home. As I suggested in chapter 3 experience is communicated through the subject's voice as well as depending on the viewer to empathetically sense the embodied and emotional substance by putting oneself in the subject's place. As for ethnographic writing, the 'writing culture debate' or 'crisis of representation' in anthropology has influenced ethnographic filmmaking about the home. For example, Lutkehaus and Cool (1999) identify a trend towards the 'indigenous and autobiographical' in recent student ethnographic film/video work at the University of Southern California. They discuss Cool's *Home Economics* (1994), a video that examines 'the ideal of home ownership in suburban Los Angeles County', making a

'quintessentially anthropological' argument seeking to show the way of life of petit bourgeois, suburban homeowners while simultaneously turning 'this showing into a critique of contemporary American society' (1999: 130). As a critical response to existing approaches to representation they claim this video departs from existing paradigms in observational cinema to 'situate the anthropologist/filmmaker within the video and to acknowledge the authored nature of the representations it represents' (1999: 133). To achieve this a number of strategies were employed. The video has voiceover narration but consists of '"real time takes" … in which the video's three subjects give lengthy responses to Cool's short prompts and questions', and 'Shot in the subjects' kitchens, living rooms, and backyards and recorded with a camera carefully set up on a tripod and left to run unattended for long periods of time, the interview portions of *Home Economics* take on the tone of "kitchen conversations" rather than interviews proper' (1999: 131). Cool aimed to foreground the subjects' experiences as homeowners, their perceptions, and the meanings this holds for them, simultaneously conveying her own implicit critique of the meaning and value of home ownership and consumerism (1999: 132). Thus the video claims a 'quiet' (rather than 'intense') reflexivity. Cool appears on camera and is heard asking questions (1999: 133). However, rather than representing the filmmaker as film subject, 'By representing the anthropologist/filmmaker as a voice in dialogue with – but distinct from and external to – the film's subjects, *Home Economics* creates a place from which to advance its anthropological critique' (1999: 134). The experience of home that *Home Economics* represents is expressed as Cool's film subjects speak to her and the camera. As such the experience communicated is reflected on and defined by the informant. Sitting on a chair in the garden, a sofa or the stairs, or organising the kitchen while being interviewed are sensory experiences and viewers might empathetically imagine themselves into the homes to sense their aromas, textures, sounds and sights. However, this would be based on the viewer's own anticipation of these not on the film subject's own pluri-sensory experience.

Read's observational and Cool's interview-based approaches to ethnographic video both focus on the intimate, domestic and familiar. Read communicates about Dana's experience of creating home effectively through Dana's words and actions along with evidence of her own presence in this process. In contrast, Cool challenges the paradigms that inform traditional ethnographic documentary, claiming her representations hinge on the relationship between ethnographer and subject, rather than on observation. They offer alternative approaches to representing other people's experiences of home. Yet these remain primarily ethnographic film projects that speak to and about the ethnographic practices of their own medium rather than participating in mainstream written anthropology of the home.

Above I suggested that the potential of film and writing might be defined by reflecting on how anthropologists use them to communicate anthropological and ethnographic knowledge. A review of existing representations of the home indicates that these have developed in ways specific to this particular subfield of anthropology and the challenges it involves. Nevertheless, written and filmic representations have

responded to these challenges in different ways. The written anthropology of home represents informants' experiences in case studies framed by theory and description. Informants' voices become quotations that supplement and substantiate the author's anthropological narrative and photographs often objectify material objects. In contrast, in ethnographic film a focus on individuals is essential to exploring the material home. Recent ethnographic films foreground the relationship between the film subject and her or his home, giving the subject's voice a leading narrative role and adopting a reflexive style that makes the relationship between filmmaker and subject both explicit and fundamental for understanding the film. In such work anthropological framing is either implicit or a voiceover.

Next I define my own video and written materials in relation to the discussions above.

Visual research materials from data to knowledge

Above I described our video tours of my informants' sensory homes. I encouraged my informants to discuss and show what most interested them. However, our interviews were structured by my research objectives and, unlike observational cinema, a checklist scripted each tour. We had just one hour of tape and rather than waiting for events to unfold we consciously used this technology within a constrained time period to explore and represent each informant's home and to discuss human and material relationships, sensations, identities, emotions, memories, creativity and activity associated with this domestic space and its material and other agencies. The videotapes are consciously framed realist recordings and products of this experience. They also show my own subjective vision of my informants' homes and are a product of the intersubjectivity between my informants and myself and the material context we worked in. The tapes thus represent simultaneously my view through the camera and my informants' own representations of their selves and homes (performed to myself and the camera). Their content might be analysed to produce conclusions about how they presented self and home on video. However, the tapes are clearly not direct realist representations of the everyday lives of my informants. This does not mean they reveal nothing about how the relationship between self and home is articulated and produced in everyday life. Indeed, our task included discussions and demonstrations of how everyday domestic activities were performed. Thus my informants described through embodied performance and visual and other sensory props what mattered to them about their everyday activities and the objects and sensations they involved. These were likewise not realist representations, but expressive performances of the everyday.

Henley suggests defining ethnographic film in terms of how it was produced. Drawing from the parallel between observational cinema and participant observation, he argues that both represent the common belief that 'understanding should be achieved through a gradual process of discovery, that is, through engagement with the everyday lives of the subjects rather than by placing them within

predetermined matrices, whether a script in the case of the filmmakers or a questionnaire in the case of anthropologists' (2000: 218). According to this definition of conventional ethnographic discovery, my tapes would not measure up to the yardstick of good ethnography. However, new research contexts demand new approaches. This is particularly pertinent for work that bridges the gap between applied and academic anthropology, and I take this issue up in chapter 5. It is also an important issue for academically driven projects. Following Miller (2001a), we need to rethink research methods to work with individuals in the intimate spheres of their lives. Moreover, as argued in the 1990s (for example, Amit 1999; Kulick and Willson 1995), new ethnographic narratives that depart from notions of discovery and exploration are more appropriate in circumstances where the everyday lives of researchers and informants are not separated by great geographical or cultural distances. This implies a range of researcher–informant relationships: Miller classifies research in the home as intrusive in its impact on informants' lives, and Cool seeks to represent her informants' voices alongside her academic voice. By working with a video camera I invited individuals to present their own versions of the intimate worlds they inhabit. Each tape tells me a story about an individual's life in and relationship to her or his sensory home, comprising a case study – often biographical, frequently self-reflexive – containing knowledge and representations that were verbalised, visualised and embodied. As ethnographic footage the tapes are descriptive, but informed and shaped by the anthropological principles and questions that structured my interview checklist. If my research had a discovery story this was the narrative of my own journey of comparison and difference though different homes.

Although my video methods departed from the principles of participant observation, they were informed by my training at the Granada Centre for Visual Anthropology (University of Manchester), where I learnt reflexive observational ethnographic film methods. For Ruby reflexivity is key, achieved when 'the producer deliberately, intentionally reveals to his or her audience the underlying epistemological assumptions' behind the particular ways she or he formulated and sought answers to questions, and presented her or his findings (2000a: 156), and is synonymous with 'proper', ethical anthropology (2000a: 167). My interviews unfolded as conversations, rather than questionnaires, making the relationship and intersubjectivity between researcher and informant clear, and acknowledging the role of the camera. Pushing the definition of observational cinema further, the tapes are observational and reflexive because they are about a research experience. My video footage references the observational and reflexive strands in conventional ethnographic film, but is not best classified as observational cinema. The tapes also represent some of the dilemmas and departures of doing ethnographic research in the home as expressed above by Cool and Miller. By developing a methodology that reflects the concerns of both written and filmic anthropology I hope to have produced materials that are relevant to both. The remaining question is how these materials can be published in a text that will also be relevant to both written and visual anthropology.

Making more conversant texts I: the future of ethnographic film

Whereas in the past video figured little in the ethnographic film literature, recent calls for a new visual anthropology discuss video in a context of changing methods and relationships of filming (researching) and representing anthropology. MacDougall, comparing his experiences with film and video, proposes that the single person filming that video allows makes the ethnographic filmmaker's situation more similar to that of the anthropological fieldworker doing participant observation (2001: 6). This changes the relationship between videomaker and subjects, potentially empowering the latter. Alone and with fewer technological concerns MacDougall found he could interact more easily with the video subjects and follow the flow when the unexpected happened (2001: 10–11). As MacDougall notes, 'Video is not simply a replacement for film but a medium with its own capabilities and limitations' (2001: 9). These new perspectives and developments in digital video methodology partly bridge the gap between research and representation, proposing new video research methods and new forms of ethnographic video. They also resituate visual methods in relation to mainstream anthropological research and representation. MacDougall predicts a future with 'new ways of shooting ethnographic film' and new formats, such as CD-ROMs, DVDs and the Internet, and new increasingly specialised ethnographic film forms, suggesting 'that some ethnographic films become more unwieldy and "difficult", but this is perhaps one of the necessary growing pains of a more mature and interesting visual anthropology' (2001: 12).

Ruby also proposes an anthropological cinema that departs from the professional expectations, values and equipment of the film world that have dominated ethnographic film (2000a: 21), arguing instead that anthropologists should produce new visual anthropological texts that use film to represent their work in ways 'parallel to, but not necessarily less significant than, the printed word' (2000a: 22). Ruby used a digital video camera to film the lives of the residents of the US Oak Park community, his home town (and Ernest Hemingway's) near Chicago. Working alone with the camera, free from the constraints of broadcast documentary making, he developed a reflexive collaboration with the subjects of his video that involved their working with him to plan and agree how their lives might be filmed and viewing both footage and edited forms of the film as it developed over a whole year. He initially intended to produce 'experimental video ethnographies' in the form of 'a body of work that is not designed for public television or the classroom but rather as an expression of scholarly communication – a video book with an introduction, several chapters, a conclusion and appendices' (Ruby 2000b). Although Ruby initially conceived the product of his 'Oak Park Stories' project (Ruby 2001) as a new type of anthropological film, as his research developed he became less convinced: 'I was determined not to do what others had done – produce a "film" that depended upon accompanying written materials to make it a "complete" ethnographic statement.' Drawing from Biella's (1993b) work

on the limitations of film for conveying ethnographic knowledge, Ruby suggested his text would need 'an audience of one' sitting at a computer and assuming 'the activist stance that is the norm for people working with a computer and not passively waiting to be amused by the television' (Ruby 2001). In fact at the time of writing this book Ruby is developing a series of CD-ROM representations of this work that combine text, photographs, audio recordings and video footage, discussed in chapter 6.

The new film genres Ruby and MacDougall propose and the closer relationship between ethnographic film and written texts Henley (2000: 222) anticipates signify part of the future of visual anthropology. Nevertheless, like Ruby, I am unconvinced that the future of visual anthropology necessarily lies in the production of a new anthropological cinema.

Making more conversant texts II: images, words, and hypermedia

In proposing a new anthropological cinema, ethnographic filmmakers seek to integrate visual and mainstream anthropology, and produce films that converse more closely with written discourses in anthropology. However, as Henley (2004) has also argued, observational cinema is profoundly limited in its potential to make a theoretical anthropological contribution. As an alternative I shall explore the idea of texts that reference discourses of ethnographic film and writing. Applied to my sensory home project, the issue is as follows. Forty hours of videotape represented my experience of researching the home, my informants' embodied and sensory self-representations of self and home, and collaborative reflexive explorations of their homes. However, to make 'the sensory home' comprehensible as an anthropological concept in this chapter, I devoted a section to it. I related the concept to existing literature on the home and the senses to convince readers it is appropriate to understanding my quotations and descriptions of informants' experiences, practices and representations. Moreover, I foregrounded the discussions theoretically in chapter 3. An anthropological filmmaker could add a layer of theoretical explanation in a voiceover to ethnographic footage. However, this strategy would not engage with written anthropology on its own terms using the intricacies of written language, but as a disembodied voice speaking over visual images. Moreover, as Henley has noted, there are both practical and stylistic problems in inserting such 'experience-distant' contextualisation in observational film. Theoretical and methodological voiceover commentary aiming to situate the film anthropologically would 'undermine the whole purpose of observational film by creating a disengagement with the subjects in favour of the authoritative voice of the narrator' (2004: 122) and be unpractical in terms of timing and editing (2004: 122–3).

In 1999, when interviewing, I envisaged how an ethnographic 'film' might develop. Some informants gave me permission to use their tapes in visual publications. A film would have allowed me to reflexively represent individual informants' unique gendered, embodied and sensory experiences of and in their homes. It

would have facilitated the emphasis on consciousness (both my own and my informants') that MacDougall has proposed would be a feature of the visual anthropology of the future (1998: 271–4). It would have allowed me to evoke audiovisually experiences of emotion, embodied experience, smell, touch and sound in ways that are untranslatable into written words. Rather than situating my informants' views, actions and experiences within a 'culture' through abstract theoretical discussion, it would have focused on the continuities and differences between them as individuals performing their own gendered identities through their everyday practices, thus exploiting what MacDougall has described as the benefits of ethnographic film. However, when working with these materials anthropologically I realised that – although I could use them to represent my informants' voices, sensory experiences and embodied actions and a reflexive take on the research – I also needed to use language to represent much that I wanted to express about and with them. My analysis of these tapes is situated within existing academic discourses about sensory experience and engagement, gender, agency, performativity and home (Pink 2004a). Moreover, my analysis of my informants' experiences, views, actions and strategies focuses on the question of how I and they see them as departing from conventional gendered behaviours and roles. I cannot participate in these written academic discourses without writing. One option would be a film and a written text. However, were my films screened at a film festival I doubt many would read my book. If I published my work in a journal my film would not be distributed with it. In short, my potential film would exist in a similar relationship to the anthropologies of the senses, the home and of gender to those films about the home discussed above. As I began to produce theorised anthropological (as opposed to descriptive ethnographic) representations from this work, its written and video aspects remained inseparable – one was always contingent on the other. Although I had already decided to write a book, *Home Truths* (Pink 2004a), based on this work, in which I inevitably resorted to written description and transcripts to represent video, I wanted to explore other options. Seeking a solution I began developing this work as CD-ROM hypermedia projects that combine still and moving images with written words. Because film has a linear narrative structure (Crawford and Turton 1992: 5) its viewer could not treat its theoretical narrative as a reader of a written text would, moving backward and forward through the text and structure of the argument (Zeitlyn 2001: 38). Such a film would exist as a contribution to visual rather than mainstream anthropology. Moreover, as I have outlined in chapter 3, there are additional problems relating to the capacity of film to represent other people's sensory experience. Even working in my own (English) and another European (Spanish) culture, there were still aspects of my informants' sensory homes that might better be represented in writing.

Questions of how hypermedia functions as anthropological or ethnographic text have been well rehearsed elsewhere (Pink 2001a). It suffices to mention that hypermedia is potentially interactive, multilinear, multivocal and multimedia. Hypermedia narratives can be constructed to be meaningfully interlinked with other narratives composed of different and mixed media. Hypermedia ethnography

might contain interview transcripts, fieldnotes, photographs, video footage, written articles, ethnographic films, entire books, and other works. Online, these may be linked to further materials. Some examples are discussed in chapter 6. To represent the sensory home in hypermedia I conceptualised each product of my research as having a particular role and place in anthropological/ethnographic representation. Rather than implying that these categories of materials should be classified as communicating fixed types of knowledge, below I suggest working uses.

Women's Worlds: a CD-ROM in progress

In an experimental CD-ROM project *Women's Worlds* (in progress), I am developing the theme of the sensory home in a written essay and two multimedia case studies. In the written sections of *Women's Worlds* my objective is to engage with conventional anthropological academic writing in a way that integrates the visual to recognise the intersubjective and performative origins of ethnographic insights that theory might be applied to. The written essay is structured in sections, each accessible through a chronological narrative or a set of section headings on the first page and at the foot of each subsequent page, as is conventional for online

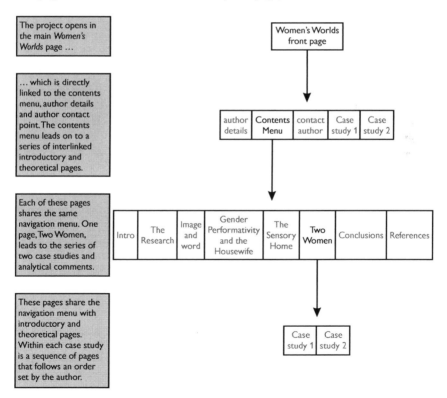

The project opens in the main *Women's Worlds* page ...

... which is directly linked to the contents menu, author details and author contact point. The contents menu leads on to a series of interlinked introductory and theoretical pages.

Each of these pages shares the same navigation menu. One page, Two Women, leads to the series of two case studies and analytical comments.

These pages share the navigation menu with introductory and theoretical pages. Within each case study is a sequence of pages that follows an order set by the author.

Women's Worlds front page

| author details | Contents Menu | contact author | Case study 1 | Case study 2 |

| Intro | The Research | Image and word | Gender Performativity and the Housewife | The Sensory Home | Two Women | Conclusions | References |

| Case study 1 | Case study 2 |

Figure 4.1 Women's Worlds: project map

articles. It begins with an anthropological theoretical discussion and links to multimedia ethnographic case studies developed separately in other narratives of the CD-ROM. The essay thus includes quotations and video clips from informants' conversations with me about their homes, showing visually the art, images and material objects and technologies they implicate verbally: we see Virginia telling me about her painting and her use of the radio (see quotation 2 on page 63). The essay concludes with a summing-up section that returns to anthropological theory. The essay aims to engage with existing written work on the senses and the home, imitating its style and referencing and contributing to its content and arguments, whilst simultaneously acknowledging the relationship between informant and researcher, and reflexively inserting the intersubjectivity and conversational style described by Cool (see page 66). By inserting video clips in the text I integrated the visual and spoken, something not achieved by the separation of written quotations (of human subjects speaking) and photographs (of material objects) represented in Miller (2001c). Nevertheless, in this essay the visual was subordinate to my anthropological argument and video was treated as realist illustration of the research experience, of what informants said and how their homes looked, and as a means of inserting a visual quotation that is evocative of the intersubjective and sensory experience of the research into the written text. As such, the written text is intended to provide an anthropological framework for understanding the visual representation of the home and the sensory, embodied and emotive experience of it emphasised in the case studies.

One option would have been to edit a short ethnographic video and include this on the CD-ROM. However, as Mason and Dicks (2001) have pointed out, existing software does not facilitate easily making hyperlinks to written text via video. The video would have been included as a linear documentary video, and as a narrative that would be isolated from (and that could possibly be viewed to the exclusion of) the project's written texts. As such, it may have shared the fate of the films I discussed above because it would not engage fully with anthropological writing. Instead I attempted to reference film in two ways:

- First, by treating the case study sections as film narratives, borrowing a montage style from film, as Marcus (1995) has suggested. Grimshaw's (2001) book, itself an experiment of basing writing on film styles (in her case montage and *mise-en-scène*), demonstrates that montage can be a successful strategy for written anthropology. It would seem equally appropriate for hypermedia narratives.
- Second, by embedding video clips in the written text. These acknowledge a reflexive filmmaking style but depart from usual uses of ethnographic film.

The edited digitised video clips in *Women's Worlds* are of up to three minutes. Technically this is because longer clips take longer to load, and the storage capacity of the CD-ROM has limited the amount of video used. In *Women's Worlds* these video clips have a dual role, as both a reflexive device and a medium for

representing examples of the diverse practices, opinions and experiences that form part of different women's everyday lives in their homes. As video and *not* film they also serve to link fieldwork and representation. As MacDougall has argued, video is 'not simply a replacement for film but a medium with its own capabilities and limitations' (2001). In particular, working alone with digital video is more akin to a fieldwork than a filmmaking situation, and is a process producing subjective footage that represents this context. Video is a medium and technology used to both explore and represent ethnographic experiences and informants' self-representations. However, such video is never *only* about its own making, it is also a narrative device that uses metaphor to represent emotions, experiences and actions. In *Women's Worlds* these video clips also communicate my informants' descriptions, practices and emotions as I had recorded them through their spoken words, embodied actions, facial expressions and the objects and space in which our encounter had taken place.

In the case studies, I wanted to represent my informants' stories, experiences and performances as they unfolded in the context of our collaborative video interviews. To do this I developed montage essays that combined written description, interview quotations and video clips. I wanted to create a text that compares the subjectivities and biographies of individual women, to explore notions of femininity and what it might mean to be a woman in a contemporary context, and how this is experienced and articulated in the context of the sensory home. In the case studies, because our interviews started with a tape-recorded interview, my informants' introductions of themselves only exist in transcripts and not on video. Without shooting extra footage, it would have been difficult to edit a coherent ethnographic documentary 'film' to include on the CD-ROM. Instead, I produced each informant's story by combining quotations of their transcribed words, video clips and my own descriptions. For example, Holly's pages begin with a still portrait of her and a quotation from her interview where she describes herself in terms of her biography of moving home and the sort of person she sees herself as. The following pages go on to combine my own descriptions with more quotations and video clips. The case study pages are designed to juxtapose video, quotations and my own commentaries, allowing a combination of what MacDougall has called 'deep' (video) and explanatory (writing) reflexivity, and simultaneously a representation of my informant's story of her life as a unique gendered individual in a particular sensory home. I sought to create a dialogue between video and printed words as different forms of representation, as having the potential to represent different sorts of knowledge, and as being able to reference and engage in different debates and discourses. Within each page the montage style is employed: each page is made up of a combination of different visual and written texts and voices represented in layers between which the user can move using a navigation system internal to the page. To make my role as anthropologist and author explicit I include myself as a character in the text alongside my informants and I use still images of specific objects and aspects of home, imitating realist uses in Miller (2001c) but contextualising these fragments by juxtaposing them with other stills, video clips and words as part of the visual

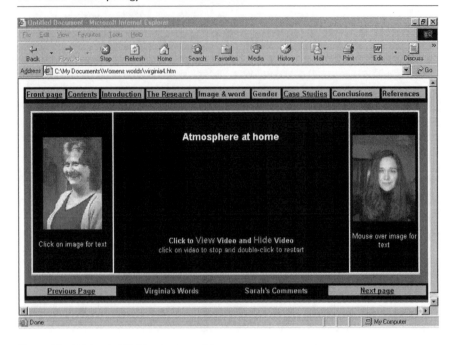

Figure 4.2 *Women's Worlds*: a case study page

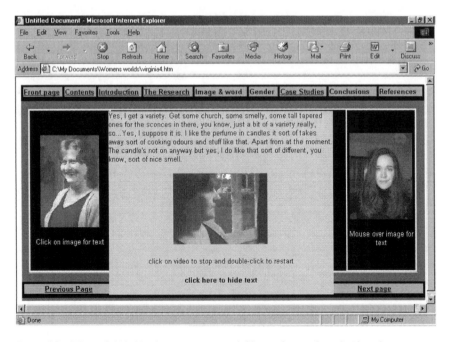

Figure 4.3 *Women's Worlds*: the same page with Virginia's words and video showing

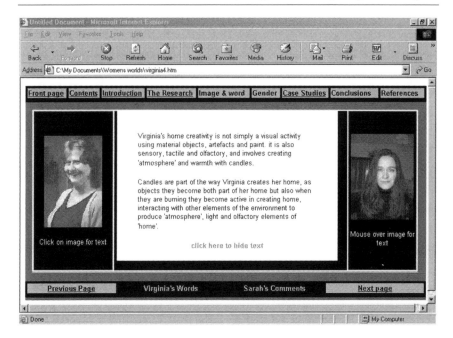

Figure 4.4 Women's Worlds: the same page with my commentary

composition of the pages. For example, above I described how Holly had participated little in the visual decoration of the flat she shared. In hypermedia I represent this using a video clip where Holly describes the living room as we tour it, evidencing her lack of visual self-expression, with my comments and a video still of her small contrasting contribution to visual display in the kitchen. On the following page to explain how Holly shares space with her cousin is a video clip showing our discussion of her wardrobe and space in the bedroom (Holly 1) followed by my description and a second quotation (Holly 2). Along the head of the page are links to the project's other narratives, making the theoretical texts accessible via hyperlinks so that anthropological theory is always present. Moreover, since the same video clips appear in the case studies and theoretical sections, links between these sections are implied.

Hypermedia, writing and film: bridging the gap

In chapter 3 I discussed some of the limitations that ethnographic film encounters in participating in mainstream anthropology. Neither observational film nor ethnographic film based on interviews or anthropologically informed reconstructions (although they represent and evoke cultural narratives and individual experience) can communicate explicitly enough about anthropological theory or methodology to contribute to or converse with mainstream anthropological debate (Henley 2004; Pink 2004b). In *Women's Worlds* I am trying to bridge this gap by

combining and interlinking video and written representations of everyday experience with more abstract discussions. My aim has been to surpass some of the limits of film and writing to create a text that combines abstract theory with experiential reflexivity. Film brings the individual to the fore (MacDougall 1997). In doing so film introduces the most fundamental element in anthropology, the relationship of an individual fieldworker to individual informants, as it unfolds. It focuses on the specificity of the experiences through which ethnographic knowledge is produced and offers a 'deep' reflexivity that cannot be achieved in the same way through the 'explanatory' reflexivity of writing (MacDougall 1998). If ethnographic film is seen as almost opposed to anthropological writing, in terms of distinctions such as specific/general, the individual/the abstract and anthropological theory/ethnography, then the visual will appear to challenge the coherence of an abstracting science. Instead, in *Women's Worlds* I have made the individual a welcome component, a necessary part of the relationship between research and representation and a means of creating links between fieldwork and theory. In *Women's Worlds* my intention is to incorporate the visual into the written texts to anchor the theory in the embodied sensory experiences of everyday life it seeks to explain and generalise from. Its inability to achieve this integration of image and word, and ethnography and theory, is one of the limitations of film. This does not mean that anthropologists should not make films but that film may not be the most effective way to combine or challenge written anthropology with the visual. The potential of hypermedia is in fact to bypass what MacDougall (1997) and Grimshaw (2001) have coined as the challenge of the visual and to use the visual to enlarge the scope and impact of the theoretical on the ethnographic and *vice versa*.

Likewise, hypermedia provides a key platform for developing multimedia and contextualised representations of projects in applied visual anthropology. In the next chapter I examine applied visual anthropology practice, and its commonalities with and departures from academic anthropology. Then in chapter 6 I return to the theme of hypermedia anthropology to examine more fully its potential for a visual anthropology for the twenty-first century that works with multiple media, ethnography and theory, converses with diverse audiences, and might lead to social interventions.

Part III

Engaging with the real world

Chapter 5

Visual engagement as social intervention

Applied visual anthropology

Introduction

In 2003 and 2004 a series of editorials published in *Anthropology Today*, the news-letter of the Royal Anthropological Institute in Britain (Barnett 2004; Mars 2004; Sillitoe 2003), urged anthropologists to take more account of the applied role of the discipline. Anthropology, they insisted, has a role to play in a wide range of areas, which include 'development ... forensic science, the media, the "culture" industry, heritage work, museums and galleries, teaching, intercultural relations, refugee work and the travel industry' and 'law, banking, social work, human resources, retailing, management and the armed forces' (Sillitoe 2003: 2), as well as education and health – and particularly in the battle to reduce the transmission of HIV (Barnett 2004). The participation of social anthropologists in the (usually collabo-rative) task of creating social interventions that might improve other people's conditions of existence, bringing 'hidden' issues into public view or supporting developments in profit-making industries of course does not only affect Britain.[1] It is an international concern.[2] It is also, as I shall demonstrate in this chapter, an area of anthropological practice in which the visual has a key role to play.

In 1999 and 2000 I undertook three applied anthropology projects, using video to investigate 'cleaning homes and lifestyles', laundry practices and everyday hair-styling practices.[3] The first of these provided the ethnographic materials discussed in chapter 4. Following this, in 2003 I convened a series of seminars about applied anthropology in Britain (Pink 2005).[4] This experience inspired me to investigate the range and scope of applications of visual anthropology outside academia inter-nationally. This research includes reviewing historical and contemporary published and unpublished literature, and face-to-face discussions and e-mail contact with practitioners. It has shown that visual anthropology is thriving in a range of public, NGO, 'community' and business contexts. My analysis includes examining applied visual anthropologists' methodologies of research and representation, relationships to academic anthropology, and types of social intervention that characterise these engagements. Because this involves working with anthropologists to learn about their experiences and practices, when possible I prefer them to write academically about their work themselves so that through citation I can make them co-authors

in my statements about developments in this field. As part of this work I have edited an issue of *Visual Anthropology Review* (Pink 2004c), and a book *Visual Interventions* (Pink forthcoming)[5] on the question of applied visual anthropology. These publications contain key case studies of contemporary work in the field, some of which I discuss here.

In chapter 1 I highlighted increasing uses of anthropology in applied contexts, characterised largely by non-academic interest in (various constructions of) 'ethnography' as a route to understanding other people's experience.[6] This combined with the accessibility and availability of user-friendly digital visual technologies means visual methodologies are commonplace in non-academic 'ethnography', although not always informed by visual anthropological theory and practice. In this chapter I develop these points to suggest that applied visual anthropology constitutes an important area of engagement for anthropology in the twenty-first century. First, the visual has unique potential as a form of social intervention and anthropological perspectives can usefully inform this. Second, applied visual anthropological engagements can contribute to theory in both visual and mainstream anthropology. Third, there are interesting parallels between interdisciplinary approaches to visual methodology (outlined in chapter 2) and applied visual anthropology practice. Applied visual anthropology has a part in a future arena where anthropology might achieve a stronger identity as a discipline with a public role and responsibility and has a unique contribution to make in a context of interdisciplinary activity.

The origins of applied visual anthropology

As I outline in chapter 1, accounts of applied visual anthropology are absent from current versions of the history of the subdiscipline. The applied strand has moreover been excluded from definitions of visual anthropology (asserted since the 1970s) as a three-stranded subdiscipline that focuses on visual research methods, the study of the visual, and visual representation (for example Ruby and Chalfen 1974). A fourth strand could be added to this agenda – the use of the visual as a tool of social intervention. While this was not the dominant purpose of many who saw themselves as visual anthropologists in the 1960s to 1990s, during this period applied anthropology figured in the practice of academics now regarded as leading figures in the promotion of visual anthropology. In this section I discuss three key contributions, to demonstrate the form this work took, and particularly its departure from the dominant practice of ethnographic filmmaking.

Margaret Mead was, throughout her career, an energetic supporter of visual anthropology (for example, I discuss her academic collaboration with Bateson in Bali in chapter 2). She was also an advocate of applied anthropology. During World War II and the early cold-war era Mead actively advised the US government. Particularly interesting here is the Columbia University Research in Contemporary Cultures project, 'designed to investigate the cultures of the modern nations with whom we [the USA] were allied and with whom we were fighting, including Germany, Britain, Russia, France and Japan' that Mead founded with Ruth

Benedict (Beeman 2000: xvi–xvii).[7] Part of its work is published in Mead and Métraux's research manual *The Study of Culture at a Distance* (2000 [1953]), which suggests an application of visual anthropology for the distance study of national character though analysing visual materials such as film and fine art. One of Bateson's contributions to 'The Study of Culture at a Distance' project – his analysis of the Nazi film *Hitlerjunge Quex* (1933) – exemplifies this application. Bateson asked 'what sort of people are the Nazis?', a question he considered vital because 'Our intelligence service depends on an ability to guess at German motivation' and knowledge about 'what sort of people the propagandists are' was equally important for understanding German propaganda and morale in Germany and the impact of Nazi propaganda in the USA (Bateson 1980: 20 [1953]). This could be achieved, because 'the film was made by Nazis and used to make Nazis' and thus 'we believe that at a certain level of abstraction that film must tell us the truth about Nazism' (Bateson 1980: 21). While we may now be critical of Bateson's assumptions about how film might be read as text, his work is a good example of the application of an anthropology of the visual in work designed to produce interventions.

Later work specified an applied visual anthropology more clearly. John Collier Jnr is best known for *Visual Anthropology: Photography as a Research Method* (1986 [1967]) – a manual for the development of a systematic approach to visual research. This book made a very important contribution to visual anthropology, although its approach, congruent with the scientific project of the anthropology of the era, has more recently been criticised for Collier's realism, empiricism and statistical method (Biella 2001–02: 55; and see also Edwards 1997; Pink 2001a). Since its publication it has been used as a textbook in visual methods and is probably universally known amongst visual anthropologists. A re-reading of the book reveals that the majority of Collier's own work discussed in the text is drawn from applied projects he was involved in as a visual anthropologist. For example, Collier discusses the Vicos project (carried out by Cornell University and the University of San Marcos, Lima), which is also a frequently cited example in applied anthropology texts (for example van Willigen 2002: 33).[8] The goal 'was to prepare the Indian peons of Vicos to take over their colonially established hacienda and live as free citizens of Peru'. Collier's photographic inventory was 'to measure systematically some of the influences of the project on Indian families' by photographing 'every wall, in every room, of every home' in a random sample of the families (Collier and Collier 1986: 51). This produced two thousand negatives, used to create qualitative and statistical information (1986: 54).

Following this starting-point I contacted Malcolm Collier[9] to discover more about his father's role in applied visual anthropology.[10] Much of John Collier's career was dedicated to applied visual work, although this has largely gone unreported in existing literature (but see Biella 2001–02; Barnhardt forthcoming). A notable exception is Collier's work with native Alaskans, which examined the (ir)relevance of the North American education system reproduced in schools in native Alaskan communities, reported on in *Alaskan Eskimo Education* (Collier 1973). Collier's film study of Eskimo schools formed one unit of this national study

Figure 5.1 A photograph from John Collier's Vicos project, representing the cultural inventory of the family homes discussed in *Visual Anthropology: Photography as a Research Method.*
Photograph by John Collier Jnr, reproduced here by courtesy of the Collier Family Collection. (Other photographs can be viewed online at http://etext.lib.virginia.edu/VAR/collier/collier.html, accessed 10 July 2004, and see J. Collier 1997/98 and M. Collier 2003.)

of American Indian Education funded by the US Office of Education. The project sought to answer the question of 'How should the White society educate the Red or Brown American?'. Collier was invited to add a visual dimension to the regional part of this interdisciplinary and multi-method study in the Northwest Coast and Alaska, directed by the anthropologist John Connelly in 1969.[11] Collier's film study produced 'some twenty hours of classroom film data' and covered 'more than forty educational situations' in the remote Kuskokwim river villages, the air hub and trading centre, Bethel, and in Anchorage, Alaska's largest city (Collier 1973:1–2).

The purpose of Collier's film study 'was to track the well-being of Eskimo children through all varieties of school environments of this region – mission schools, BIA [US Bureau of Indian Affairs] schools, state schools, city public schools'. The

Figure 5.2 Four frames (separated from each other by 1–2 seconds in real time) from John
Collier's super-8 research film footage of a Head Start program in Kwethluk,
Alaska, winter 1969.
Photograph by John Collier Jnr, reproduced here by courtesy of the Collier Family
Collection.

film data 'was systematically analyzed and evaluated by a team of four San Francisco State College students and graduates with training in both education and visual anthropology'. Collier's final report, combining these perspectives, was submitted to the US Office of Education. The bulk of this material was incorporated into Collier's book (Collier 1973: 2).

Collier's contribution was informed by anthropological theory. Building on Ruth Benedict's (1934) concept of the 'language of culture', whereby 'The cultural language is the total communication of group-shared values, beliefs, and verbal and non-verbal language', Collier saw 'effective education' as 'the degree of harmony between the students' culturally and environmentally acquired intelligence, and the learning opportunities and the intelligence-developing procedures and goals of the School'. When school and Eskimo cultural processes are in conflict educational failure is likely (Collier 1973: 4), and Collier found that neither the White American curriculum nor its teaching practices was culturally suited to Alaskan Eskimos. Collier went on to develop similar applied visual anthropology approaches to understanding Native American education in other contexts (Barnhardt forthcoming), which led him to argue that cultural diversity and a bottom-up approach to education were key to a successful education undominated by ethnocentrism. Such ethnocentrism, he suggested, was at the foundation not only of the education system but also of the visual anthropology of his era, criticising a context where 'Despite developments in urban anthropology, medical and educational anthropology the body of anthropological literature and all the most prestigious ethnographic films deal primarily with archaic and perishing tribal people' (Collier and Laatsch 1983: 223, cited by Barnhardt forthcoming).

Richard Chalfen is better known in visual anthropology for his writing on home media. However, since 1966 when he 'became a consultant at PCGC [Philadelphia Child Guidance Clinic] to develop the concept of "socio-documentary filmmaking" with culturally diverse groups of adolescents' (Chalfen and Rich 2004: 20), Chalfen has worked collaboratively with medical staff to apply visual anthropology to health issues. The socio-documentaries produced realised more than Chalfen's academic goals. Whereas 'The [academic] focal question in this work was to understand better the problematic relationships of sub-culture, social organization and pictorial expression', for the clinical staff and social workers who viewed them 'The films were offering them what they felt was an innocently-derived, transparent "window on life" view of their ethnically diverse constituency'. Chalfen had inadvertently developed an applied visual anthropology. His most recent project was a collaboration with Michael Rich[12] using a method called Video Intervention/Prevention Assessment (VIA) – ' a research method in which children and adolescents with a chronic medical condition are given the opportunity to create video diaries of their everyday lives with illness. They are asked to "Teach your clinicians what it means to live with your condition"' (Chalfen and Rich 2004). Embedded in anthropological principles, VIA is situated by Chalfen and Rich as a hybrid methodology with applied aims at 'the nexus of visual anthropology, applied anthropology, media anthropology and medical anthropology.

Moreover, they insist that it pertains to 'a reinvigorated visual anthropology, one considerably advanced beyond the myopic attention to and production of ethnographic film' (2004).

Each of these examples of applied visual anthropology extends visual practice beyond ethnographic filmmaking. Collier and Laatsch and Chalfen and Rich make critical statements to this effect, resonating with Ruby's point that it is now 'time for ethnographic film-makers to stop being so concerned with making "important" films and to become more interested in how their work affects the people they portray and those who view the images' (Ruby 2000a: 221). The works discussed above are excluded from existing accounts of visual anthropology. The area of visual practice that is, in contrast, recognised for its potential for social interventions is 'indigenous media', which is sometimes classified within the subdiscipline of media anthropology, and sometimes within visual anthropology (for example Morphy and Banks 1997). I return to indigenous media as social intervention and what Ginsburg calls 'cultural activism' (for example Ginsburg et al. 2002: 8) and explore its status as applied visual anthropology below. First I examine the meaning of 'applied visual anthropology'.

What is applied visual anthropology?

Applied visual anthropology projects are not only largely excluded from accounts of visual anthropology but also from the applied anthropology literature. Visual anthropology methods are not accounted for in the sets of methods listed in standard applied anthropology texts (for example Ervin 2000; Gwynne 2003; MacDonald 2002; Nolan 2003; van Willigen 2002). As a result neither literatures have engaged with the question of its definition.[13] Broadly, applied visual anthropology involves using visual anthropological theory, methodology and practice to achieve applied non-academic ends. It usually entails an element of problem solving, engages in 'cultural brokerage' (Chalfen and Rich 2004) – representing the experience of one group of people (or 'culture') to another – and is interdisciplinary. However, within this definition there is much variation in: the relationship of the applied visual anthropology project to academic work; training and expertise of practitioners; the client or group of people the project intends to serve, and the institutional context this implies – in other words, industry, public, community or NGO sector; the nature of the experiences it seeks to research and represent; the sort of intervention aimed for; and the methodologies used (I examine examples of how these differences emerge in the following section). Generally, applied visual anthropology differs from academic visual anthropology as it has a problem-solving component, aims to create social interventions led by research into human experience, and is 'client' or 'user' driven rather than inspired by theoretical, substantive or methodological questions deriving from academic practice. It also differs from applied anthropology, which is expanding its brief to include work that is less research-led. For example, applied anthropologists working in social development might work as project assessors – a role that builds on the anthropologist's research

and social development experience but does not involve her or him producing representations of how a particular group of people experience certain aspects of their realities (see Green 2005).

Whatever the institutional context, applied visual anthropology is usually (excepting work such as Bateson's analysis of Nazi propaganda film) characterised by collaborative approaches in which the subjects of the research play an active role in the production of data. Sometimes they have a personal or community stake in the findings of the research or plan to use the final visual product of the research, in other (usually commercial) cases they might be paid a fee for their participation. Participation is also important for methodological reasons. If we assume applied visual anthropologists are seeking to collaboratively research and represent (to diverse audiences) other people's experiences, the appeal of the visual becomes clear because it should assist, to use MacDougall's (1998) term, the 'transcultural communication' of the experiences of one group of people to others. Film and video are especially good at representing aspects of human experience, through their use of visual and verbal metaphor they encourage the audiences' empathetic interpretation of emotions, sensations and other dimensions of experience that might superficially appear to be common between different cultures. Nevertheless, as I warned in chapter 3, the idea that we can feel other people's feelings and sense their sensory experiences by viewing how they are metaphorically represented in audiovisual media, can mean that without written cultural contextualisation we will actually experience what we think are *their* experiences in terms of *our own* cultural and individual biographical knowledge. Their experiences cannot really become ours and will always to a degree be incomprehensible. This does not mean that attempts at such visual communication are not worthwhile. Nevertheless, like academic anthropologists, applied visual anthropologists need to make their visual representations culturally meaningful to their audiences. This might involve contextualising the experiences of those represented to make explicit what those experiences mean in terms of *their* culture. It will also involve another form of cultural translation. Academic anthropologists need to write their work into anthropological terms (the culture of academia), and if visual anthropologists hope their representations will converse with and participate in the debates of mainstream written theoretical anthropology they must engage their photography and video with these debates to some degree at least through the use of written words, as I have argued in chapters 3 and 4. Applied anthropologists likewise need to write their ethnography into the language and culture of the institutional or social context in which their target audience operates. This might take rather different forms. For example, Susan Levine, who was an anthropological consultant on an applied visual anthropology analysis of how local people in Southern Africa interpreted fictional film produced as part of an HIV/AIDS education project, stresses the effectiveness of producing 'films that tell local stories in local languages about people living with HIV/AIDS' (2003: 70). Likewise, in a quite different context in chapter 6 I show how to present the findings of a consumer video ethnography to industry partners – I needed to show other people's experiences within conceptual

frames and categories that were meaningful in that particular institutional context. Such an objective, like the presentation of academic visual anthropology, benefits from combining multiple media. As I outline in chapter 6, innovative hypermedia projects are being developed in applied contexts.

Finally, applied visual anthropology projects are neither simply applied projects that use visual methods, nor visual anthropology projects with an applied effect. Rather, applied visual methodologies tend to draw from both subdisciplines and often additionally from interdisciplinary influences. In this sense applied visual anthropology has an identity in its own right, and I return to this issue at the end of this chapter. These issues and points form the basis of my analysis of case studies below. First, however, I outline the potential of the visual in social intervention from anthropological and interdisciplinary perspectives.

Visual interventions: the interdisciplinary context

The idea of visual media as a form of social intervention is long established. John Collier noted how photography could change 'social thinking dramatically'. Historically, he noted how the police reporter Jacob Reis's photographs of slum conditions in New York City 'helped establish the first building codes and apartment regulations', and the sociologist Lewis Hine's photographs of child labour 'were influential in passing the first child labour laws'. Collier suggested that the process of such a method – 'Observation, synthesis, and action' – was 'the essence of applied anthropology' (1967: 4). It is not only within visual anthropology that the potential of visual media projects to empower local communities or individuals or bring their 'hidden' identities or problems into a public domain to support their cause has been recognised. In this section I discuss the legacy of wider interdisciplinary and historically embedded applications of visual media in processes of social change as a context for understanding how visual media have been implicated in such processes through a selective review of cases from more and less developed contexts.

There is a solid history of the use of audiovisual media in a range of projects by 'first-world' nations that can be seen in some way as educational[14] or pedagogical. These encompass both top-down and bottom-up agendas to make interventions. Some interventions have been developed as part of wider government-funded processes of 'nation-building' (Goldfarb 2002). Others are concerned with empowering individuals and community groups to educate themselves and others through their own media productions. For example, in the USA, with the introduction of portable video recorders in the late 1960s, video production became a part of political activism in an atmosphere of optimism about the possibilities 'for artists to effect social change by producing works that performed social critique' (Goldfarb 2002: 66). By the 1970s, 'community activists launched cable access centers and video collectives in urban and rural centers' across the USA, developing alternative and critical broadcasts to existing television and availing airtime to some marginalised communities (2002: 67–8). Later, with changing approaches to

pedagogy in the 1970s and 1980s, initiatives to train young people in video production and to create their own (critical) media texts became popular.

These types of initiative are different from the area of practice anthropologists have been most interested in – indigenous media – which in contrast is defined as a particular form of cultural activism specifically produced by people 'who have been dominated by encompassing settler states such as the United States, Canada and Australia' – as opposed to productions by ethnic minorities who have migrated to such states and national or independent cinemas of Third World nations. It involves a specific political dynamic as it is implicated in 'broader movements for cultural autonomy and political self-determination' and in tension with the dominant culture (Ginsburg 2002b: 11). Some well-documented examples are:

1 the development of Inuit television – including satellite transmission of small-scale Inuit video productions – which has 'played a dynamic and even revitalizing role for Inuit and other First nations people, as a self-conscious means of cultural preservation and production and a form of political mobilization' (Ginsburg 2002b: 41);
2 indigenous Aboriginal media in Australia, which by the 1990s had expanded from TV and documentary production to the making of feature films (Ginsburg 2002b: 52); and
3 the Kayapo uses of video 'to document not only historical encounters with Brazilian state power but internal political events as well', which Turner suggests has 'contributed to a transformation of Kayapo social consciousness, both by promoting a more objectified notion of social reality and by heightening their sense of control over the process of objectification itself, through the instrumentality of the video camera' (Turner 2002: 87–8).

Unlike the video activism discussed by Goldfarb, indigenous media has become linked with visual anthropology, inviting comparisons with ethnographic film. The idea of indigenous media extends MacDougall's notion of a 'participatory cinema' (1975, 1998) to an extreme where control is ceded to film subjects. Any comparison of the two is inextricable from questions about the power relations of the production and control of films, and needs to account for how by the 1970s some indigenous peoples who had previously been film subjects became concerned with producing their own films (Ginsburg 2002a: 214–15). In this sense indigenous media production can be considered a critical response to academic ethnographic filmmaking. However, as Ginsburg insists, there is a common concern in both practices with 'mediating across cultural boundaries' whereby ethnographic film aims to create 'understanding between two groups separated by space and social practice' and indigenous media to 'heal disruptions in cultural knowledge' – it 'offers a possible means – social, cultural and political – for reproducing and transforming cultural identity amongst people who have experienced massive political, geographic and economic disruption'. As such both ethnographic film and indigenous media are involved in the '*process* of identity construction' (original italics)

(2002a: 216–17). Indeed uses of film produced by anthropologists with, and for, indigenous peoples have also supported their self-definition and assertion of their rights within and outside their immediate communities. For example, in the USA Harald Prins, an anthropologist trained in filmmaking, became involved with native-rights work on behalf of a Mi'kmaq community with whom he had been doing fieldwork. Part of this work involved his participation in issues related to Mi'kmaq rights, resulting in a land-claim settlement and federal government recognition of their tribal status, the success of which was partly due to a film about them that Prins co-produced and they sponsored (Prins 2002: 59).

Uses of video in participatory social development, community empowerment, and notably in HIV/AIDS education/awareness campaigns also demonstrate the transformative 'power' of documentary and fiction video/film for social intervention. For example, Shirley White and the contributors to her (2003) *Participatory Video: Images that Transform and Empower* outline an agenda for using video in development (for example poverty alleviation, women's empowerment, revealing and re-negotiating social inequalities, and health education/awareness) through a participatory process. A project with a more anthropological perspective is the *STEPS for the Future* project, which produced a series of HIV/AIDS fictional education films in southern Africa. It was 'designed as an intervention by film-makers into the HIV/AIDS pandemic using film to address powerful and entrenched attitudes – denial, stigmatization and discrimination – which have fuelled infection rates and debilitated treatment programmes' (Chislett *et al.* 2003: 9). Here Susan Levine applied visual anthropology methods to explore the responses of rural and urban audiences to the *STEPS* films to produce ethnographic data on 'the impact of locally produced documentaries on people who have limited access to films and forums for HIV/AIDS discussion' (2003: 58). Her work demonstrated how people's base-line knowledge, derived from conventional HIV/AIDS education methods, increased after viewing locally produced films that they could engage with at a level of narrative and individual experience.

The examples of visual media production discussed above have in common that they are all concerned with making social interventions. However, the difference between this work and an applied visual anthropology is that while the former has been subject to anthropological analysis, which is itself a form of applied visual anthropology, the latter uses anthropological methodologies as part of the process of creating appropriate interventions. The examples discussed above also demonstrate the effectiveness of visual forms of cultural activism and social intervention. They invite us to consider more seriously how anthropologically informed visual practice might be engaged as a form of social intervention.

Applied visual anthropology in practice

Although it has emerged in an uncoordinated form and with limited sharing of practice and experience, a significant range of applied visual anthropology is developing. Project types might be grouped in terms of sector (for example education,

health, government, industry, disaster and conflict relief, empowerment of local people or communities, heritage, development and more) or through the sorts of social interventions they make. Some projects produce anthropologically informed films about other people's realities intended to influence how target audiences conceptualise and act in relation to certain issues. For example, Dianne Stadhams' production of a television programme as part of communications for development work in the Gambia (Stadhams 2004), the filmmaking unit A Buen Común's film *Mujeres Invisibles* produced with women living in marginalised neighbourhoods in southern Spain (see Camas *et al.* 2004), and HIV/AIDS awareness films (see Biella 2003; Tongue *et al.* 2000). Other media and communications objectives shape the design of alternative forms of visual representation. For instance, posters, hypermedia projects and exhibitions can inform decision-making in commercial and public-sector contexts, and employees of large organisations can be invited to experience multimedia texts that report on the everyday experiences of consumers through online project reports (for example Steele and Lovejoy 2004). Applied visual anthropology research might lead to business actions applied to new product designs or branding strategies, or in the public sector to new policy initiatives. The forms of social intervention this involves are different from the perhaps more directly felt results of, for example, making a marginalised woman feel empowered through having the opportunity to redefine her own identity in a documentary video, or increasing drug-users' awareness of HIV risks: first, by influencing how policy makers or business understand their consumers or clients; second, through its input into the design processes (of policies or products) applied visual research also intervenes in the creation of the technologies, experiences and routine practices through which the everyday lives of both consumers and the providers and recipients of policy provisions are constituted.

Rather than skimming the surface of many projects and sectors, here I contrast two areas of applied visual anthropology that have different aims and that achieve different forms of social intervention – on the one hand industry, and on the other the empowerment of marginalised people. In the former the impetus for intervention comes from 'above'. Research is commissioned by a company to solve 'problems'. It usually forms part of the wider multidisciplinary research agenda of the business and, although it normally intends to improve consumer or user experiences, it also aims to generate profit. The latter is initiated quite differently. In some cases it is not, at least explicitly, institutionally embedded in that a project might be initiated at the request of people who have suffered a crisis or be identified by the anthropologist him- or herself through a broader fieldwork project or long-term fieldwork with a community. In others it might be related to, in collaboration with or alongside, existing local projects with similar aims.

For each area, linking to the wider themes of this book, I review questions of: the social interventions intended; the relationship with academia; the approach to experience; and the interdisciplinary context of the project.

Visual innovations in industry

Uses of visual ethnography in industry are widespread. However, these may not be anthropologically informed, especially when carried out by market-research agencies, and the 'ethnography' practised is often far from the conceptualisation of long-term participant observation that many anthropologists still see as the discipline's hallmark. Long-term fieldwork in one place, involving everyday interactions with informants over a year or more, presents an ideal scenario. However, it is not always either possible (due to unavailability of funding and time) or necessarily the most viable method for contemporary (academic or applied) research, as I describe for the anthropology of the home in chapter 4. Nevertheless, one can distinguish between the 'brand' of 'ethnography'[15] offered by market-research agencies with no anthropological input and that practised by anthropologists working within anthropological frames. Business press releases and online reports indicate anthropologists are increasingly popular because they provide unique insights into how consumers experience products and the social relationships and cultural worlds companies market them to. Here I discuss work in two burgeoning areas: design anthropology and consumer ethnography.

Adam Drazin notes 'While ethnography has a long history in certain areas of design, such as Scandinavian design, recently contextual design and participatory design have been gathering steam within the design mainstream' (2005). Anthropologists are increasingly employed in these roles, often using visual methods. Steele and Lovejoy (2004) report video and ethnography have played an important role in the history of research in corporate settings, but, citing Wasson (2000), comment that due to issues of corporate and client confidentiality it is difficult to assess ethnography's influence. However, currently a growing literature reports on this work, some of which is linked to academic anthropology. Design anthropology is sometimes specifically identified with visual anthropology – the 'executive summary' for design anthropology on the Centre for Pervasive Computing web site in Denmark notes 'much needs to be learned about combining (visual) anthropology with design activities and interventions in use context'. Amongst their research themes they list a need for designers to 'move beyond "merely" understanding work practices' because 'Users are real people with feelings, dreams' – this means an interest in 'Experience modelling' and what we might call the cultural brokerage of 'Bringing together user culture and design culture'.[16] However, we also need to distinguish between the processes of anthropology and design anthropology. Of particular interest is work the visual and design anthropologist Werner Sperschneider has been involved in developing in Denmark. With a background in academic anthropology and ethnographic filmmaking,[17] Sperschneider has generated interesting work in a design anthropology context. Sperschneider, Kjaersgaard and Petersen (2001) describe how, while anthropological understandings are generated through the *researcher* combining insider and outsider perspectives, this process is reversed in participatory design. Here *users* combine insider and outsider understandings by participating in design activities and reflecting on their own

practices. As such design anthropology is 'Not *our (the designers)* point of view not *their (the users)* point of view, but an additional point of view, a double perspective'. Video contributes to this double perspective 'as tool and as metaphoric device for thought and ideas'. Sperschneider and Bagger (2003) report on two methods developed in Danfoss (Denmark) involving 'Design-in-context', which are 'design sessions staged in the user's own work environment, and based on scenarios developed by the user'. These involve, first, users taking control of the research context, guiding the researchers around the work context (while being videoed) and creating the scenarios in which they would use products. Second, they describe a workshop in which groups of users of a future waste-water plant produced videos of a future scenario, thus encouraging them to 'collaborate in a co-design event' and represent their future design visions on video using a series of props. Sperschneider and Bagger highlight two key points about the design-in-context approach – it is collaborative and participatory. It also, using video, invites the expression of visual knowledge and ideas, and situates and communicates about practice within contexts that are visual and material. Design contexts are of course also sensory, as Büscher, Krogh, Mogensen and Shapiro (2001: 2) put it (for the case of architectural designers): 'Sound, smell, a proprioceptive sense of contours, a more comprehensive field of view, and the experience of different forms of sociability in different kinds of spaces provide knowledge that often proves crucial to good design'.

Design anthropology is not unconnected to academic anthropology. The example cited above involved academically trained PhD anthropologists who have links with universities and are writing back about their practices to the academic community. As a visual anthropology practice, its aims and the roles of anthropologist and informant/user are clearly different to those delineated in an academic visual ethnography. However, simultaneously they develop themes of user participation and collaboration in the production of (visual) knowledge close to ideas discussed by Banks (2001) and myself (Pink 2001a) in recent methods books, and to the principles upon which MacDougall (1998) builds his notion of 'transcultural cinema'. However participation and collaboration are additionally important in applied anthropology because fieldwork is normally short-term and methods must be adapted to context (sometimes this means an interdisciplinary context). In a situation where it is impossible for the ethnographer to wait a year for the actual experience of people's practices to unfold, visual collaborations play an important role in both generating user-led representations of their practices, experience and ideas in a short time-scale, and in turn representing these 'in context' to designers.

A second area of visual anthropological practice in industry is 'consumer ethnography'. In chapter 4 I discussed my video ethnography of the 'sensory home', which was developed as an applied video ethnography project to understand the relationship between 'cleaning, homes and lifestyles', developed with Unilever research in 1999. Elsewhere I discuss the findings of this work in academic terms (Pink 2004a) and examine the relationship between academic and applied aspects of the project (Pink 2004d). The following year I undertook a similar project with Unilever to explore and situate laundry processes in the sensory home. My research was part of

a wider product-focused project drawing from the wider contextualising data visual ethnography offers. I worked in a team with Jean Rimmer (of Unilever) and an agency specialising in psychology-based market research. The project was interdisciplinary and designed to effectively triangulate data without excessive overlap. The research supplied a rich source of data for the client and provided me with new anthropologically informed materials used to develop academic insights.[18]

My interviews and video tours sought to identify (amongst other things): a sense of the (gendered) identity, everyday life, priorities and morality of my informants; representations of their actual everyday practice; their feelings about and use of products; representations of the laundry process in the home; a sense of the presence of laundry and potential laundry as it permeates the home and its relationship to other elements of the material and sensory culture of the home; and the sensory aspects of this. To achieve this the work was necessarily collaborative. Each encounter with an informant lasted for two to three hours and consisted of an in-depth interview and the video tour itself, each of which was for about an hour. There was no time for long-term fieldwork or repeat visits to witness practice as it occurred in informants' everyday lives. Instead, my role was to work with them to facilitate their representation of the processes, practices and routines that made up their everyday lives and of the sensory environments that these activities worked towards creating in their homes. This type of research produces informant-led representations, rather than the ethnographer's first-hand observations of the minutiae of everyday life collected over a year or more as one lives and shares the cultural world and experiences of one's informants. However, the research did enable me to understand my informants' practices and routines, to gain a sense of how these were mutually constituted along with their identities and moralities and how in turn these influenced their domestic consumption (in the applied sense, their product choice). Video was important in this process for two reasons. First, it facilitated my informants' self-representation. They could 'show' on video how they do things and what is important to them. Second, it gave me a visual record of our encounter, which documented not only what MacDougall (1998) has called the 'deep reflexivity' of the process of knowledge production, but also the material context where we interacted and informants' embodied representations of their sensory experience. For many market researchers such in-depth study of the sensory home might seem an over-long route to discovering why a particular product fits into someone's life. To me as a visual anthropologist it appeared the only way. Video was also key in communicating my findings to the client. I produced a detailed ethnographic written report and developed a CD-ROM report, which included video clips that represented 'key findings' in terms of practices and identities. By uniting visual and written text in the reporting process, I could combine the specific and the general by engaging the client with informants' representations of themselves, their actual experiences and practices, alongside written statements of key findings and responses to some specific research questions (the problem-solving nature of applied visual anthropology).

My laundry research also represented academic concerns. It was related to, and drew from, the anthropology of the home and questions of consumption, and

explored gendered identities and how these were constituted through sensory domestic practices (like the project discussed in chapter 4). My academic writing based on this research has focused on questions of gender and domestic consumption (Pink forthcoming), taking as a key theme the sensory focus inspired through my collaboration with industry and the research concerns of this field. Sensory aspects of marketing and consumer experience have been on the agendas of manufacturers of domestic goods since the nineteenth century (Howes 2003) and continue to form an important concern (some research agencies focus on sensory aspects of consumer experience). Whereas anthropologists have focused largely on visual, aural and material aspects of culture, social relations and experience, the sensory nature of experience in modern western society has long since been key to how manufacturers of domestic and personal goods understand their consumers. Visual anthropologists can learn much from their long history of substantive interest and empirical experience in this field.

The research discussed above emphasises a participatory and collaborative approach to producing knowledge about consumer and user experiences. Moreover, it is stressed in consumer and design research that such knowledge concerns not solely visual material aspects of practice, but also sensory experience. These projects, carried out within a focused and limited time period, collaboratively produce video representations of experience, not direct experience itself. The aim is usually to bring designers, scientists and marketers to a closer understanding of their consumers. Such work is interdisciplinary, it evolves alongside contributions from academic disciplines to respond to the client's research question (possibly also producing surprises and raising new questions). This knowledge must be represented in forms that communicate with the language of industry, requiring an element of cultural brokerage. It can also contribute to visual anthropology, both substantively and methodologically.

Empowering the disenfranchised

Above I demonstrated the effectiveness of the visual as a tool for empowerment in participatory video projects in developing countries, media education projects in the USA and indigenous media projects. Here I discuss examples of video use in applied projects that are anthropologically informed and led by visual anthropologists.

My first focus is the work of an independent Spanish documentary-making unit A Buen Común, an interdisciplinary team drawing from anthropology and psychotherapy, including the Spanish visual anthropologist Ana Martinez Perez. The basic principles of the unit's work are (Camas et al. 2004) that 'social research should be a form of intervention, rather than methodological practice', which dissolves the 'barrier between researcher and researched', thus making the film's main characters 'full members of the research and film-making process'. Their documentaries focus on issues such as identities in crisis, exclusion, and the loss of work cultures and are initiated through discussions of these issues with the film's

subjects at the 'needs assessment' stage of their first encounters (2004: 132). The request for intervention comes from the film subjects or related organisations, it always involves the participation of film subjects, and it is their interpretation of experiences that the films aim to communicate – 'it is they who should relate their life experience and transmit their knowledge to contribute to the social dynamic that has hereto excluded them' (2004: 133). The resulting films propose to

1 empower those who participate in them, through self-awareness gained in the reflexive process of documentary production; and
2 create a social intervention by 'revealing the hidden' and making explicit the voices and concerns of people who are usually 'invisible' in public forums.

One example of A Buen Común's work is the documentary film *Mujeres Invisibles* (*Invisible Women*), developed through a collaborative project in the city of Córdoba, working with women from marginalised *barrios*, the city council and two grass-roots organisations working towards equality. The film, composed of interviews with women whose experiences 'represent a reality that usually remains hidden or at best forgotten for the comfortable educated consumerist urban middle classes', aims to bring their voices into the public domain (Camas *et al.* 2004). *Mujeres Invisibles* was informed by the work of members of the unit who were involved in it as part of a related project – the 1998–99 *Taller de las Cuatro Estaciones* – a workshop that explored local women's identities, desires and sexuality (Martinez 2000: 28). It represents an anthropological theory of gender diversity that matches with recent anthropological studies of Andalusian gender (Pink 1997, 2004a), which recognise that contrary to previous anthropological constructions of Mediterranean gender as based on a model of honour and shame, there are many ways of being a woman in contemporary Córdoba. The film is therefore embedded in interdisciplinary, applied and anthropological influences. As an ethnographic documentary it departs from the dominant observational style to develop a narrative based on a series of intercut interviews with a series of women who recount aspects of their life experiences centring on themes of motherhood, family, relationships, work, and their survival strategies in adverse circumstances.

It would be impossible to reveal these 'hidden' biographical experiences in an observational documentary, as they rely on memory and self-representation. However, it is clear that each woman who appears in the film is herself the product of the life she tells. As a process the filmmaking achieves one of its social intervention aims, to empower local women through collaborating in the production of a document of self-definition. Moreover, for two of the women who travelled to northern Spain to accompany a screening of the film, it created a chance to be greeted by the local authorities and to speak in public to an audience who applauded them. As a finished product it was used to launch the 2000 Spanish Feminist Association conference, an audience of women who had lived out quite different identities to the women in the film, but who yet called out in unison 'long live the women's struggle' as the screening ended. The interesting point was that it

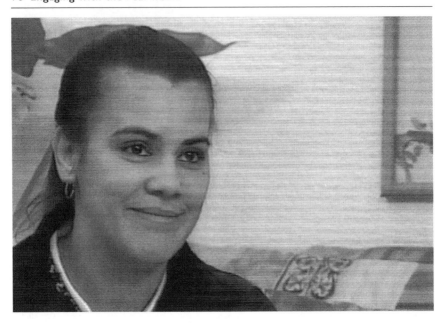

Figure 5.3 Still from the *Mujeres Invisibles* interview, with Amalia.
Source as below.

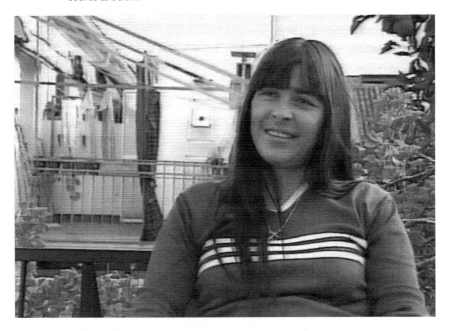

Figure 5.4 Still from the *Mujeres Invisibles* interview, with Carmen.
Reproduced with permission of A Buen Común. *Mujeres Invisibles* was financed by the Junta de Andalucia and the Ayuntamiento de Córdoba, Spain.

was not the experiences portrayed that united these Spanish women of very different class backgrounds, but the notion of a women's struggle (Camas *et al.* 2004: 135). The achievement of *Mujeres Invisibles* was to give a voice to such testimonies in a contemporary feminist context – 'to make visible the lives of some women who do not deserve to be anonymous', not only in Córdoba but in a series of other screenings (Camas *et al.* 2004: 136). As a work in applied visual anthropology *Mujeres Invisibles* is an example of how an ethnographic documentary can bring hidden experiences into a public domain in ways that will intervene both to produce shifts in the lives of those who participated in the film and to highlight issues to concerned audiences. Its inclusion in the Feminist Association Conference signified a level of social inclusion perhaps not achieved previously.

A second example is Jayasinhji Jhala's video work in the aftermath of a 2001 earthquake in western India. Jhala demonstrates how when visual practices and products are anthropologically informed they can produce social interventions, which similar practices with no anthropological component lack. His experience constitutes both an argument for visual anthropological interventions in disaster contexts more generally and a demonstration of how this might be articulated in one specific context. Here I describe just one aspect of Jhala's experience to demonstrate the contribution applied visual anthropology methods can make in a context where relief agencies (of various kinds) also used visual assessment methods to measure damage and relief needed (see Jhala 2004 for a detailed account). Jhala was involved in identifying damage in villages of Surendranagar District. His concern was to intervene to subvert 'the victimization caused by neglect that made [some earthquake] victims invisible' (Jhala 2004: 62). Jhala, like Martinez (above), uses the notion of invisibility. It is by making the hidden visible that interventions are constituted.

Both Jhala and government assessment teams used video to document damage in the villages, using contrasting methods. The government teams consisted of a supervisor with a note pad, a video cameraman, and the supervisor's assistant carrying a measuring tape. The team would first video the head of household standing in front of their home holding a placard with their name. Then the owner would show the inspection team damaged parts of the house. Short clips of damage were shot and sometimes measurements of collapsed walls made (Jhala 2004). Jhala's contrasting method was based on the idea of the 'walk through' from the ethnographic film *Lorang's Way* (MacDougall and MacDougall 1979), similar to my video tour method discussed in chapter 4 and on page 95. Jhala met household heads and had an initial conversation with them in a part of the house they chose (similar to the interviews preceding my video tours), in which he described his purpose to see if the person would agree to document the damage. The owner then walked around the house 'talking as they went, describing what happened on the fateful day'. At the points of damage they faced the camera to report on the damage. Jhala suggests his method had a psychological benefit, in that people were able to tell the story of their earthquake trauma and loss. Moreover, 'property owners were part of the footage and were cinematically attached to the damage they described. They could not be removed from the footage as they were in it', which meant that their damage reports could not

be separated from their claims for support, making data manipulation (which was possible in the government method) difficult. Whereas Jhala's method made victims and damage visible, the government method left space for power relations that would render them invisible (Jhala 2004).

A Buen Común and Jhala both present models of participatory and collaborative video that seek to make the hidden concerns of marginalised people visible. Although they build on theoretical and methodological principles of ethnographic filmmaking and ethnographic research, they simultaneously show how applied visual projects, produced within a circumscribed time frame, innovate to develop methods at variance with the long-term participant observation model. Moreover, they share characteristics with the industry projects outlined above. All ask their video subjects to either become video makers themselves or to collaborate with the video maker to develop *their own* representations of their experiences. The focus on process in the written work I have discussed here also represents an ongoing concern with reflexivity and collaboration that not only permeates the applied visual anthropology literature but also the interdisciplinary approaches to visual methods across the social sciences and humanities that I discussed in chapter 2.

Significantly some of the examples discussed emphasise how applied visual anthropology pays particular attention to sensory experience. In chapters 3 and 4 I outlined the growing interest in a new phenomenological anthropology of the senses and embodiment amongst academic anthropologists and how this poses certain challenges to the idea of a visual anthropology. The same is relevant in contemporary applied visual work. At a panel I convened on Applied Visual Anthropology at the 2004 EASA (European Association of Social Anthropologists) conference, Christina Lammer's written and video work about the experience of interventional radiology, and Paul Basu's discussion of experiences of conflict and the post-conflict context in Sierra Leone both pointed to the embodied and non-visual sensory aspects of these experiences. These phenomenological concerns with experience and the senses permeate both academic and applied visual anthropology, for which they pose similar questions about how to best represent such experience, an issue I follow up in my discussion of anthropological hypermedia in chapter 6.

An engaged visual anthropology

Visual anthropology is a subdiscipline that has enormous potential to be active in the world. Rather than simply producing more anthropology for academic audiences, visual anthropologists have a unique opportunity to communicate across academic disciplines and cultural boundaries. The effectiveness of the visual as a mode of social intervention is well established in historical and interdisciplinary contexts. In this chapter I have demonstrated the effectiveness of making *anthropologically informed* visual interventions.

Yet applied visual anthropology is a practice in its own right and its practitioners develop sets of methods distinct from those of applied and visual anthropologies. It

cannot be tacked on as a development of a pre-existing visual anthropology either chronologically or methodologically. Applied practices have surely influenced the development of academic visual anthropology practices. First, John Collier's applied practice informed the training that was given to all of us who studied his methods text (1986 [1967]). Second, it is likely that ethnographic documentaries such as Granada Television's 1970s and 1980s *Disappearing World* series have influenced academic ethnographic filmmaking practice. Third, my video tour developed for an applied project led me to a method I advocate for academic research. Moreover, while applied visual anthropology doubtlessly draws from visual anthropology methods it is also methodologically distinct. Chalfen and Rich's VIA method is an excellent example that draws from visual, applied, medical and media anthropology (2004), and Sperschneider and Bagger's 'design-in-context' (2003) similarly exhibits characteristics of participatory visual anthropology (giving informants the camera, asking them to film their worlds, and collaborating with them to view their everyday workspaces), but draws from models developed outside anthropology. Likewise, the filmmaking practices of A Buen Común are based on principles developed by its interdisciplinary team, combining perspectives from visual anthropology, psychotherapy and applied anthropology. Indeed, Drazin has pointed out often 'Applied anthropologists ... need to work alongside other research professionals, and with very un-anthropological perspectives, if they are to further the interests of anthropology as a profession' (2005). Therefore, applied engagements of visual anthropology involve not only visually informed or oriented social interventions but also usually a series of other elements that might include:

1 engaging with an interdisciplinary context of applied research;
2 researching, collaboratively or in a participatory design, other people's experience as they narrate and/or show and perform it;
3 representing this experience in ways that are framed culturally and institutionally to try to give the target audience a sense of it that is in a familiar 'language' but simultaneously causes them to stand back from their existing knowledge and experience to understand new forms; and
4 ideally also both drawing from and contributing to academic mainstream visual anthropology theoretically, methodologically and substantively.

Applied visual anthropology has something of its own 'history', although until this history is made visible, or verbalised, it will not serve as a reference point, archive of good practice, or identity-forming myth for a 'community' of applied visual anthropologists. Applied visual anthropologists have tended to work in isolation from one another and from a 'community' of visual anthropologists within which they might share practice, and little of their work has been published. The distinctive identity I suggest for applied visual anthropology here is constructed through my interpretation of existing work. I return to the significance of this for the future of visual anthropology in chapter 7 to discuss the public responsibility of anthropologists.

Part IV

Visual anthropology and digital technologies

Chapter 6

Visual anthropology and hypermedia

Towards conversing anthropologically

In recent years it has become clear that the future of visual anthropology depends partly on how its practitioners engage with new visual and digital media and technologies. In chapters 4 and 5 I suggested that hypermedia provides one way to create a visual anthropology that converses with and participates in existing written academic and applied anthropology. Hypermedia can combine written theoretical, descriptive, pedagogical and applied anthropology narratives with reflexive audiovisual and photographic representations of knowledge and experience that can only be communicated (audio)visually. It also allows visual ethnographic materials to be framed in ways that are meaningful for their target audiences. Combining the benefits and strategies of written and (audio)visual forms of anthropological communication creates texts that can reference and thus converse with existing bodies of knowledge and debate pertaining to different areas of written anthropology, visual anthropology or applied contexts. It invites a visual anthropology for the twenty-first century that is both influenced by and influences the development of written anthropology, and simultaneously departs from and references existing textual forms. Similar principles apply to the use of hypermedia in applied visual anthropology. Here, where project reports have tended to be word-based, hypermedia reporting and dissemination can integrate visual knowledge into a communication medium that is framed verbally in the institutional or community based 'language' that is meaningful and relevant to its audience.

In my book *Doing Visual Ethnography* (2001a) I outlined a theoretical and practical agenda for anthropological hypermedia.[1] By then the idea of anthropological hypermedia was already established. In fact Seaman and Williams had predicted that by the beginning of the twenty-first century 'new ethnographic genres will develop to use hypermedia technology' (1992: 310), but 'the best hypermedia ethnographies will be a fluid mix of sound, image and text constructed in such a way to take advantage of its strongest features' (1992: 308). Peter Biella's *Maasai Interactive* was being developed during the 1990s (Biella 1993a) and was used as a template for Gary Seaman's design for *Yanomamö Interactive: The Ax Fight* (1997) – a didactic CD-ROM and book package developed by Biella, Gary Seaman and Napoleon Chagnon based on Tim Asch and Chagnon's film *The Ax Fight* and Chagnon's written ethnography. Since then leading visual anthropologists have increasingly suggested a new

hypermedia visual anthropology (including Biella 2004; Henley 2004; Ruby 2001) and recent innovations in anthropological hypermedia are beginning to suggest the forms this genre might take. In this chapter I explore the implications of this for the relationship between visual and written anthropology in academic and applied visual anthropology in the twenty-first century.

Hypermedia, books and film: continuities, conversations and differences

In this section I review contemporary and historical approaches to the relationship between hypermedia, written text and film to clarify how we might identify on the one hand continuities and 'conversations' between them, and on the other distinguish their differential potentials for anthropological communication and concomitant limitations. Through this I demonstrate why hypermedia can 'converse anthropologically'.

In an article about the precursors of today's digital media Simon Cook[2] argues that new media designs have not developed from the linear narrative of cinematic forms, but have their origins in the late-nineteenth-century visual archive. He identifies 'a shared database form ... behind much of the apparent diversity of today's electronic forms of word and image' (2004: 60),[3] which has continuities with the late-nineteenth-century scientific book. This form combined written words, 'objective' visual images that were usually machine-rendered and graphs (2004: 63) in a textual form that crafted 'a universal form of *self*-classification through compartmentalizing the whole body of the book into main text, contents, index, footnotes and bibliography' (2004: 62) and included visual and written database technology (2004: 63). The strategies by which images and written text were organised in these early books are to some extent mechanised in the construction of contemporary digital database type media (such as web pages), in the form of 'the visual navigation strategies embedded into contemporary computer applications, such as site maps, scrolling pages, desktop icons, and so forth'. In this context Cook resituates cinema as one of many possible outcomes of the late-nineteenth-century visual archive, from which other new media can also be understood to have emerged (2004: 70). This analysis of digital hypermedia as a related but alternative technology to film, itself emergent from a historically rooted multimedia form rather than the chronological outcome of the application of cinematic models to new media, can also be used to conceptualise the relationship between ethnographic film and anthropological hypermedia. Cook's analysis also indicates some key commonalities between the academic book and hypermedia, which I explore below.

A dominant way of contrasting film with written text and digital hypermedia has involved emphasising the linearity of film in relation to the multilinear potential of books and hypermedia (see Pink 2001a). Books can function as multilinear texts – they are not necessarily read linearly from front to back cover and their database structure facilitates, through index and contents pages and footnotes, non-linear access to compartments and themes of knowledge. Rod Coover, a documentary artist whose work references ethnographic and anthropological approaches, suggests other

continuities. In a printed essay that combines image and word (2004b) to represent his CD-ROM *Cultures in Webs* (reviewed on page 120) Coover proposes that the article evokes 'the hypermedia reading experience [in printed text] by interweaving photographs, text, interview excerpts and proverbs to suggest how relationships between visual and verbal referents evolve in the cultural imaginary' (2004b: 7). Coover turned from documentary film to hypermedia to avoid working linearly for two main reasons: first, because in his multi-sited ethnography 'materials gathered in different media through diverse methods, modes and cultural perspectives may not easily fit into a single model of representation' (2004b: 8); second, because a linear representation would lose the juxtapositions he saw in local Ghanaian uses of foreign words and imagery, which were added to 'flags, trotos and minibuses, taxis, boats and building walls'. In contrast, using hypermedia he could include 'material surrounding, associated with or commentary upon a primary narrative ... through montage, rollovers and links' (2004b: 14). These approaches emphasise the commonalities between print and hypermedia texts. However hypermedia can actually have structures in common with both print and film media, and as such have referents in each as Coover's hypermedia practice demonstrates. 'Montage Metaphors and Worldmaking' is a critical digital essay about film that forms one of the three narratives of Coover's CD-ROM *Cultures in Webs* (2003). Here Coover analyses three ethnographic films – Gardener's *Forests of Bliss*, Monnikendam's *Mother Dao The Turtlelike* and Trinh's *Naked Spaces* – suggesting their fragmenting editing styles break linear forms to anticipate 'the multi-linear worldmaking available to digital media documentarists'.

These commentaries suggest that although commonalities and differences between film, writing and hypermedia can be identified it is incorrect to essentialise these relationships. There are many types of film and written narrative, and in this sense the distinctions and similarities between film, writing and hypermedia will sometimes be finer than in others. While audiences cannot have the interactive control over film narratives that allows them to explore the multiple narratives film montage might imply, this technique can offer hypermedia artists a model for non-linear hypermedia innovations. Similarly, the continuities between written and hypermedia text ought not be treated as an essential likeness. Hypermedia forms also depart from structures used to create printed books, and these might be perceived both in terms of author experience as well as the structure of the text itself. For example, Ruby (2004), reflecting on the production of his *Taylor Family* CD-ROM, notes how 'I found writing in a nonlinear fashion to be amazingly freeing. I did not have to worry about some editor telling me that I was going off on too many tangents and that the work lacked coherence'. Although written text has potential for database access and non-linear reading, it is still necessarily constructed as chunks of linear narrative, that according to academic writing conventions tend to be of between 6,000 to 8,000 words long. Footnotes can contain some tangential information, but do not, as Ruby points out, permit the freedom digital hypermedia allows. The multilinear potential of hypermedia can thus be seen as both a departure from and a referent to existing film and writing styles. Its virtue is that hypermedia can combine different database and other forms

of access and narrative structures, and as such take these in new directions, as we shall see in the projects discussed below.

Hypermedia has the capacity (depending on how it is authored) to reflect, imitate and deconstruct aspects of different genres of anthropological film and writing. By focusing on the continuities between anthropological hypermedia and ethnographic film and writing we can explore the potential of hypermedia to 'converse' with filmic and written anthropologies. By this I mean our ability as anthropological hypermedia authors to construct referents, maybe to montage, to forms of visual juxtaposition, ordering of images, structures of written argument and debate and other strategies that coincide with different styles of film editing and anthropological writing. Therefore it is through our understanding of how film communicates that we might harness some of its qualities for reproduction in hypermedia. There are various ways to do this, which I noted above, and that can be combined in the same text. First, as Coover suggested, to imitate editing styles when constructing hypermedia pages. Second, as I suggested in chapter 4, to imitate existing film genres in the video clips that are presented within a hypermedia text. This strategy should facilitate the production of hypermedia texts that are conversant with existing discourses and styles in ethnographic film. In chapters 3 and 4 I suggested that such texts could incorporate the deep reflexivity and ability of participatory observational film to communicate transculturally, which MacDougall (1998) has advocated. Hypermedia might also, as Coover (2003) suggested, imitate montage and juxtaposition in other ethnographic film genres.

However, the advantage of hypermedia is that it does not permit this at the expense of communicating on the terms of mainstream written anthropology. There are important historical and contemporary continuities between uses of written words and still images in printed academic materials and hypermedia. These might be represented through the structure of the text, reflecting the database and archival models that inform how (even some of the most experimental) written anthropological texts are constructed (Clifford and Marcus's (1986) *Writing Culture* has an index, contents page, bibliography, and notes on contributors). Existing printed forms might also be reflected in writing styles and participation in existing discussions of theoretical, methodological and substantive issues that are direct referents to existing written texts.

Because these continuities between anthropological hypermedia, writing and film exist, hypermedia texts can reference existing anthropological texts and as such participate in and comment on the discourses and narratives they present. This is the essence of the notion of 'conversing anthropologically': the idea of producing new texts in hypermedia form that both draw from and communicate with and about existing texts in multiple ways. In this chapter I build on this notion to review selected existing projects in anthropological hypermedia emerging from academic and applied visual anthropology and related disciplines. The issues I explore reflect the wider concerns of this book, including: how each hypermedia project references and departs from written and filmic anthropology; its ability to converse anthropologically; and how each succeeds in representing other people's experiences through a combination of written and audiovisual media.

The analysis below also accounts for the three stages that visual researchers have identified as essential to visual analysis: production, content and the context of consumption (see chapter 1). The projects discussed below reveal various production processes and relationships that involve different configurations of individuals and institutions. Content and design are also important elements in the way hypermedia representations communicate about experience and theory, and much of my discussion below focuses on strategies used to achieve this. The context of consumption is of equal significance. I cannot report on the reception of these projects, but when possible I draw from authors' reports on how their work has been received and on its impact.

Visual anthropologists and hypermedia: recent developments

In this section I review two hypermedia CD-ROM projects developed from and intending to represent visual research and knowledge for anthropological purposes.

Yanomamö Interactive: The Ax Fight (1997) is an interactive CD-ROM and study guide by Peter Biella, Gary Seaman and Napoleon Chagnon. The printed study guide comprises

1 Chagnon's introduction to Yanomamö ethnography for the diverse audiences of anthropology students, non-didactic anthropological uses and 'non-anthropological' users; and
2 Seaman and Biella's CD-ROM user guide.

The CD-ROM 'explores an incident of structured, limited violence that took place in a Venezuelan Yanomamö village in 1971'. It is centred on Chagnon and Asch's *The Ax Fight*, a unique didactic ethnographic film that reveals how ethnographic understandings emerge in fieldwork situations (Nichols 2004: 236) and, using an explanatory structure to challenge the truth claims of the expository narrative common to observational ethnographic film (Nichols 2004: 231–2), raises anthropological issues about ethnographic and filmmaking methodologies. The CD contains interlinked resources (photographs, historical, descriptive and analytical texts, biographical details of 51 people, kinship diagrams, maps, figures and charts). Its new perspective on *The Ax Fight* reconsiders the questions the film posed and invites the user to explore additional data about Yanomamö culture and society (Biella *et al.* 1997: 37). *Yanomamö Interactive* also reflects *The Ax Fight*'s concern with the repeated analysis of film footage – which hypermedia technology facilitates (Biella 2004: 244). Thus a pedagogical model developed initially in a film supported by written texts is adapted to benefit from characteristics specific to hypermedia. The multimedia format also integrates the film's own reflexivity with anthropological theory. It 'converses anthropologically' by inviting users to engage in theoretical controversies specific to Chagnon's work on the Yanomamö, by reading theoretical texts and analysing the visual data all interlinked on the CD.[4] Biella points out how ethnographic film has not always been taken seriously

because it 'resists' scholarship in that, although it can document and interpret 'non-recurrent empirical observations', it is hard to separate these from the film-maker's interpretations. He suggests that interactive hypermedia resolves this by integrating scholarship into the use of film through 'Non-linear links to texts [which] release interpretation and open ethnographic film more fully to the search for new meaning' (Biella 2004: 257–8). *Yanomamö Interactive* achieves this partly through its layout into a screen divided into four interlinked sections that show *The Ax Fight* film and/or related footage, genealogies, individual biographical data and photos, and scrollable written text documents. The materials and the hyperlink relationships constructed between them are extensive and complex. It has an explicitly encyclopaedic database structure, which invites users to look up cross-referenced material via links and thus realise relationships between filmic, photographic, diagrammatic and written theoretical, methodological and descriptive materials. Through its didactic narrative it integrates and establishes a conversation between written and visual anthropologies. Indeed, the interdependency between audiovisual representation and written words is at the centre of its message as it demonstrates the incompleteness of film and writing as separate representational genres.

While *Yanomamö Interactive* situates the individual within complex relationships and motivations as part of an event (for example through individual profiles) it does not represent the voices of individual Yanomamö involved. While some degree of collaboration was necessary to make the film at all, it might be classified as an observational film, rather than as a participatory project where Yanomamö individuals represented their own experiences. In fact the CD-ROM focuses more concretely on the anthropologists' experience, exploring how anthropologists might retrospectively interpret visually confusing footage. Wilton Martinez's (2004) discussion of student interpretations of *The Ax Fight* shows how, basing their understandings on known stereotypes students also tended to feel distant from the Yanomamö as individuals (for example 2004: 222–3). It is yet to be reported if the CD-ROM, by linking the film with anthropological theory and revealing personal profiles and motivations of Yanomamö, will overcome this by offering students a closer anthropological appreciation of the footage and understanding of the experience of individual Yanomamö.

Jay Ruby's (2004) CD-ROM, *The Taylor Family*, is part of his *Oak Park Stories* series. This CD-ROM is a multimedia portrait of the Taylors, an African-American family living in Oak Park, the North American community or neighbourhood that is Ruby's field site (and birthplace). In the introductory page of the CD-ROM Ruby describes the project:

> *Oak Park Stories* is a series of experimental, reflexive and digital ethnographies that attempts to explore a forty-year-old social experiment in Oak Park, a Chicago suburb. It is experimental in that I have not followed the traditional method of producing a book or a film but instead made an interactive and nonlinear work that has both video and text.

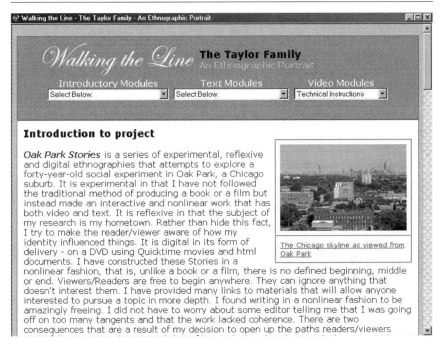

Figure 6.1 Jay Ruby's *The Taylor Family*. Introductory page.
© Jay Ruby. Reproduced with permission of Jay Ruby.

The hypermedia project is structured around three main narratives of introductory, text and video modules, indicated in a navigation bar running along the top of the page, and is present throughout the project (except the video pages). The navigation bar offers three corresponding drop-down menus so users can move easily between different sections of the text at any time while viewing the CD. Ruby's project offers a user experience that allows freedom to browse and explore the categories of information the project contains and to follow the hyperlinks that are created within narratives to connect different texts at appropriate points. The written texts are clearly presented in a font that is easy on the eye facilitating reading on screen.

Ruby emphasises there is 'no defined beginning, middle or end', which in itself guides the viewer to a certain pattern of use, although one might follow the order of the links provided. Ruby's project engages its user with written, photographic and video texts. It achieves the aim of being an *anthropological* hypermedia text by virtue of interlinking these texts and the meanings they communicate both with each other and with a wider existing literature. In a section called 'Anthropological implications of the project' Ruby engages, through written text, with existing anthropological literature to situate his work theoretically and as a contribution to existing anthropological knowledge. In doing so he establishes a conversation between his text and existing written texts that discuss themes such as suburbia and reflexivity in anthropology. In the section on 'Integration', composed of written

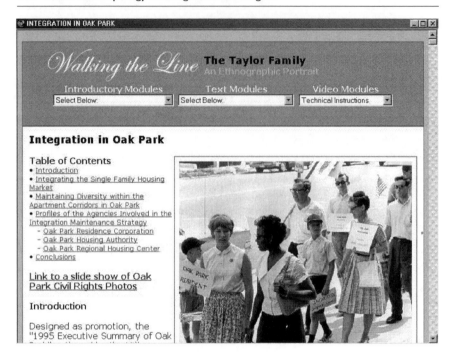

Figure 6.2 Jay Ruby's *The Taylor Family*. The 'Integration in Oak Park' page contains details of campaigns, changing policy and Ruby's commentary. It presents both photographic and written versions of this history and experience.
© Jay Ruby. Reproduced with permission of Jay Ruby.

text, links to relevant documents and articles and photographic images, he reflects the process of integration and its meaning and thus on the applied potential of such research, to ask if the model of racial integration presented by the Oak Park experience provides lessons for other communities. In this way Ruby situates the project using a very effective medium – written words. In all but the more theoretical text, words are combined with photographs to communicate about a range of issues that are fundamentally anthropological but are also of interdisciplinary interest (for example linking to sociology of suburbia and the interdisciplinary concern with reflexivity discussed in chapter 1), and are relevant beyond the academy in public policy and applied anthropology. Although they benefit from containing references and links to a far wider range of resources and links both within the text and online, in their style and organisation these texts also reference and imitate conventional written texts, making them accessible to and able to participate in the debates of the academic and policy communities whose interest they might stimulate.

These and other introductory modules provide a wider context of the Oak Park story and racial integration from which users can understand the personal stories and experiences of the Taylor family, who are represented in the text and video modules. Other texts combine Ruby's writing, photographs and links to media

representations and local people's writing to represent the history of African-Americans in Chicago and in Oak Park, the situation of middle-class African-Americans and to 'the achievement gap' in White and African-American education. Here Ruby again combines different styles of written text with photographs to create histories that are simultaneously personal and general.

In the video module section users meet the Taylor family themselves. This drop-down menu leads to four videotexts: an introduction to the Taylor family; the stories of the parents, Yolanda and Craig; and an epilogue. The videos are linear texts that users can nevertheless stop and start and scroll back and forward and which by replicating some multimedia properties themselves, reference hypermedia forms. The Introduction demonstrates this well. Referencing a self-conscious reflexive ethnographic film style, it begins with Ruby's own voice explaining to the Taylors (on camera) how he will 'use' them in this project, as an example of an African-American middle-class family, and discussing with them how they feel about this.[5] Using long takes, virtually unedited, this and the other videos use linear narrative devices to guide the viewer through their stories, which contrasts with the navigational freedom users experience when moving through the written and photographic texts discussed above. After the reflexive introduction the video screen cuts to a written text where Ruby explains his lack of video-making experience and the unprofessional nature of the footage with its background noise, lighting, and so on. Although I did not find the technical limitations restricting, this text is significant as it guides the viewer to what is important about the video; to hear and see the Taylors express their stories themselves, and to learn about what matters to them, their values and their priorities. This scrolling text is followed by a slide show of Taylor family photographs contextualised by information cards. The next section returns to an interview with the Taylors. They now sit at a table viewing and discussing a selection they have made of their family photographs on a laptop. This footage is intercut with stills of the photographs discussed. This (and the other videos) brings the research context to the fore, reflexively representing how knowledge was produced and revealing how informant-selected family photography constituted a narrative structure for the interviews, which was in turn a vehicle through which the Taylors constructed their memories and biographies. The videos demonstrate this process as it occurred in a context of intersubjectivity. The Introduction ends with another scrolling written commentary that situates the video in relation to both the Taylors' own biographical experience up to their moving into Oak Park and the general context represented in the CD-ROM.

As Ruby states, 'THIS IS NOT A MOVIE'. The videos of The Taylor Family depart from ethnographic film conventions in a number of ways. First, they reveal the video research methodology to reflexively insert the research process into the medium of representation. Second, in a way similar to those ethnographic films that are successfully interview-based, the interview format of Ruby's research is contrary to the observational ethnographic filmmaking process that Henley (2000) equates with participant observation. As I suggested in chapter 4, our definitions of ethnographic filmmaking needs to be extended to encompass contemporary research contexts where anthropological research departs from 'traditional' subject matter and methodologies to explore collaboratively life

histories or everyday lives in modern western domestic contexts. Ruby's use of video pertains to a practice that is increasingly prevalent in (visual) anthropology in the twenty-first century – where the camera is an aspect of our collaborations and representations rather than serving primarily as a filmmaking instrument. The structure and editing style of Ruby's videos also constitute an interesting challenge to observational documentary. The videos combine multiple media in an authored linear narrative that guides the viewer. In doing so the videos themselves imitate the multimedia format of the hypermedia text, by taking us from written scrolling text, to photographic slide shows, to reflexive shots of conversation or of informant's self-representations, yet this occurs with more authorial control than is imposed by the drop-down menus of the printed text and photographic pages. In this sense the use of video is more fully integrated into and cross-references the multimedia format. As I discussed in chapter 3, observational cinema styles do not accommodate narrative breaks to insert text and cross-referencing in this way; Ruby's hypermedia videos offer one alternative to these existing forms.

Finally, what does *The Taylor Family* CD-ROM communicate about other people's experience? And how does it achieve this? As Ruby states, he is not interested in constructing grand narratives. Rather, he shows how personal and family narratives lived in a particular locality are situated within historical and contemporary, sociocultural and political contexts. Experience is represented as collective (that is, the experience of African-Americans of particular generations and in particular political and historical circumstances) and as personal (as expressed in the Taylors' individual biographies). We do not witness life as it was experienced, in the form of cultural displays, performances, enactments of everyday activities and behaviours. In this sense the experiences we learn about are undoubtedly experiences that have been defined and are in fact redefined through the process of telling them. In the videos we do witness research as it was experienced and therefore are able to reflect anthropologically on the processes by which past experiences and memories are (re)defined and constituted through the research act.

Yanomamö Interactive and *The Taylor Family* are very different in their intentions, styles of presentation and levels of financial investment. *Yanomamö Interactive* is a didactic text, with an encyclopaedic database structure that is designed to engage anthropology students and non-anthropological users. Its production was a collaborative effort, developed by Seaman and Biella's design, then re-designed in Multimedia Director software by commercial multimedia designers financed by the publisher (Harper 2004: 114). The interface for Jay Ruby's *The Taylor Family* was provided by a company, BIRKEY.COM,[6] who worked with Ruby. *Yanomamö Interactive* is published by Thompson Learning and retails at approximately $30.[7] *The Taylor Family* (based on research funded by University and funding board support) will be published by Documentary Educational Resources (DER) in the USA. A more extreme contrast is a DVD version of Robert Gardener's ethnographic film *Dead Birds* distributed by DER to institutions at $295.[8] These differences must not be understood in terms of the anthropological contribution of each project, but rather with reference both to the market forces that drive academic publishing and distribution and to the availability of institutional and research council funding.

Each CD-ROM also uses video to communicate differently about social experience. Whereas *Yanomamö Interactive* employs event-based interactive materials and anthropological analysis, *The Taylor Family* explores one family's biographical experiences within a wider social, political and historical context. While *Yanomamö Interactive* provides a database of biographical information about individuals viewed at a distance in the film, and comments on their possible motivations for participating in the fight, *The Taylor Family* presents detailed video interviews with two informants who self-consciously represent their own lives in their own words and photographs. Both the CD-ROMs use video/film to reflexively bring the research encounter to the fore. In *The Taylor Family* Ruby discusses the research process on video with his informants and makes his own role explicit. In *The Ax Fight*, to a black screen, we hear Asch and Chagnon discuss events that led to the fight, to learn how Chagnon's earlier assumptions are questioned. In addition, one of *Yanomamö Interactive*'s written texts describes the fieldwork encounter and filmmaking experience. These CD-ROMs are anthropological texts that communicate ethnographically, theoretically and methodologically and engage with concerns that go beyond those of visual anthropology. They participate in the mainstream as didactic or research texts, and in different ways converse anthropologically as ethnographic film cannot.

Hypermedia in applied visual anthropology

Parallel to the academic hypermedia projects discussed above are recent developments in applied visual anthropology. Academic and applied visual anthropological hypermedia representations have different goals. The reporting process and target audience of applied projects require that knowledge and experience be presented in frames that communicate to different institutional contexts and audiences. To my knowledge such projects have been developed in business (below) and in didactical medical contexts for training clinicians (see Chalfen and Rich 2004). Below I discuss two applied uses of hypermedia, a series of CD-ROMs I produced with Unilever Research in Britain, and an online project developed at Microsoft in the USA.

In the case study in chapter 4 I discussed my study of gender in the sensory home, which, like my applied video ethnography outlined in chapter 5, began life as applied consumer ethnography. Before developing the academic CD-ROM projects *Gender at Home* and *Women's Worlds* discussed in chapter 4, I produced a series of hypermedia representations as part of the reporting and dissemination activities I developed with Unilever that I discuss here.[9] Having produced a written report and summary CD-ROM, I was invited to propose further dissemination projects based on the 40 hours of video data and we decided on two projects. The first was to produce a documentary video about 'living alone' to represent consumers' homes, practices and feelings to an audience of Unilever researchers composed of both social scientists, and chemists and scientists from cognate disciplines involved in product development. To produce the documentary I worked with Unilever researchers and editors and a freelance scriptwriter. With my training in ethnographic documentary-making, I had some ideas about how the documentary might bring out the 'voices' of the subjects of the videos, and

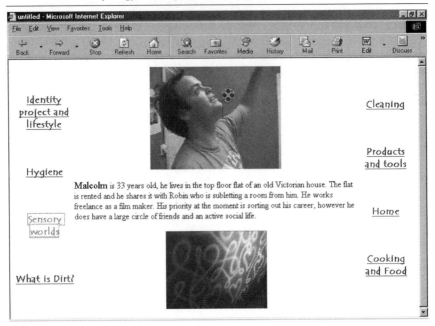

Figures 6.3 Screen captures from a CD-ROM based on my interview with Malcolm, one of the 'Cleaning, Homes and Lifestyles' informants. These screens use video and still images in combination with written ethnographic data to represent lives and homes.

The Project of Home · The Meaning of Home · Sensory Aspects of Home · Renting or Owning a Home · Use of Rooms in the Home · Changing the Home

Changing the home

Apart from furnishing his home, Malcolm has also changed it by **decorating** it. Not much planning has gone into the decorating Malcolm has done as he has simply used paint that he has available. Usually the paint has been salvaged from a job he's worked on

Figures 6.3 continued

selected the footage accordingly. Simultaneously, the video needed to be framed and structured by voiceover and through editing techniques to make both the information it communicated and its presentation style appropriate and useful to its intended audience. Second, I produced a series of ten CD-ROMS, each featuring one informant. One aim was, by delving deeper into the lives of individuals, to give Unilever researchers a deeper understanding of how their consumers experienced their lives and homes. Structured by the key themes of the research, each CD-ROM introduced its user to the home, identity, and everyday experiences and practices of an individual consumer. These themes were represented using a combination of still images, video clips and a limited amount of written text, a format intended to make the CD-ROMs interesting, appealing and easy for people to dip in and out of on their PCs during a busy work schedule. By combining images and text in this way I presented snippets of ethnographic data and real people's experiences in a way that was made meaningful and useful through its relationship to written text – in short, allowing the consumer to speak within a frame that made some sense and was relevant to the people who were interested in what she or he had to tell.

Tracey Lovejoy and Nelle Steele work as ethnographers for Microsoft. They describe the purpose of their work as to 'observe people across various demographics, and then integrate the behaviors, practices, needs and issues that emerge during fieldwork into the design and implementation of Microsoft products' (Steele and Lovejoy 2004: 71). Working in a product development context, they are concerned with how knowledge is produced and consumed, stressing how the

1 Import and arrange your pictures

2 Record your story

3 Add a title page

4 Add music and preview your story

5 Select quality settings for your story

6 Save your story and project

Figure 6.4 Tracey Lovejoy and Nelle Steele's Photo Story project. The software interface as the anthropologists saw it when they constructed their pages.
Windows® XP; Microsoft® Plus! Photo Story. ©2004 Microsoft Corporation All Rights Reserved.

Figure 6.5 Tracey Lovejoy and Nelle Steele's Photo Story project. The web pages as their colleagues saw them when they logged on to engage with the project: 'Consumption on a web site'.
Windows® XP; Microsoft® Plus! Photo Story; Microsoft® SharePoint™; Microsoft® Internet Explorer. ©2004 Microsoft Corporation. All rights reserved.

'consumption of knowledge isn't a singular event; it unfolds over time as a dialogue among us, our product team colleagues, and participants, and this is where the key transformations happen that will impact the product'. In their (2004) article they describe their visual ethnographic fieldwork about technology in Brazil, which included participants showing them their technology, day-long observations with each family member, and 'in-context' and semi-structured interviews and diaries. To record this they combined hand-written notes, digital photos and video. Their representation of this work to colleagues was an ongoing process, via the Microsoft Intranet. Using new software – Microsoft® Plus! Photo Story – they developed a hypermedia project that sought to bring their colleagues closer to the research participants' everyday experiences

> ... each day in the field we moved our photos from our digital cameras to our laptops, and then went through our hand-written notes and photographs and pulled together a short, narrated 'slide show' (sometimes adding music or quotes from participants pulled from video) that was posted by a colleague on an intranet site other employees could visit. For those who wanted more detail, each Photo Story had an accompanying text blog, or web log, which added depth and richness to the images and voice annotation they saw and heard.

While no single participant can be held up as a representation of all Brazilians, we were able to incorporate information from the literature & statistical data reviews conducted previous to our study to help present a broader perspective of life within Brazil.

This method of representation was highly successful in engaging Microsoft employees with the research. Steele and Lovejoy attribute its success to the relationship between the technology used, the context (in other words, the working environment) and content. First, viewers (themselves interested in technology) 'weren't compelled to consume the data in a single fashion, nor were they compelled to consume it in a linear way'; rather, they could dip in and out of the different types of visual or verbal text as and when they wished. Second, life in Brazil was 'exotic' for the majority of the audience. Third, Steele and Lovejoy ensured viewers' engagements were interactive, replying to every e-mail sent regarding the work.

Both these commercial projects aimed to bring corporate employees closer to consumers' everyday experiences, to offer them privileged ethnographic insights into others' experiences and practices and the individual, biographical and cultural meanings of these. The hypermedia projects achieved this partly by placing the individual at the centre of the analysis, represented through a mix of audiovisual, photographic and written materials providing both context and description. While my Unilever CDs took each individual as one project, Steel and Lovejoy formed a continuous narrative that followed different individuals in 'real time' as they posted new materials on a daily basis. One idea informing these practices of representation is to introduce one set of people to the lives of another, who are different from them, by creating greater proximity. This involves a form of cultural brokerage (Chalfen and Rich 2004) typical of applied anthropology that frames the strange with familiar language to provide a starting point from which to challenge existing assumptions in an accessible form. This approach also harnesses the potential of film and photography to bring informants' own self-representations to the fore – their words, gestures and performances, which cannot be communicated in written description – to encourage empathetic understandings from the viewer. To successfully tell the story of how particular products and practices are engaged by particular individuals in specific (cultural) contexts it needs to encompass both commonalities and differences and to frame this with the appropriate institutional categories.

The interdisciplinary context

Ethnographic hypermedia projects are not limited to anthropology and in this section I extend the discussion to the interdisciplinary context to look at two ethnographic CD-ROMs that represent anthropology's common interests with arts practice and social policy.

Rod Coover's *Cultures in Webs* CD-ROM project has three narratives. The first is an essay on ethnographic documentary practice and hypermedia, the second is based on Coover's documentary photography in France and the third on his documentary

video in Ghana. In a short printed introduction to the CD-ROM, Lucien Taylor has treated this project as a form of visual anthropology, going as far as to suggest that *Cultures in Webs* 'in many ways adumbrates an interactive sensory anthropology of the future' (2003: 3). Here I analyse *Cultures in Webs* to suggest that

1 it is better seen as a related genre that has developed within a wider context of hypermedia development influenced by anthropological concerns;
2 although it represents some aspects of sensory experience a sensory hypermedia anthropology would require a fuller anthropological engagement; but
3 the value of *Cultures in Webs* as an example of ethnographic hypermedia prac- tice lies in Coover's use of aesthetics to communicate about themes of anthro- pological interest.

Taylor (following MacDougall 1998) bases his argument on the idea that film and video communicate synaesthetically. The visual evokes taste, feel and sound to imply that which is not visible, creating an interplay between different dimensions of sensory experience, that combined with the interaction between linguistic and visual signification is essential to how linear film/video communicates. This interplay, he suggests 'arguably comes to *constitute* the signifying system of interactive hypermedia' (original italics), because 'the plentitude of the human sensorium and of practices of symbolization are no longer exclusively evoked through media acting on one or two truncated human senses, teetering between two- and three-dimensionality', rather in hypermedia this is possible because language, imagery and sound (of different types) all 'rub shoulders with each other literally as elements of the work itself' (2003: 2). In chapter 3 I argued that although ethnographic film or video can communicate sensory experience synaesthetically, and through symbol and metaphor, this is limited by its failure to situate these experiences culturally and theoretically. Here I similarly argue that for hypermedia to communicate anthropologically about sensory experience, written, audio and visual texts need to do more than 'rub shoulders' as they evoke experience, but rather to more self-consciously construct contexts though which it can be comprehended.

One narrative of the CD-ROM, 'Concealed Narratives', is composed of a series of video fragments that form the narrative of Coover's research trip in Ghana. Most pages are composed of a background image, some written text and video clips or still images.

The page shown in figure 6.6 has a background still audience image while a section of written text describes the context of Coover's joining a national music survey project in Ghana. Below the text is a video screen that opens with the page. The video begins to play with no sound, then synchronous sound is first introduced, but next the sound continues with a series of freeze-frame images of the singers. Here Coover emphasises in turn different elements (visual and sound) of the sensory experience of the performance. By separating elements of an integrated sensory experience this page comments on the relationship between vision and sound, persuading the user to focus on different elements in isolation. But how

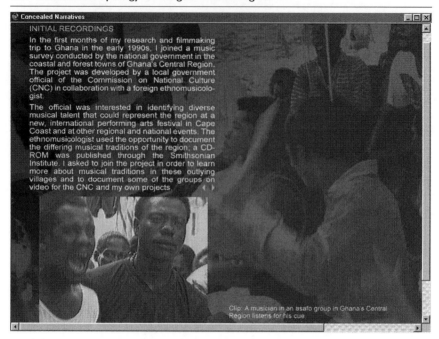

Figure 6.6 Rod Coover's *Cultures in Webs*. The third page of this narrative is exemplary in its combination of writing, sound, and still and moving image.
© Rod Coover. Reproduced with permission of Rod Coover.

might this anticipate 'an interactive sensory anthropology of the future'? Coover's written focus is on ethnomusicology and filmmaking and makes no mention of other senses. If by a sensory anthropology one refers to anthropological representations that deliberately emphasise that sound and vision are components or 'fragments' of experience (a term Coover uses to describe the units of experience hypermedia draws together), then Coover's strategies achieve this. But if, as I suggest in chapters 3 and 4, a sensory anthropology involves an engagement with sensory perception that is both theoretical and ethnographic, and that engages not just with cultural constructs of the sensorium but also with individual sensory biographies and experience, then Taylor's claims cannot be justified. 'Concealed Narratives' does not engage analytically or theoretically with sensory experience. Rather Coover's attention to the visual and aural aspects of performance are exemplary because they exploit the multimedia potential of hypermedia to invite users to engage with the video representation of the performance from new visual, audio and linguistic perspectives.

Rather than heralded as a new visual *anthropology*, this CD-ROM is better situated as an example of how written, audio and visual materials can be combined to construct meanings. One example is on the fifth page of 'Concealed Narratives'. Here, a still image is the background to a written text that describes how different performing groups of musicians compete for space and discusses the ironic

symbolism of their using ex-colonial spaces for their performances. The following page elaborates on the context of the performances and filming. Written words to the background of a still image describe the context of local political tension in which the video was recorded. Here written words represent what is not visible or audible in the audio and visual representations of this event because 'beneath the surface of the performance was a palpable tension not captured by the recording'. At times the visual can imply that which is not visible, in other instances written words are needed to make explicit what would be hidden in an audiovisual representation.

Next Coover's narrative jumps to a harvest festival. Here video interviews allow local chiefs to describe the festival events in their own words, accompanied by written contextualisation and background photographs while wild sound in the videos also provides a sense of location (figure 6.7).

These pages of audiovisual excess followed by pages with the absence of video force the user to attend to different aspects of the performance, and thus to experience it differently, before taking us back to the words of a chief in an interview and some written contextualisation on the following page.

Coover's beautifully produced project succeeds in its aim to represent the political and symbolic aspects of performance in Ghana. With its combination of

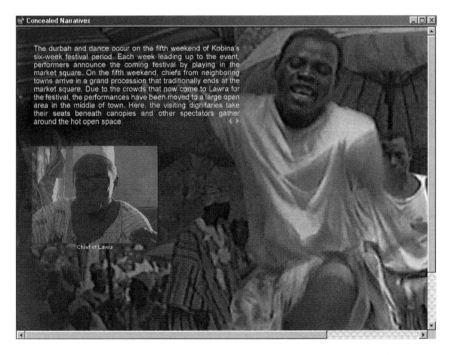

Figure 6.7 Rod Coover's *Cultures in Webs*. An interview with a chief is combined with written text and a background performance still.
© Rod Coover. Reproduced with permission of Rod Coover.

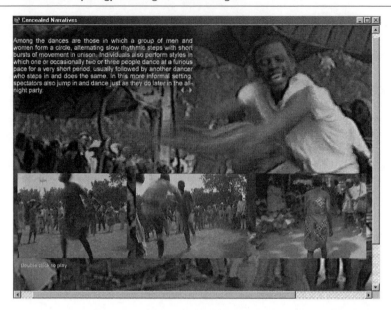

Figure 6.8 Rod Coover's *Cultures in Webs*. Other pages combine words and images similarly but use video clips of performances; one page has a set of three clips the user can view by clicking on them, along with contextualising writing and music.
© Rod Coover. Reproduced with permission of Rod Coover.

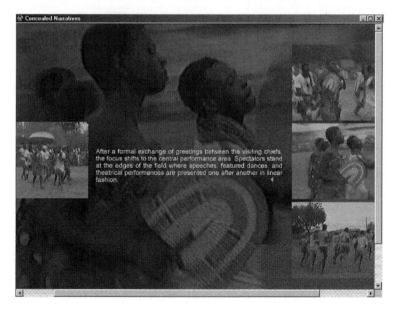

Figure 6.9 Rod Coover's *Cultures in Webs*. On the next page the music continues over still images, this time emphasising sound over image and isolating moments of performance in close-up and wide shots.
© Rod Coover. Reproduced with permission of Rod Coover.

written text, image and sound it surpasses ethnographic film in its ability to contextualise audiovisual materials. However, Coover does not claim to be an anthropologist and does not directly engage with anthropological theory. Moreover, while his methodology resonates with some aspects of ethnographic practice and offers interesting models for ethnographic representation, in other ways *Cultures in Webs* does not bring us close to how people experience their realities in the sense I would expect an anthropological work to. The user has only very brief encounters with the people she or he 'meets' in 'Concealed Narratives'. Some voice their opinions but little is revealed about the emotions embedded in their sensory embodied experience. In this sense the video footage does not engage the capacity of film to represent individual experience, as video footage is mainly from 'formal' interviews or an observational perspective on a performance, which does not draw us into the film subjects' world. The personal narrative we follow is Coover's own, representing his experience of shooting 'a film about politics and aesthetics'. Thus, what we do learn about other people's experiences is through Coover's words. In a series of pages about a ceremony honouring an American Peace Corps worker, he writes 'The young worker [who we see in the video footage] is at times uncomfortable with this unfamiliar position, at times exhausted by it' and analyses the symbolic meanings of the event in words. Anthropologically the style is unrevealing on two counts. First, Coover writes in the ethnographic present, but if the peace-corps worker had not communicated this information to him reflexively in the past tense, he could not have known it. Second, we do not know if she told him she was uncomfortable, or if he assumed this from his own experience. In sum the 'truth claim' embedded in the style of the statement is problematic for a reflexive anthropology. Despite these anthropological shortcomings *Cultures in Webs* is a key text for visual anthropologists. It provides a model for combining visual and written communication in hypermedia for which aesthetics matter and which is informed by ethnographic film theory and practice. Anthropologically this CD-ROM achieves less than Ruby's *The Taylor Family* and Biella's *Yanomamö Interactive*, but it is of a different genre from either of these.[10]

A very different CD-ROM is *Sexual Expression in Institutional Care Settings for Older People*, by Gill Hubbard, Alisa Cook, Susan Tester and Murna Downs (2003), which contributes to sociology and social policy. This work uses video, still images and written words to represent the findings of research about the sexuality of older people living in care homes. It is a collaborative work created by the researchers, film producers and interactive CD developers. The researchers' ethnographic methods produced written fieldnotes and video footage, and the CD-ROM's video clips emulate this, using actors to reconstruct scenarios from the research that represented how older people in care settings express their sexuality. These video clips are set within and contained on pages accessed through links made on a series of 'findings' pages organised thematically, in a report/article style.

Consisting of an introduction, methods section, findings, and discussion with both academic conclusions and a summary of the policy implications, the article/report progressively demonstrates how older people's sexuality – an issue frequently

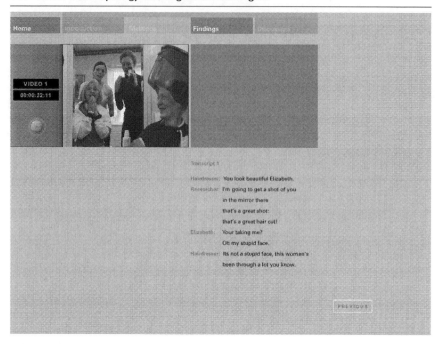

Figure 6.10 A video page from the *Sexual Expression in Institutional Care Settings for Older People* CD-ROM shows actors in a research scenario along with a transcript of their conversation.
Reproduced with the authors' kind permission.

overlooked in studies of ageing – forms part of their identities and everyday lives. Academic writing links these research findings, which are brought to us through video, transcripts and description, to existing literature, and enables the CD-ROM to function as an article/report that engages fully with and contributes to its academic and policy fields. By summarising the findings in more accessible language on the right-hand side of the screen, the CD-ROM also makes them easily read by policy makers. Moreover, the project successfully brings the research context to the representation of the findings of the research in a way that, depending on the audience, can serve as 'evidence' and can be evocative of the sensory experience of older people's sexuality, in the form of visual representations of sexual identities (for instance, through make-up and hair styling) and touching and affection. In a research area where it would be problematic ethically to use research footage of older people suffering from dementia, reconstruction has allowed a place in the text for the voices and embodied emotions of those represented. It attempts to evoke something of their experience alongside academic theory and policy recommendations that both frame experience and extrapolate from it.

The two projects discussed in this section work with very different narratives, aesthetics and principles of video production. They also evoke and contextualise the visible and non-visible experienced realities of their subjects in different ways.

The difference lies in that *Cultures in Webs*' 'Concealed Narratives' represents culture through a series of explicit cultural performances, mainly in the form of public display, music and dance along with individual performances of chiefs and local dignitaries' commentaries and explanations. Coover analyses this in terms of its political and symbolic import. The sequential narrative of Coover's pages allows users little freedom to choose their own routes through the text, thus maintaining another quality of filmic representation while departing from this in the multimedia construction of the pages. *Sexual Expression in Institutional Care Settings for Older People* represents and analyses everyday interaction as it was performed as part of the research encounter and between residents and carers, as evidence of how older people construct, experience and communicate about their sexuality. Its database navigation system allows users to move between sections at will.

Conclusions: hypermedia and the future of visual anthropology

The hypermedia projects reviewed in this chapter combine written and visual representations to create multilinear, multimedia and interactive texts that communicate theoretically, in institutional language and ethnographically. There are undoubtedly commonalities amongst these projects. For example, they construct reflexive relationships between ethnographic research, visual representation and written contextualisation and argument; simultaneously mimic and depart from existing genres of written and visual representation within their own disciplines; and use written words to situate ethnographic video footage contextually. Nevertheless, there is also something very *ad hoc* about the ways these projects developed. With the exception of the relationship between Biella's *Maasai Interactive* and *Yanomamö Interactive*, these projects do not explicitly cross-reference each other. While they share more general conventions common to hypermedia representations, they have been developed independently to represent particular research projects rather than conforming to the conventions of an emerging *academic* hypermedia genre as they variously imitate and depart from narratives of printed articles, film montage, pedagogy and report writing.

These differences are partly explained by the varied intellectual concerns of the hypermedia project producers and the practical elements of production processes. There are important differences in the contexts in which these applied and academic hypermedia projects have been produced. The first of these is the institutional setting: for instance, working in a 'fast product cycle setting' Steele and Lovejoy (2004) recognise that they cannot emulate approaches such as that demonstrated by Biella in his *Maasai Interactive* (or *Yanomamö Interactive*). Second, funding constraints and the availability of professional technical software, services and skills influence the design process – *Sexual Expression in Institutional Care Settings for Older People* was financed by a research grant, while *Women's Worlds* is an unfinanced project. Third, the way publishers perceive a project's market value influences how it is disseminated (and often produced) – *Yanomamö Interactive*'s

publisher hired professionals to produce a product that would sell; other CD-ROM projects are disseminated non-commercially by their authors. As yet no established hypermedia anthropology publishing processes and practices exist, as they do for books and films.

Anthropological hypermedia remains an emergent and experimental genre. Its ability to reference and depart from familiar narratives underlies its potential to converse anthropologically with a range of media and to construct relationships between (audio)visual and written materials and the experience and argument each best represents. In chapter 4 I suggested that hypermedia anthropology might surpass the limits of film by combining the synaesthetic and metaphoric communication of sensory experience evoked audiovisually with contextualising written words that situate experience in terms of cultural specificity and difference. Combining image, sound and writing in hypermedia is alone insufficient to produce a visual anthropology that engages with the relationship between the senses. Rather, to communicate about other people's experience we need to

1 engage more profoundly with the culturally specific epistemologies that inform how that experience is constructed; and
2 explore ways of analysing and representing different aspects of human experience using different media.

These questions remain unresolved in examples of contemporary practice, but hypermedia invites new texts that could achieve this.

Hypermedia also offers a route towards comparison in anthropology that film does not. A strength of ethnographic film is its capacity to represent the specificity of individual experience. Following MacDougall (1998), it communicates the commonalities of human experience transculturally. But this is simultaneously a weakness, since film is limited in its capacity to situate experience culturally and to communicate the epistemologies required to inform our understandings of other people's experiences. In the next chapter I suggest that hypermedia presents a medium though which visual anthropology might participate in a newly formulated comparative anthropology. Because hypermedia texts can be designed to communicate in different ways to different audiences (as in the case of *Sexual Expression in Institutional Care Settings for Older People*), this applies to academic and applied anthropology.

Finally, hypermedia invites visual anthropologists to contemplate new ways of presenting and framing research. It provides an alternative to film and writing that can reference and link these two genres of representation. Hypermedia does not replace books or films, and does not need to, but for visual anthropology to achieve its potential in the twenty-first century it needs to create the stronger links with writing and in doing so re-situate video within anthropology. Hypermedia invites multiple routes by which this could be achieved.

Part V

Conclusion

A visual anthropology for the twenty-first century

Visual anthropology has never been purely 'visual'. Ethnographic films and photographs have always focused on substantive themes, represented ethnographic subjects living in specific cultures, and been informed by anthropological theory. The name 'visual anthropology' was coined by Margaret Mead in the 1960s when, complaining that the references to 'non-verbal' anthropology that were bandied at the time were unfortunately negative, she proposed that a more positive title would be 'visual' anthropology (Allison Jablonko, personal communication[1]). This has always been a controversial label. Jay Ruby actually never supported the term 'visual anthropology', arguing that the 'anthropology of visual communication' was the more appropriate title (Ruby 2001–02). However, it seems now that the subdiscipline has outgrown the implications of both these defining terms, which, although they correctly stress the subdiscipline's emphasis on the visual, also deflect attention away from questions of relationships between the visual and other areas of experience and communication. Nevertheless, I am not about to propose renaming visual anthropology. Visual anthropology *is* about the visual and about visual communication, even if this is reasserted in terms of a relationship between visual and other elements of experience, practice, material culture, fieldwork and representation. Rather, as I have suggested in the preceding chapters, my aim is to re-situate visual anthropology's practices and rethink its identity in terms of its relationship with other areas of anthropological theory and methodology.

The contexts I discuss in each chapter of this book are domains where a visual anthropology might be contested, but they also present opportunities for reconsidering its potential. In addition, they suggest that visual anthropologists should engage more explicitly with a number of factors that have not previously fallen within its scope. These engagements themselves raise questions about the status and ultimately the independence of the subdiscipline from others. For instance, first, if visual meanings and experiences are treated as inseparable from other elements of sensory experience, should part of visual anthropology be subsumed under a sensory anthropology that also deals with other categories of sensory experience and communications? Second, if visual anthropology is concerned so much with the analysis and use of visual media for anthropological research and representation, then could it not simply become subsumed under media

anthropology – a subdiscipline that also deals with (amongst other things) 'non-visual media' such as radio, and if we follow McLuhan's (1964) broader definition of media with any type of resource that facilitates communication? Third, would a strand of applied visual anthropology not just become applied anthropology that uses visual methods? Finally, if we are to insist that visual anthropological representations converse more eloquently with written anthropology,[2] does this not mean that visual anthropology might reasonably be forsaken in favour of a renewed mainstream anthropology that has a visual component to its methods of research and representation? If this integration of visual anthropology into other fields led to its disintegration as a coherent subdiscipline in its own right, surely the objective of ensuring attention to the visual in anthropology would have been achieved?

The above speculations are intended to be provocative rather than predictive. Such engagements are not likely to bring about the end of visual anthropology; rather, on the basis of the new engagements and opportunities I have suggested in this book, visual anthropology has a role to play as a distinctive and coherent subdiscipline that links with other areas of academic anthropology and has an influence on a wider interdisciplinary stage.[3] Visual anthropology moreover has a history, its own foundation stories, personalities, methodologies, filmmaking and photographic practices, theories and a whole conglomeration of events, activities and institutions that have developed. It is not ready to be fragmented into pieces that would be reallocated into different subdiscplines; it has specific relationships with a series of (sub)disciplines that necessarily impact on how we understand the visual, the question of vision, and the methods of research and representation we engage in. Some of these indeed challenge the concepts that informed visual anthropology as it developed during the twentieth century. It is these that I propose are important for its progression in the twenty-first century.

In this concluding chapter I develop this argument by discussing how a renewed visual anthropology that responds to the opportunities and challenges of a sensory anthropology, hypermedia, and its applied strand might participate in an anthropology for the twenty-first century through a focus on three central roles: first, in renewed forms of comparative anthropology; second, as a conduit for the public responsibility of anthropologists; and, third, as a unique player in an interdisciplinary social science.

The visual in comparative anthropology

Cross-cultural comparison has in some ways become unfashionable in social and cultural anthropology (Fox and Gingrich 2002: 1). My reason for taking it up here is that some visual anthropologists have also suggested visual anthropology is opposed to and essentially forms a critique of the comparative method. One option would be to argue that given these two factors visual anthropology fits well in the context of a mainstream discipline that has departed from its comparative project. However, I shall suggest that an alternative route involves rethinking both the role of comparison in anthropology and the ways visual (and ultimately hypermedia)

anthropology treat cultural difference. This I propose might lead to a comparative anthropology in which visual anthropology plays a key role.

The rejection of comparative anthropology has been in part the result of some valid critiques of the scientific project of a holistic, comparative, relativist and observational anthropology that emerged as mid-twentieth-century anthropologists sought to establish the identity of anthropology as an academic discipline. As I noted in chapter 1, this 'new anthropology' was also a project by which visual methods and media were rejected. By the 1970s the theory and methodology of cross-cultural comparison were criticised 'because they compared what were assumed to be self-contained, stable and highly integrated cultures, when the reality was that all local cultures exist within a world system integrated by capitalist expansion and absorption' (Fox and Gingrich 2002: 2). From a visual anthropology perspective, David MacDougall has joined the critique of anthropology's comparative project, arguing that because throughout its history ethnographic film has underlined the 'visible continuities of human life [across cultures]' it has always 'challenged and in a sense opposed anthropology's prevailing conceptions of culture and cultural difference' (1998: 245). Following MacDougall, Lucien Taylor suggested that the contribution culture makes to 'both lived experience and personal identity' is in fact less than 'it is in our immediate professional interests to admit' (Taylor 1998: 20). Taylor contrasts written anthropology, which he characterises as foregrounding culture, to ethnographic film, which instead evokes the particular, is orientated to the individual and uses narrative. He equates ethnographic film with 'life', where he claims culture is placed in the 'phenomenological background' and similarities between individuals become more apparent than their cultural differences, both being 'pre-anthropological'.[4] For Taylor the future convergence or divergence of (a cultural) anthropology and ethnographic film will therefore depend on one or another scenario. In the first, ethnographic film will emerge as 'post-anthropological', which I assume would create an even greater rift between the two. In the second, anthropology will become 'post-cultural', which I understand to mean that it will have responded to a certain challenge made by ethnographic film and thus the discipline would be transformed.

MacDougall's point, that film represents human commonalities in ways that disrupt the cultural holism of written anthropology, forms part of his wider argument (also made by Grimshaw 2001, 2005) that mainstream anthropology needs to respond to and will potentially be transformed by the challenge of the visual. One of my aims in this book has been to suggest that although mainstream anthropology should benefit from this influence, it is precisely because ethnographic film lacks cultural contextualisation and theoretical framing that it is difficult for it to influence mainstream written anthropology. Henley has, like MacDougall, emphasised the quality of observational filmmaking to represent a sense of other people's experience. However, Henley warns against, as he puts it, 'the lame assumption that a common humanity and some empathetic powers of intuition are all one needs to achieve an understanding of a film subjects' [sic] world that is different from one's own' (2004:

120). While MacDougall rightly suggests that such empathy might help achieve understanding through those human similarities that transcend culture, Henley insists that such work needs to be framed by an 'appropriate interpretive context' because it is 'an analysis of how culture or variable social and political environments are inscribed upon those commonalities [that] remains a defining concern of the anthropological project as a whole' (2004: 120). Moreover, ethnographic film and its take on experience is not necessarily 'better' or 'closer' to 'life' than ethnographic writing. Anthropologists cannot get inside other people's lives or have *their* experiences. Nevertheless, as I outlined in chapters 3 and 4 through a discussion of phenomenological and experiential approaches to ethnographic methodology, we have a variety of techniques for getting close to them through *our own* lives and experiences. Film/video and talk/writing allow us to research and represent this in different ways, as described in chapters 3, 4 and 6. However, without any dimension of comparison or theoretical engagement with anthropology the closeness to life that Taylor claims for ethnographic film is limited because it might obscure differences underlying apparent commonalities by not contextualising them in terms of the culturally specific (and frequently contrasting) epistemologies that inform them. As Geurts' (2002) work on the Anlo-Ewe sensorium discussed in chapter 3 such contextualisation is crucial. I now connect these points with a wider anthropological discussion about comparison in anthropology to suggest how the visual might have a role in a revised comparative anthropology.

Gingrich and Fox have argued for a review and reintegration of cross-cultural comparison in anthropology. They propose this might be in diverse ways, using a 'rich *plurality of comparative methods*' (2002: 2, original italics). Although the original imperialistic, scientific and generalising comparative project of anthropology has been correctly critiqued, cross-cultural comparison clearly still plays a vital role in the work of the discipline in several ways. First, anthropology is unavoidably comparative in that in doing anthropology we are constantly comparing 'our' and 'their' knowledge, actions and representations. Ethnographies such as Geurts' (2002) work on the Anlo-Ewe sensorium make a powerful argument for comparison as a way of acknowledging the fundamental differences in the local epistemologies that inform everyday practice, experience and emotion in different cultures. Second, the audiences and readers of our anthropological texts need to be given a basis upon which to understand differences between their own cultures and the cultures represented. Third, some would argue that comparison forms part of the role and responsibility of anthropologists and anthropology in a wider interdisciplinary and global context. Approaches to cross-cultural comparison of which these arguments form a part are nevertheless different in important ways from the original comparative anthropological project formed from the 1920s onwards. They explore commonalities and differences between individual experiences in different cultures, are not necessarily linked to grand theory building, and might compare not whole cultures but aspects of cultures.

Comparison is indeed, as Melhuus stresses, 'at different levels, inherent to anthropology and ... to disregard the challenges posed by cross-cultural

comparison [as recent discussions, and re-thinkings of ethnography often have] is to undermine the anthropological enterprise' (2002: 72). This could be interpreted as being precisely what MacDougall intends in his notion of the visual as a challenge to the anthropological enterprise. These critiques of the cultural holism and comparative approach of twentieth-century social anthropology were certainly necessary. Nevertheless, it is interesting to rethink the relationship between visual anthropology and mainstream anthropology in terms of more recent proposals regarding what cross-cultural comparison might mean for a *contemporary* anthropology. This means an anthropology that has criticised its colonial origins and the scientific agenda by which it was driven throughout much of the twentieth century, has questioned its methods of research and representation to (for example) incorporate subjectivity, has become more reflexive and acknowledges that other cultures (while they are to some degree territorialised) are not necessarily circumscribed within localities, but might be 'multi-sited'.

One might ask why comparison is relevant to a contemporary anthropology. Melhuus suggests there are two reasons: it provides interesting documentation of cultural variations, but more importantly such descriptions serve to 'address broader issues and contribute to a more general understanding of sociality' (2002: 82). It is this that allows anthropology to make a more general contribution to the more interdisciplinary exercise of social theory building in the social sciences (2002: 87). She suggests that rather than comparing objects of essences we are comparing relationships and meanings – which effectively means we are comparing 'contexts' (which are constructed both by anthropologists and informants) (2002: 82). Another way of looking at this is to understand new comparative practices as not of constructing or comparing 'whole cultures' but as a focus on culturally contextualised uses of what Moore calls (1999b; see Pink 2004a) 'concept metaphors' (such as gender), which will allow us to examine how particular anthropological and local categories that recur across cultures actually operate to affect individual agency.[5] As such we can explore the differences and commonalities between how these categories are constructed, experienced, inform social action, and are possibly resisted and stretched by different individuals in specific and different cultural contexts.[6] Such an approach by no means excludes the individual, or prioritises 'culture' over the individual, but opens a space in which culturally contextualised individual experience is made comprehensible through comparison of three types:

1 within the same culture with other similarly or differently positioned individuals;
2 between different cultures where individuals might be involved in comparative/comparable practices or situations; and
3 by comparison with anthropological categories.

As Melhuus stresses there are anthropological reasons for explicating and comparing 'our' and 'their' 'processes of making sense'. Her focus on context means not simply

identifying cultural specificity or difference but also understanding how such contexts are constructed (2002: 86–7) and making anthropological interpretations of the 'visible and available' (2002: 87). The difference between the way contexts are constructed by people who live them and by anthropologists is that by the former they are 'intuitively assumed' whereas the anthropologist needs both to make visible such intuitive contexts and simultaneously to recontextualise these contexts through anthropological constructions with the goal of delineating 'a more encompassing universe of meaning' (2002: 87). Such an approach need not necessarily preclude a focus on intersubjectivity and the individual or recognition that such processes of making sense are actually often collaborative in fieldwork. It requires a reflexive unravelling of the relationships and negotiations by which knowledge is produced in fieldwork, for which the work of 'deep' (filmic) and 'explanatory' (written) reflexivity that MacDougall identifies can be equally important.

So what might ethnographic film and video offer a *contemporary* comparative anthropology that

1 acknowledges both commonalities and difference, emphasises context and the variant forms of it;
2 is reflexive about how it constructs its own contexts and theories; and
3 is prepared to compare these with (rather than simply using them to overpower) the context and meanings of other people as they intuitively *live* them?

First, because observational ethnographic film can open directly onto the lives of its subjects, it is capable of revealing comprehensible (or apparently comprehensible) commonalities between humans intuitively living and making meanings in different (cultural) contexts. But it also reveals the incomprehensible – those visible and audible aspects of other people's lives and experiences that we cannot (even think we can) understand without some contextualising knowledge about how meanings are made and lived out through social action in that specific cultural context. This stresses both the strength of ethnographic film, and its limitation – its 'pre-anthropological[ness]' as Taylor puts it. Second, genres of ethnographic film that depart from the observational model, using interviews or working with informants to reconstruct and represent their experiences either through spoken words or embodied enactments, also offer us a pre-anthropological representation. In this instance of how people understand their lives as being lived, incorporating film or video into a *contemporary* or re-thought comparative anthropology would afford it a role in the representation of how people intuitively live their lives, how they reflect on or define their experiences, and in the comparative (cognitive) act of viewing through frames of similarity and difference. To take the step of comparing contexts, and becoming anthropological, making those links to a wider context of anthropological meaning and theory building would require its combination with writing.

In chapters 4 and 6 I discussed the potential of anthropological hypermedia in a visual anthropology for the twenty-first century. I suggested that an important feature is its multimedia capacity to combine video and writing and in doing so craft

meanings 'between' them, which will be conversant with both visual and mainstream anthropologies. It is this new type of text that could support the integration of a visual and renewed comparative anthropology. Within this project there is also a second role for ethnographic film and particularly for a visual anthropology that combines film and writing. To build a new comparative anthropology Melhuus calls for radical thought and for potentially even restructuring how we think anthropologically (2002: 88). It is here that I think there is space for the 'challenge' (or maybe better the 'contribution') of visual anthropology to the mainstream. Once integrated with writing, film might invite a shift towards a closer scrutiny of commonalities of human experience within an anthropology where forms of context, contextualisation and comparison are almost inevitable.

Visual anthropology as a conduit of the public responsibility of anthropologists

In Britain university anthropologists are rated in terms of their research outputs (normally lists of academic publications) and the amount of research funding they are able to generate from sources external to their universities (from funding councils). Here research councils are increasingly interested in funding projects that will have some wider relevance outside academia and actively encourage collaborations with industry, government and other sectors. In US universities anthropologists are rated in terms of their research (including the quality of journals their work is published in and the number of times their work is cited), teaching and service (which refers to administrative roles in an academic department and other professional service to professional associations, non-profit organisations or the community generally). In Norway, however, the public responsibility of anthropologists as academics is made even more explicit. Here, '*formidling* – that is, popularizing or mediating scientific knowledge to a general public – has been instituted as one of the three obligations, along with teaching and research, which the academic staff at universities must meet' (Melhuus 2002: 75). The Norwegian anthropologist Thomas Hylland Eriksen emphasises social anthropology's potential for 'making sense of the present age' through contributing to mainstream media 'to engage with a wider intellectual public sphere' (2003: 3). In Norway, Eriksen writes, anthropologists are frequently commentators on current events by writing articles published in news media, discussing minority issues on television, and writing popular and polemical books for non-academic audiences. While, he notes, some academics feel 'betrayed and misunderstood' by this, others have 'become highly skilled in using the media to influence public opinion' (2003: 3) about contemporary issues.

While in the Norwegian context this responsibility becomes part of the job description of an academic, there is also a wider issue of the moral responsibility of anthropologists to participate as commentators in public debate and to communicate anthropologically informed knowledge to a general public in ways that both reveal hidden aspects and complexities of issues that journalistic arguments might make appear clear-cut, and that might also serve as forms of social intervention.

The example Eriksen discusses – of a media debate played out in newspaper columns between the anthropologist Marianne Gullestad and Shabana Rehman (an influential newspaper columnist, minority activist and stand-up comedian) – demonstrates this well. He suggests that the unique contribution of anthropology to this debate was based on its ability to represent 'versions of lived reality that never make the headlines'. Gullestad's writings reminded 'Norwegian newspaper readers that there are many other stories, experiences and life-worlds among members of first-, second- and third-generation minorities, in addition to the ones offered by [Rehman]' (2003: 5).

In chapter 5 I outlined historical and contemporary uses of the visual as a form of social intervention in various forms of cultural activism as well as applied anthropology. I argued that visual anthropologists should take account of the potential of anthropologically informed visual work in processes of social change, empowerment and identity construction. Following the emphasis on the way images and words can be combined effectively to represent both applied and academic anthropological work in chapter 6, I discussed how hypermedia representations might be used in the production of anthropologically informed social intervention. Here, building on this, I explore in more detail the role of visual anthropology in communicating as part of a publicly responsible anthropology. Linking with the discussion in the last section, the framework I suggest here also builds on another theme of this book, the importance of contextualised visual communication. Melhuus suggests that one of the reasons why comparison is relevant to contemporary anthropology is that anthropologists have a public responsibility to account for context, because 'it is through contexts that sense is made'; without it we would produce 'nonsense' (2002: 83). As Eriksen stresses, this ability to represent the complexities of contexts to a broader public is also one of the unique potentials of social anthropology. The question this leads to is, what might be the role of visual anthropology in such a public anthropology?

There are two ways to think about the public role of visual anthropology: first, as providing anthropologically informed popular representations of other people's experiences and practices, and as such to reveal complexity and difference in ways that contest monolithic definitions of reality and morality that might be represented in politically motivated journalism; second, in producing other types of media representation that combine image and word, using each to do what they are best at.

The first possibility has been played out to some degree already in various forms of ethnographic filmmaking. For example, in Britain in the 1970s and 1980s the *Disappearing World* (Granada Television) and *Under the Sun* (BBC Television) era of ethnographic films made for television brought anthropological research to the general public. However, more often than not (and particularly in the early days) these films represented 'exotic' and distant cultures rather than commenting on contemporary public issues or participating in debates of concern within contemporary nation states, as the type of public anthropology Eriksen advocates would. To develop a new type of public visual anthropology based on documentaries

anthropologists would be dependent on television programming agendas, which, as Henley (2005) has described, do not currently support anthropological film, in Britain at least. Other examples of the use of ethnographic film to influence opinion have been discussed in chapter 5. These include indigenous media projects – which, however, might be seen as activist works, intended to place issues relevant to one group on a wider public agenda, rather than advancing an anthropological commentary on public issues. They also include other examples of applied ethnographic filmmaking, which involve the production of anthropologically informed films that bring particular issues to the attention of target audiences, usually of a limited scope. Again, these practices alert us to the potential of ethnographic documentary in social intervention, but do not constitute a public or popular visual anthropology.

Drawing from the discussions of applied visual anthropology in chapter 5 I would suggest that in common with this a popular visual anthropology would have a role of cultural brokerage, by attempting to bring anthropological insights to a general public audience. It would need to act as a broker on two levels, to enable a general public audience to understand the experiences of the people it represents and at the same time to make accessible the anthropological argument that contextualises these experiences. Stand-alone ethnographic films might not achieve this. Wilton Martinez's work (for example 1994, 2004) has suggested that ethnographic film often fails to act as a cultural broker even in anthropology classrooms, leaving students to understand the experiences of the people they view according to their own pre-existing narratives and stereotypes. With no further empirical evidence to elaborate how wider general-public television audiences engage with ethnographic film representations I would not want to disregard the potential of new forms of ethnographic filmmaking in this role. Nevertheless, I think the role of visual anthropology in a future public anthropology has greater potential if it is developed as a form that combines images and words. Above I have described how in Norway, where public anthropology is already a reality, anthropologists see its contribution as lying in its unique ability to represent other people's lives and the complexities and variations they exhibit from the 'inside' (Eriksen 2003), and as being part of the moral responsibility of anthropologists to provide the contextualisation that brings 'sense' to what would otherwise be 'nonsense' (Melhuus 2002) – or in other words to make complexity and difference meaningful in ways that are at once anthropological and accessible to a general public. These two sides of the coin of anthropology's role in the public domain also coincide with the approach to exploring the roles of visual and written anthropology I have outlined in the previous chapters. I have discussed how visual media can allow informants and anthropologists to represent aspects of experience and commonalities in human experience that are not accessible in written texts, but that to make these meaningful anthropologically they need to be contextualised both theoretically and culturally in ways that are established in written anthropology. Might a public visual anthropology have a role to play in terms of presenting individual commonalities in wider contextualised and culturally comprehensible ways that will allow 'cultural brokerage' and

understanding? I cannot predict if or how this potential might be realised, but suggest it is most likely to succeed if it is based on existing successful forms of media dissemination. In the future this might take a hypermedia form on the Internet, in online newspapers and other forums. Future developments in both anthropological and mass-media practice will determine if and how it will emerge, and developments will also be influenced by the extent to which contemporary visual anthropologists engender and act on a sense of their public responsibility.

Visual anthropology as a unique player in an interdisciplinary social science

I noted in chapter 1 the interdisciplinary context in which visual anthropology is now increasingly being situated. I argued that the subdiscipline should find a space in which it might continue to make a distinctive contribution to an interdisciplinary field of visual studies as well as participating in the wider contribution of anthropology to social sciences (and humanities). Here I suggest that this contribution might be both theoretical and methodological and may draw from developments in academic and applied visual anthropology discussed in this book.

First, how might visual anthropology be implicated in the role of social anthropology as a distinctive social science discipline? Melhuus suggests it is a commitment to a comparative anthropology that will guarantee its continuation on an interdisciplinary social scientific stage through a role in social science theory building. Indeed, it is social anthropology's emphasis on cultural difference that has been appreciated by other disciplines in the past. For example, in the 1980s the sociologist Anthony Giddens went as far as to suggest in an introductory sociology text that a sociological imagination has three strands involving 'an *historical*, an *anthropological* and a critical sensitivity' (1986: 13). The anthropological perspective contributes a break away from the idea that western ways of life are superior to those of other cultures (Giddens 1986: 19), appreciating the diversity of ways of life that exist, and through such awareness Giddens hoped 'we can learn better to understand ourselves' (1986: 20). Using this anthropological knowledge, along with historical knowledge of how other ways of life exist in other times and in other places, sociology establishes a basis upon which to develop a critique of industrialised societies (1986: 22). While, from the perspective of a sociologist, this definition of the role of anthropology might well seem viable, it is of course not satisfactory to social anthropologists. As I discussed above, a more viable way of understanding the potential of a comparative anthropology is by conceptualising it as a means of comparing how categories, practice and agency are constructed and constituted both between different cultural contexts and within anthropology itself. If this is the case a new visual anthropology that combines image and word can offer an experiential and much richer contribution to social sciences. It can enable a form of theory building that reveals the experiences upon which that theory is based.

An example would be to consider how recent work in visual culture studies has constructed industrial society as an increasingly 'visual' culture. In chapter 2 I

noted that visual culture studies is a visual branch of 'methodologically eclectic' (Lister and Wells 2001: 64) cultural studies, with all of its contingent theoretical and critical underpinnings. Lister and Wells tell us that 'With the late twentieth century's explosion of imaging and visualizing technologies (digitization, satellite imaging, new forms of medical imaging, virtual reality etc.), they [the proponents of visual cultural studies] suggest that everyday life has become "visual culture"', calling for a new field of study of both images themselves and 'the centrality of vision in everyday experience and the production of meaning' (2001: 62–3). Evans and Hall similarly refer to the 'visual culture' in which we now live, which is 'pervaded at all levels by a host of cultural technologies designed to disseminate viewing and looking practices through primarily visually mediated forms' (1999: 7). As is clear from the contents of Evans and Hall's reader on *Visual Culture* (1999), the interests of this subdiscipline have a firm and particular historical and regional focus: modern industrial society and its transition into postmodernity.

Visual culture scholars are thus interested mainly in the visual aspects of just one particular type of culture. The subdiscipline's proponents assert that the interdisciplinary project of visual culture is now organised on the model of anthropology (rather than history as it was in the past) (October 1996: 25, cited in Evans and Hall 1999: 6). Nevertheless, visual cultural studies has its own distinctive project, embedded in the theoretical and critical agenda of cultural studies, that differs from that of anthropology. The existence of visual cultural studies is in part justified by an argument that we now live in an increasingly (modern western) visual world permeated by new visual technologies. However, does this make modern western culture and institutions *more visual* than those of 'other' cultures? I would suggest it does not. As I have argued in chapters 3 and 4, assumptions that vision is necessarily always the dominant sense in modern western experience and practice are problematic. Instead I would suggest that the evidence of new visual technologies implies new forms of visual practice, new modes of visual production, content, dissemination and interpretation, perhaps combined with new interrelationships with other elements of sensory experience. Rather than assuming that some cultures can be comparatively 'more visual' than others, or the extent to which a culture is visual can quantitatively increase, we need to focus on the qualitative questions of how visual practices change. By taking an anthropological approach that situates visual practices within local and cultural contexts, it becomes clear that the idea that in the modern west we live in a 'visual culture' that is 'pervaded at all levels by a host of cultural technologies designed to disseminate viewing and looking practices through primarily visually mediated forms' (Evans and Hall 1999: 7) does not mean that in other cultures where other technologies are used people do not live in a culture that is equally visual. For visual culture studies of this kind, then, a visual anthropology that re-situates the visual in terms of its relationship to other senses and attends to context as a means of making sense of visual practice allows us to recognise diverse visual cultures and the complexity that they entail. By taking a revised comparative perspective – that doesn't compare whole cultures and the levels to which they are permeated by new visual technologies, but instead

compares commonalities and differences between categories of visual practice – we might gain a wider interdisciplinary perspective on how visual images and technologies are implicated in the production of culture and the constitution of identities and relationships.

Visual anthropology also has a key contribution to make to the project of 'methodology building' in the social sciences. The academic study of and provision of training in methodology has, in Britain at least, become a key concern of research councils, and it seems to me important that both anthropological and visual methods of research are able to influence these developments. There has, as I have noted in chapters 1 and 2, been broad interdisciplinary interest in visual anthropology as a methodology not least because, as Banks also notes, 'most academics would acknowledge that of all the social science disciplines it is anthropology, in the form of visual anthropology, that has made most use of visual materials in the course of research' (2001: x). One question is how to ensure that visual anthropology maintains this status in the context of the haste to develop discipline-specific visual methodologies as outlined in chapter 2. Another is to identify the unique contribution that visual anthropology can make to an interdisciplinary social science project of methodology building. Moreover, this needs to be achieved in a way that avoids both the unscholarly interdisciplinary exchanges and inappropriate interdisciplinary borrowings I identified in chapter 2.

For this to be achieved there needs to be some common level of interdisciplinary understanding across the social sciences (and humanities) of the aims and ethics of a social scientific visual methodology. In chapter 2 I outlined a series of shared themes that resonate across approaches to visual methods in sociology, geography, visual cultural studies and anthropology, and that are also found in uses of visual ethnography in documentary filmmaking, photography and hypermedia: reflexivity, collaboration, ethics and the relationship between the content, social context and materiality of images. Along with visual sociology, visual anthropology is distinguished amongst these disciplines in that it applies these principles to both the analysis and production of (audio)visual representations. As I outlined in chapter 2, broadly across the social sciences the different 'visual subdisciplines' are agreed on a model of analysing visual images in terms of their production, content and consumption. Added to this, visual anthropologists have begun to emphasise on the one hand the materiality of visual images (for example Edwards 1999, 2001), and on the other their intangibility (for example Edgar 2004; Orobitg 2004). On one level, this approach offers a visual anthropology that extends to sensory experience an opportunity to intervene to demonstrate that a purely visual methodology is insufficient to understand the meaning of images. Instead, images need to be understood in terms of how their visual element is made meaningful in relation to a full set of culturally specific sensory categories. On another level, it insists on attention to how we experience visual artefacts.

In their practice of visually representing social science research both visual sociology and visual anthropology are also interested in visual methods of researching and communicating experience. This can be linked to phenomenological strands in both anthropology and sociology, however significantly the two disciplines differ in

their approaches to phenomenology. As Katz and Csordas (2003) outline, the essential difference between the anthropologists' and sociologists' approach to phenomenology is that the former seeks to provide an insider representation of other people's experience, whereas the latter seeks to critique the ways in which commonsense understandings of experience are constructed by (sub)cultures in her or his own culture. This is not to say that anthropology does not have a critical role, as I have argued in the previous section; indeed, anthropologists can play a key public role in highlighting inconsistencies in their own cultures. However, the ethical responsibilities and collaborative tendencies of contemporary visual anthropologists are part and parcel of the unique identity of visual anthropology whose ethnographic practice brings to the fore ways of researching and representing other people's experiences and seeking ways to make these comprehensible to others.

In the previous chapters of this book I have discussed these issues in an attempt to identify what visual anthropology might contribute to mainstream anthropology. In chapter 5 I also noted how one of the reasons why visual ethnography is becoming so popular in applied research is because it provides methods by which researchers might represent the experiences of one set of people to another set of people in ways that can be made meaningful. It is not only important that the unique contribution of visual anthropology to a wider social science methodology-building programme be acknowledged and developed. If an applied visual anthropology is to continue to flourish it is equally important that its identity is asserted within the undisputedly interdisciplinary context of applied social science research.

Conclusion: rethinking the visual, multiple levels of engagement and diverse audiences

This book calls for a review of the place of the visual in anthropology. My argument is not simply that the visual should be paid greater attention in anthropology, as that is already starting to happen in both academic and applied contexts. However, as the study of visual media and their use as methodology starts to figure more strongly in anthropology it also becomes necessary to approximate the challenges that emerge from this engagement. Primarily this requires that we 'rethink' the visual in terms of its relationships with other elements of experience and representation. This task has several implications for visual anthropological theory and practice. For instance, first, it might involve asking: What is vision and how does it operate as both an embodied experience and a cultural category in different social and cultural contexts? Moreover, how are culturally specific relationships between vision and other sensory categories constructed and how are these related to cultural conventions and human agency to break or change them? Second, such a rethinking requires that we interrogate our uses of visual methods and media in research, to examine the relationship between (audio)visual and other media (such as writing, drawing, digital media, installation art, performance). As such, visual anthropology might be redefined as not simply the anthropology of the visual and

the use of visual methods in research and representation, but as the *anthropology of the relationship between the visual and other elements of culture, society, practice and experience* and the *methodological practice of combining visual and other media in the production and representation of anthropological knowledge.*

Finally, a disclaimer: my intention in this book has been to suggest a set of opportunities and challenges to a visual anthropology for the twenty-first century. I have aimed to be provocative rather than prescriptive and by no means to set an agenda for future work. I hope that other visual anthropologists will engage in a constructive critique of the ideas I have presented here, which will in turn contribute to a wider project of transforming visual anthropology in ways that (re)engage it with other areas of theory and practice as it develops in the twenty-first century.

Notes

1 Engaging the visual: an introduction

1 At http://astro.temple.edu/~ruby/wava/temple/Proposal_SVA.pdf, accessed 4 September 2004.
2 At http://astro.temple.edu/~ruby/wava/temple/, accessed 4 September 2004.
3 Organised by the IWF in Goettingen, Germany.
4 Most obviously the work of Jean Rouch.
5 Notably the work of the IWF and also earlier work documented by Taureg (1983).
6 At the Working Images Conference in Lisbon 2001 Janos Tari and Laszlo Kürti both commented on the history of visual anthropology in Hungary.
7 As reported in the Commission on Visual Anthropology Newsletter, September 2004.
8 For example, Laszlo Kürti notes how the history of visual anthropology – through its focus on mainly North American, French, British and Australian filmmakers – has omitted the contribution of the Hungarian filmmaker Paul Fejos.
9 In Europe the EASA Visual Anthropology Network is actively developing visual anthropology with conference panels focusing on new methodologies and media and applied visual anthropology.
10 Substantial, although inevitably selective, histories of visual anthropology (for example Grimshaw 2001), the senses and sensory anthropology (for example Howes 2003) and applied anthropology (for example van Willigen 2002; Wright 2005) already exist.
11 Recommended sources of fuller historical accounts of the history of social and cultural anthropology are Kuper (1996) and Eriksen and Nielsen (2001).
12 This interpretation of the history of anthropology has also been contested. Morphy (1996) convincingly argues that the collaborative work on Baldwin Spencer and Frank Gillen, from 1894, with Australian Aboriginals made a fundamental and unrecognised contribution to the fusion of fieldworker and theorist that is usually attributed to Malinowski.
13 Although note there is no record of Boas discussing filmmaking with Mead (Griffiths 2002: 308).
14 The Colonial Social Science Research Council (CCSRC) set up in 1944 led to a 'dramatic expansion of the profession [of anthropology]', and focused mainly on Africa (Kuper 1996: 104).
15 In the 1950s the leading anthropologists of the day also rejected overtures from industrialists interested in anthropology's 'potential contributions to industrial welfare and personnel "problems"' (Mills 2005).
16 Linked to http://lucy.ukc.ac.uk/stirling.html, accessed 14 November 2004.
17 As Hutnyk (1990) identified for Evans-Pritchard's and Brandes (1997) for Pitt-Rivers' photographs.
18 To be found at www.utexas.edu/coc/cms/faculty/streeck/bali/Fingertips.html, accessed 14 November 2004.

19 Mead's role in the development of North American visual anthropology was nevertheless enduring. Differing from Bateson in her views about the potential of the visual, Mead insisted objective visual evidence could and should be produced though controlled and systematic methods of visual recording, and as such could be an important support to mainstream anthropology (Bateson and Mead 1976; Mead 1995).

20 During World War II Mead was a member of two committees formed by the National Research Council in the USA: the Committee on Food Habits (with Benedict and Métraux), which 'was to obtain scientific information on nutritional levels of the American population', and the Committee for National Morale (with Gregory Bateson and Elliot Chapple), which was to 'determine how anthropology and psychology could be applied to the improvement of national morale during the war' (van Willigen 2002: 28).

21 The book includes a text on 'the thinking that caused US military officials to spare the Emperor of Japan after World War II' (Beeman 2000: xxx).

22 Heider (1976) describes how, with the 1960s establishment of Documentary Educational Resources (DER), some ethnographic filmmakers made a commitment to the relationship between film and writing: 'previously, printed material had accompanied films only as an occasional extraordinary event, and it was usually on an inadequate page or two. DER took a major step in making the production of an adequate study guide accompaniment a routine part of ethnographic filmmaking' (1976: 37). However, this did not become a universal practice, indeed some argued against it (Banks 2001: 149–51).

23 See Heider (1976) for a discussion of early ethnographic films and see Loizos (1993) for a discussion of this history and a series of innovations in it.

24 See Taureg (1983) for a critical discussion of the origins and objectives of German scientific ethnographic films from 1959 onwards.

25 However, the story becomes more complex here as by the twenty-first century sensory anthropology had begun to return to a newly formulated approach to comparison, which as the book unfolds I shall suggest might also form part of a renewed visual anthropology.

26 As a visual anthropologist I am often invited to speak on visual methodology to academics in sociology and education studies and have supervised PhD students in photography, all of whom are interested in using the visual to inform their own practice.

27 For example, at the University of Kent, UK.

28 For instance planned for the AAA conference 2004.

2 Interdisciplinary agendas: (re)situating visual anthropology

1 The theme of the materiality of images is a greater concern for anthropologists than for those from other disciplines, and is not developed in depth in this article.

2 He was in fact a mining engineer.

3 Although the phrase was actually Hockings' (many thanks to Routledge's anonymous reader for pointing this out).

4 An Economic and Social Research Council (ESRC) seminar series held at the Open University, University of Leeds and National Portrait Gallery (London) in 2001 and organised by Jon Prosser, Rob Walker and Peter Hamilton.

5 I have discussed Holliday's position elsewhere (Pink 2001b), and repeat it briefly as part of the development of the argument here.

3 New sensations?: visual anthropology and the senses

1 I have touched on some of the issues discussed in this chapter and in chapter 4 in my book Home Truths (Pink 2004a) (chapter 2) in a discussion of visual methodology. Here I reiterate some of the points I made there in order to introduce the much more detailed and developed discussion of wider issues relating to visual and sensory research and representation presented here.

2 Marks defines intercultural cinema as 'characterized by experimental styles that attempt to represent the experience of living between two or more cultural regimes of knowledge, or living as a minority in the still majority white Euro-American West' (2000: 1).

3 I discuss in chapter 7 how the project of cross-cultural comparison might be developed in a revised form.

4 Grimshaw and Ravetz's edited volume was published after my initial submission of this manuscript to Routledge, while I was waiting for the readers' comments. The emphasis the editors and contributors to this volume put on the sensory demonstrates how significant the question of the senses in visual anthropology is becoming to a range of scholars and practitioners at this very time.

5 Drawing from the work of James, Husserl and Schulz.

6 Given this approach it is clear that its incompatibility with the shifts in anthropology encouraged by the 'crisis of representation' in anthropology of the 1980s and 1990s were not simply, as Howes (2003) has suggested, to do with the emphasis of the latter on textuality as I have noted in Chapter 1. The emphasis on specificity, rather than making defining truth claims about the nature of 'whole cultures', and the focus on the individual, intersubjectivity and experience as the sources of anthropological knowledge that should necessarily become part of its representation, were in a much more general sense opposed to the project of cross-cultural comparison of the sensoria of whole cultures proposed by this initial anthropology of the senses.

7 Like conversation and discourse analysis as used in social psychology and sociology.

8 I return to the wider issue of visual anthropology's relationship to cross-cultural comparison in chapter 7. Here I introduce MacDougall's approach to this to contextualise the present discussion.

9 The same example is also repeated in the prologue of my book *Home Truths* (Pink 2004a) to introduce the notion of the sensory home. However, here it is used in a different context to demonstrate a point about visual research and sensory experience.

4 Visual anthropology and anthropological writing: the case of the sensory home

1 This chapter combines existing writing developed in two publications, Pink 2003 and Pink 2004b.

2 The work discussed here was undertaken in 1999–2000 as a project initially developed with Katie Deverell at Unilever Research. I interviewed twenty people in Spain and twenty in England. Basing the sample on the changing statistical profile of Spanish and British households, I sought to explore the diversity of contemporary masculinities and femininities as they are constituted in 'the home', encompassing different generations, occupations, sexualities, and social and economic classes, as well as different domestic situations: people living alone, couples and families.

3 *Domov* was produced as part of Read's doctorate at the Granada Centre, University of Manchester, and reflects the tradition of work from the Centre (see also Read 2005).

5 Visual engagement as social intervention: applied visual anthropology

1 See Pink 2005 for an analysis of how applied anthropology is currently developing in Britain.

2 Moreover, applied anthropology has developed different ways in relation to various national anthropologies and subsequently currently occupies an uneven status across the globe (see Baba and Hill 1997).

3 Commissioned by Unilever Research.

4 The ESRC-funded *Applications of Anthropology* series developed in collaboration with the

Association of Social Anthropologists of the UK and the Commonwealth, Centre for Learning and Teaching Sociology, Anthropology and Politics, and Loughborough University.

5 Based on the (2004) *Visual Anthropology Review* issue as well as papers from a conference panel I convened at the Vienna conference of the European Association of Social Anthropologists (2004) and other invited contributions.

6 This context also signifies a new employment market for visual-anthropology graduates in a context where academic posts for visual anthropologists are few. Henley (2005) demonstrates that MA graduates in visual anthropology often seek careers outside academia: 'if we discount the 20% of graduates with whom we have lost touch, over the last ten years a clear majority, namely, 65% of our graduates (48 out 74) have gone on to work in some branch of the media.'

7 The role of anthropologists in conflict contexts is disputed and raises enormous ethical issues that cannot be addressed here because of space limitations.

8 Although these texts do not reference Collier's role or the visual component of the project.

9 Malcolm Collier, John Collier's son, has also worked extensively as an applied visual anthropologist throughout his career.

10 For more detail of John Collier's family history and biography see Biella (2001–02).

11 The field team consisted of Ray Barnhardt, his wife Carol, their baby son John, and John Connelly, who executed '"Draw-a-Man" tests and questionnaires and schedule interviewing with teachers, students, parents, and important village persons' (Collier 1973: 48).

12 Rich is Director of the Center on Media and Child Health at Children's Hospital Boston, an Assistant Professor of Pediatrics at Harvard Medical School, and an Associate Professor of Society, Human Development, and Health at Harvard School of Public Health.

13 The exception is my edited volume, *Applications of Anthropology* (Pink 2005), which includes chapters by Paul Henley and Garry Marvin covering applications of anthropology in film and television production.

14 Other instances are, for example in Britain, early 1970s uses of video to study classroom practice, Open University films used in teaching to demonstrate classroom language analysis, and the video and audio technology used extensively from the 1970s onwards by the Humanities Curriculum Project (Rob Walker, personal communication).

15 The idea of ethnography as a 'brand' in business research is discussed by Roberts (2005) and Suchman (2000).

16 See www.pervasive.dk/resAreas/designAn/designAn_summary.htm, accessed 12 August 2004.

17 Sperschneider and I both trained in the MA in visual anthropology (University of Manchester, UK) in 1989–90. He has a PhD in anthropology, and has made a number of ethnographic films.

18 These are currently being written up for publication.

6 Visual anthropology and hypermedia: towards conversing anthropologically

1 I will not repeat this work here; see Pink (2001a) chapter 8.

2 Here Cook criticises Manovich's argument that the language of the database is purely visual and derives from the language of cinema.

3 Cook is broadly right to suggest that the database concept can be found in most new media forms, and this is especially applicable to hypermedia. However, the 'much of' rather than 'all of' in the quotation in the main text should not be ignored. For example in a review of five different multimedia projects that are broadly anthropological or sociological (or at least of interest to the visual branches of these disciplines), Harper (2004) shows how each employs different narrative forms and structures to represent visual and other materials. They range from the photographic slide show that constitutes

Steiger's *En Route* (2000) to a complex compilation of classified photographic and other materials in Mohr's *A Photographer's Journey* (2003).

4 For instance, the CD-ROM invites users to engage with a debate about the cause of Yanomamö warfare that developed between Chagnon and Marvin Harris (Biella 2004: 251–2).

5 This device is also used in a more explicit form in the Epilogue where Ruby also appears on camera with the Taylors to discuss their feelings about how they have been represented.

6 A division of MIS, Inc; see www.birkey.com, accessed 23 August 2004.

7 This is the approximate cost for the pack discussed here that includes the CD-ROM and Chagnon's introduction; see the CD-ROM web site for further breakdown of the cost of other packages: www.anth.ucsb.edu/projects/axfight/, accessed 25 October 2004.

8 See the DER web site for the DVD at www.der.org/films/dead-birds.html, accessed 25 October 2004.

9 The following paragraphs have also been used to discuss this aspect of the project in an article (Pink 2004d) where I discuss the whole project in full.

10 Two other CD-ROMs, Jean Mohr's CD-ROM *A Photographer's Journey* (2003) and Rebecca Steiger's *En Route* (2000), are noted here in a footnote as being of interest to anthropologists. Mohr's *A Photographer's Journey* is built as an archive, its database qualities are explicit. The aesthetic of Mohr's CD-ROM takes us into a gallery-archive with a biographical section that importantly allows the viewer to click on the image to view not only Mohr's childhood family photographs but also the writing on the back of them, a series of thematically organised slide shows interlinked with interviews, and a searchable database of all the 1,200 (see Harper 2004) photographs. Steiger's *En Route* is a less sophisticated project that presents a CD-ROM slide show of images of a commuter journey. The CD-ROM accompanied an article (also reproduced on the CD-ROM) and photo-essay of the same images published in the journal *Visual Sociology*, which allowed the author to 'approximate the image presentation, originally presented as 35mm slides'. Mohr's and Steiger's projects provide different ways of presenting photographs in hypermedia that emulate and depart from existing forms of presentation in different ways.

7 A visual anthropology for the twenty-first century

1 Allison Jablonko noted this at the EASA Conference in Vienna 2004, in an anecdotal account of her experiences, and the point was followed up by e-mail correspondence.

2 Of course my distinction between visual and written anthropology does not intend to ignore the fact that written text is visual itself. The difference I am working with is one of the use of images and language.

3 Indeed it could be said for any subdiscipline that it could be disbanded because different areas of its concerns might be subsumed under the concerns of another subdiscipline and in this sense I have set up a 'straw person' to make this point. However, this does raise another issue about the way our academic culture has developed as a series of disciplines and subdisciplines, and the point that these are of course not discrete entities, but overlapping, collaborating and conversing areas of research and representation.

4 Criticising this point from another perspective, it seems to me that in 'life' cultural differences are actually often acutely experienced in our interactions with others. Two scenarios come to mind. First, there is the process of learning as a fieldworker though awareness of cultural difference and comparison of one's own values with those of others. Second, in their everyday lives people tend to classify others in terms of similarity and difference, and either can come to the fore in social encounters. It seems idealistic to hope that human beings are always seeking commonalities rather than differences in their contact with and judgements of others, and if it was always the former then how would we explain constructions of the other and instances of social exclusion?

5 As series editor for EASA publications from 2000 to 2004 I have also noted that comparative anthropology is alive and well in the types of edited volume the series has encouraged. Such volumes tend to draw together sets of essays, usually written by anthropologists from, and who study, diverse cultures, to respond to similar substantive, theoretical and methodological questions with reference to the 'culture' they have expertise in. A good example that is relevant here is Grasseni's (forthcoming) volume about 'Skilled vision' that examines how, in a range of different cultural contexts, vision can be seen as a skilled practice.

6 I have attempted to put this approach into practice elsewhere (Pink 2004a).

References

Printed materials

Afonso, A.I. (2004) 'New graphics for old stories – representation of local memories through drawings' in S. Pink, L. Kürti and A. Afonso (eds), *Working Images*, London: Routledge.

Amit, V. (1999) *Constructing the Field: Ethnographic Fieldwork in the Contemporary World*, London: Routledge.

Ang, I. (1985) *Watching Dallas*, London: Methuen.

Asad, T. (1973) (ed.) *Anthropology and the Colonial Encounter*, London and Ithaca NY: Cornell University Press.

Baba, M. and C. Hill (1997) (eds) *The Global Practice of Anthropology*, Williamsburg VA: Department of Anthropology, College of William and Mary.

Banks, M. (2001) *Visual Methods in Social Research*, London: Sage.

—— and H. Morphy (1997) (eds) *Rethinking Visual Anthropology*, New Haven CT and London: Yale University Press.

Barbash, I. and L. Taylor (1997) *Cross-Cultural Filmmaking: A Handbook for Making Documentary and Ethnographic Films and Video*, London: University of California Press.

Barnett, T. (2004) 'HIV: A challenge for anthropology', guest editorial, *Anthropology Today* 20(4): 1–2.

Barnhardt, R. (forthcoming) 'John Collier, Jr.: Anthropology, Education and the Quest for Diversity' in R. Blot *et al.* (eds), *Foundations of Anthropology and Education: Critical Perspectives*, New York: Bergin and Garvey.

Bateson, G. (1980) 'An Analysis of the Nazi Film "Hitlerjunge Quex"', *Studies in Visual Communication* 6(3): 20–55

—— and M. Mead (1942) *Balinese Character: A Photographic Analysis*, New York: New York Academy of the Sciences.

—— and M. Mead (1976) 'For God's Sake Margaret: Conversation with Gregory Bateson and Margaret Mead'. Available online: <www.oikos.org/forgod.htm> (accessed 30 July 2004).

Beeman, W. (2000) Introduction to M. Mead and R. Métraux (eds), *The Study of Culture at a Distance*, Oxford: Berghahn.

Benedict, R. (1934) *Patterns of Culture*, New York: Houghton Mifflin.

Biella, P. (1993a) 'The Design of Ethnographic Hypermedia' in J.R. Rollwagen (ed.), *Anthropological Film and Video in the 1990s*, Brockport NY: The Institute Inc.

—— (1993b) 'Beyond Ethnographic Film' in J.R. Rollwagen (ed.), *Anthropological Film and Video in the 1990s*, Brockport NY: The Institute Inc.

—— (2001–02) 'The Legacy of John Collier Jnr' in H. Prins and J. Ruby (eds), *The Origins of Visual Anthropology*, a special issue of *Visual Anthropology Review* 17(2): 5–60.

—— (2003) 'Introduction to the volume' in *Steps for the Future/A Kalahari Family*, a special issue of *Visual Anthropology Review* 19(1–2): 3.

—— (2004) 'The Ax Fight on CD-ROM' in E.D. Lewis (ed.), *Timothy Asch and Ethnographic Film*, London: Routledge.

——, N. Changon and G. Seaman (1997) *Yanomamö Interactive: The Ax Fight* (book and CD-ROM), Wadsworth: Thompson Learning.

Birdwell-Pheasant, D. and D. Lawrence-Zúñiga (1999) *House Life*, Oxford: Berg.

Brandes, S. (1997) 'Photographic Imagery in Spanish Ethnography', *Visual Anthropology Review* 13(1): 1–13.

Bruner, E. (1986) 'Experience and its Expressions' in V. Turner and E. Bruner (eds), *The Anthropology of Experience*, Urbana: University of Illinois Press.

Büscher, M., P. Krogh, P. Mogensen and D. Shapiro (2001) 'Vision on the Move: technologies for the footloose'. Available online: <www.pervasive.dk/publications/files/ApplianceDesign.pdf> (accessed 12 July 2004).

Camas, V., A. Martínez, R. Muñoz and M. Ortiz (2004) 'Revealing the Hidden: making anthropological documentaries' in S. Pink, L. Kürti and A. Afonso (eds), *Working Images*, London: Routledge.

Chalfen, R. and M. Rich (2004) 'Applying Visual Research: patients teaching physicians about asthma through video diaries' in S. Pink (ed.), *Applied Visual Anthropology*, a guest edited issue of *Visual Anthropology Review* 20(1): 17–30.

Chaplin, E. (1994) *Sociology and Visual Representations*, London: Routledge.

Chislett, S., et al. (2003) 'Steps for the Future [actually, life is a beautiful thing] – an introduction by the STEPS project staff, Steps for the future' in *Steps for the Future/A Kalahari Family*, a special issue of *Visual Anthropology Review* 19(1–2): 8–12.

Clarke, A. (2001) 'The Aesthetics of Social Aspiration' in D. Miller (ed.), *Home Possessions*, Oxford: Berg.

Classen, C. (1993) *Worlds of Sense: Exploring the Senses in History and Across Cultures*, London: Routledge.

——, D. Howes and A. Synnott (1994) *Aroma: The Cultural History of Smell*. London: Routledge.

Clifford, J. (1983) 'On Ethnographic Authority' *Representations* 1: 118–46.

—— (1986) 'Introduction: Partial Truths' in J. Clifford and G. Marcus (eds), *Writing Culture: The Poetics and Politics of Ethnography*, Berkeley: University of California Press.

—— and G. Marcus (1986) (eds) *Writing Culture: The Poetics and Politics of Ethnography*, Berkeley: University of California Press.

Collier, J. (1967) *Visual Anthropology: Photography as a Research Method*, Albuquerque: University of New Mexico Press.

—— (1973) *Alaskan Eskimo Education*, New York: Holt, Rinehart, Winston.

—— (1997–98) 'Cultural Energy'. Lecture, Field Museum of Natural History Chicago, 19 September 1987, *Visual Anthropology Review* 13(2): 48–67.

—— and M. Collier (1986) *Visual Anthropology: Photography as a Research Method*, Albuquerque: University of New Mexico Press.

—— and M. Laatsch (1983) *Education for Ethnic Diversity: An Ethnography of Multi-Ethnic Classrooms*, San Francisco CA: Wenner-Gren Foundation.

Collier, M. (2003) 'The Vicos Photographs of John Collier Jr. and Mary E.T. Collier' in *Visual Anthropology* 16(2–3): 159–206.

Cook, S. (2004) 'Between the Book and the Cinema: late Victorian new media' *Visual Studies* 19(1): 60–71.

Coover, R. (2004a) 'The Representation of Cultures in Digital Media' in S. Pink, L. Kürti and A. Afonso (eds), *Working Images*, London: Routledge.

—— (2004b) 'Using Digital Media Tools in Cross-cultural Research, Analysis and Representation' *Visual Studies* 19(1): 6–25.

Crawford, P. and D. Turton (1992) *Film as Ethnography*, Manchester: Manchester University Press.

Daniels, I.M. (2001) 'The "Untidy" Japanese House' in D. Miller (ed.), *Home Possessions*, Oxford: Berg.

Desjarlais, R. (2003) *Sensory Biographies: Lives and Death among Nepal's Yolmo Buddhists*, London: University of California Press.

Devereaux, L. (1995) 'Experience, Representation and Film' in L. Devereaux and R. Hillman (eds), *Fields of Vision: Essays in Film Studies, Visual Anthropology and Photography*, London: University of California Press.

Drazin, A. (2001) 'A Man will get Furnished: Wood and Domesticity in Urban Romania' in D. Miller (ed.), *Home Possessions*, Oxford: Berg.

—— (2005) 'The Need for Applied Anthropologists to Engage with Non-ethnographic Research Methods: a personal view' in S. Pink (ed.), *Applications of Anthropology*, Oxford: Berghahn.

Dunlop, I. (1983) 'Ethnographic Filmmaking in Australia: the first seventy years (1898–1968)', *Studies in Visual Communication* 9(1): 11–18.

Edgar, I.R. (2004) 'Imagework in Ethnographic Research' in S. Pink, L. Kürti and A. Afonso (eds), *Working Images*, London: Routledge.

Edwards, E. (1992) (ed.) *Anthropology & Photography 1860–1920*, New Haven CT and London: Yale University Press (in association with the Royal Anthropological Institute, London).

—— (1997) 'Beyond the Boundary' in M. Banks and H. Morphy (eds), *Rethinking Visual Anthropology*, New Haven CT and London: Yale University Press.

—— (1999) 'Photographs as Objects of Memory' in M. Kwint, C. Breward and J. Aynsley (eds), *Material Memories: Design and Evocation*, Oxford: Berg.

—— (2001) *Raw Histories*, Oxford: Berg.

Emmison, M. and P. Smith (2000) *Researching the Visual*, London: Sage.

Eriksen, T.H. (2003) 'The Young Rebel and the Dusty Professor: a tale of anthropologists and the media in Norway', *Anthropology Today* 19(1): 3–5.

—— and F.S. Neilsen (2001) *A History of Anthropology*, London: Pluto.

Ervin, A.M. (2000) *Applied Anthropology: Tools and Perspectives for Contemporary Practice*, Boston: Allyn and Bacon.

Evans, J. and S. Hall (1999) 'What is Visual Culture?' in J. Evans and S. Hall (eds), *Visual Culture: The Reader*, London: Sage and the Open University.

Evans-Pritchard, E.E. (1940) *The Nuer: A Description of the Modes of Livelihood and Political Institutions of a Nilotic People*, Oxford: Oxford University Press.

—— (1956) *Nuer Religion*, Oxford: Oxford University Press.

Ferrándiz, F. (1998) 'A Trace of Fingerprints: displacements and textures in the use of ethnographic video in Venezuelan spiritism', *Visual Anthropology Review* 13(2): 19–38.

Fiske, J. (1994) 'Audiencing' in N.K. Denzin and Y.S. Lincoln (eds), *Handbook of Qualitative Methods*, London: Sage.

Fox, R. and A. Gingrich (2002) 'Introduction' to A. Gingrich and R. Fox (eds), *Anthropology, by Comparison*, London: Routledge.

Gaines, J.M. (1999) 'Introduction: the real returns' in J.M. Gaines an M. Renov (eds), *Collecting Visible Evidence*, Minneapolis: University of Minnesota Press.

Garvey, P. (2001) 'Organized Disorder: moving furniture in Norwegian homes' in D. Miller (ed.), *Home Possessions*, Oxford: Berg.

Geertz, C. (1986) 'Making Experience, Authoring Selves' in V. Turner and E. Bruner (eds), *The Anthropology of Experience*, Urbana: University of Illinois Press.

—— (1988) *Works and Lives: The Anthropologist as Author*, Stanford: University of Stanford Press.

Geurts, K.L. (2002) *Culture and the Senses: Bodily Ways of Knowing in an African Community*, Berkeley, Los Angeles, London: University of California Press.

—— (2003) 'On Embodied Consciousness in Anlo-Ewe Worlds: a cultural phenomenology of the fetal position', *Ethnography* 4(3): 363–95.

Giddens, A. (1986) *Sociology: A Brief but Critical Introduction*, Basingstoke and London: Macmillan.

Gil Tebar, P. (1992) 'La reina de la casa en el tiempo infinito' in P. Sanchíz (ed.), *Mujer andaluza: la caida de un mito?*, Seville: Muñoz Moya y Montraveta Editores, Biblioteca Andaluza.

Gingrich, A. and R. Fox (2002) (eds) *Anthropology, by Comparison*, London: Routledge.

Ginsburg, F. (2002a) 'Mediating Culture: indigenous media, ethnographic film, and the production of identity' in K. Askew and R. Wilk (eds), *The Anthropology of Media: A Reader*, Oxford: Blackwells.

—— (2002b) 'Screen Memories: resignifying the traditional in indigenous media' in F. Ginsburg, L. Abu-Lughod and B. Larkin (eds), *Media Worlds: Anthropology on New Terrain*. Berkeley: University of California Press.

—— (2003) '"Now Watch this Very Carefully … ": the ironies and afterlife of Margaret Mead's visual anthropology' in L.A. Sharp (ed.), *Margaret Mead's Legacy: Continuing Conversations*, a guest edited issue of *The Scholar and Feminist On-line* 1(2). Available online: <www.barnard.edu/sfonline/mead/ginsburg.htm> (accessed 12 November 2004).

—— L. Abu-Lughod and B. Larkin (2002) Introduction to F. Ginsburg, L. Abu-Lughod and B. Larkin (eds), *Media Worlds: Anthropology on New Terrain*. Berkeley: University of California Press.

Goldfarb, B. (2002) *Visual Pedagogy: Media Cultures in and beyond the Classroom*, Durham NC: Duke University Press.

Green, M. (2005) 'Social Development, Institutional Analysis and Anthropology?' in S. Pink (ed.), *Applications of Anthropology*, Oxford: Berghahn.

Griffiths, A. (2002) *Wondrous Difference: Cinema, Anthropology and Turn-of-the-century Visual Culture*, New York: Columbia University Press.

Grimshaw, A. (2001) *The Ethnographer's Eye*, Cambridge: Cambridge University Press.

—— 'Eyeing the Field: new horizons for visual anthropology' in A. Grimshaw and A. Ravetz, *Visualizing Anthropology*, Bristol: Intellect.

—— and A. Ravetz (2005) *Visualizing Anthropology*, Bristol: Intellect.

Gullestad, M. (1993) 'Home Decoration as Popular Culture: constructing homes, genders and classes in Norway' in T. de Valle (ed.), *Gendered Anthropology*, London: Routledge.

Gwynne, M.A. (2003) *Applied Anthropology: A Career Orientated Approach*, Boston: Allyn and Bacon.

Harper, S. (2004) 'Multimedia and Visual Research: a review essay', *Visual Sociology* (19)1: 112–15.

Hastrup, K. (1992) 'Anthropological Vision: some notes on visual and textual authority' in P. Crawford and D. Turton (eds), *Film as Ethnography*, Manchester: Manchester University Press.

Hecht, A. (2001) 'Home Sweet Home: tangible memories of an uprooted childhood' in D. Miller (ed.), *Home Possessions*, Oxford: Berg.

Heider, K. (1976) *Ethnographic Film*, Austin: University of Texas Press.

Henley, P. (2000) 'Ethnographic Film: technology, practice and anthropological theory', *Visual Anthropology* 13: 207–26.

—— (2004) 'Beyond Observational Cinema … ' in S. Pink, L. Kürti and A. Afonso (eds), *Working Images*, London: Routledge.

—— (2005) 'Anthropologists in Television: a disappearing world?' in S. Pink (ed.), *Applications of Anthropology*, Oxford: Berghahn.

Hockings, P. (1995 [1975]) (ed.) *Principles of Visual Anthropology*, The Hague: Mouton.

Holliday, R. (2001) 'We've Been Framed: visualising methodology' *The Sociological Review* 48(4): 503–22.

Howes, D. (1991) 'Olfaction and Transition' in D. Howes (ed.), *The Varieties of Sensory Experience: A Sourcebook in the Anthropology of the Senses*, Toronto, Buffalo, London: University of Toronto Press.

—— (2003) *Sensing Culture: Engaging the Senses in Culture and Social Theory*, Ann Arbor: The University of Michigan Press.

—— (ed.) (2005) *Empire of the Senses: The Sensual Culture Reader*, Oxford: Berg.

Hutchinson, S. (1996) *Nuer Dilemmas: Coping with Money, War and the State*, Berkeley: University of California Press.

Hutnyk, J. (1990) 'Comparative Anthropology and Evans-Pritchard's Nuer Photography: photographic essay', *Critique of Anthropology* 10(1): 81–102.

Ingold, T. (2000) *The Perception of the Environment*, London: Routledge.

Jacknis, I. (1984) 'Franz Boas and Photography', *Studies in Visual Communication* 10(1): 2–60.

James, A., J. Hockey and A. Dawson (1997) (eds) *After Writing Culture*, London: Routledge.

Jhala, J. (2004) 'In a Time of Fear and Terror: seeing, assessing, assisting, understanding and living the reality and consequences of disaster' in S. Pink (ed.), *Applied Visual Anthropology*, a guest edited issue of *Visual Anthropology Review* (20(1): 59–69.

Katz, J. and T. J. Csordas (2003) 'Phenomenological Ethnography in Sociology and Anthropology', *Ethnography* 4: 275–88.

Kulick, D. and M. Willson (1995) (eds) *Taboo: Sex, Identity and Erotic Subjectivity in Anthropological Fieldwork*, London: Routledge.

Kuper, A. (1996) *Anthropology and Anthropologists*, London: Routledge.

Lammer, C. (forthcoming) 'Bodywork: social somatic interventions in the operating theatres of invasive radiology' in S. Pink (ed.), *Visual Interventions: Applied Visual Anthropology*, Oxford: Berghahn.

Levine, S. (2003) 'Documentary Film and HIV/AIDS: new directions for applied visual anthropology in Southern Africa' in *Steps for the Future/A Kalahari Family*, a special issue of *Visual Anthropology Review* 19(1–2): 57–72.

Lewis, E.D. (2004) (ed.) *Timothy Asch and Ethnographic Film*, London: Routledge.

Lister, M. and L. Wells (2001) 'Seeing Beyond Belief: cultural studies as an approach to analysing the visual' in T. van Leeuwen and C. Jewitt (eds), *The Handbook of Visual Analysis*, London: Sage.

Loizos, P. (1993) *Innovation in Ethnographic Film*, Manchester: Manchester University Press.

Long, C. and P. Laughren (1993) 'Australia's First Films: facts and fables. Part six: surprising survivals from Colonial Queensland', Cinema Papers 96: 32–7. Available online: <www.bodley.ox.ac.uk/external/isca/haddon/article.html#R20> (accessed 29 July 2004).

Lutkehaus, N. and J. Cool (1999) 'Paradigms Lost and Found: the "crisis of representation and visual anthropology"' in J.M. Gaines and M. Renov (eds), Collecting Visible Evidence, Minneapolis: University of Minnesota Press.

MacDonald, J.H. (2002) (ed.) The Applied Anthropology Reader, Boston: Allyn and Bacon.

MacDougall, D. (1975) 'Beyond observational cinema' in P. Hockings (ed.), Principles of Visual Anthropology, The Hague: Mouton.

—— (1995) 'The Subjective Voice in Ethnographic Film' in L. Devereaux and R. Hillman (eds), Fields of Vision: Essays in Film Studies, Visual Anthropology and Photography, London: University of California Press.

—— (1997) 'The Visual in Anthropology' in M. Banks and H. Morphy (eds), Rethinking Visual Anthropology, London: New Haven Press.

—— (1998) Transcultural Cinema, Princeton: Princeton University Press.

—— (2000) 'Social Aesthetics and The Doon School', Sights. Available online: <http://cc.joensuu.fi/sights/david2.htm> (accessed 12 November 2004).

—— (2001) 'Renewing Ethnographic Film: is digital video changing the genre?' Anthropology Today 17(3): 15–21.

Marcoux, J.S. (2001) 'The Refurbishment of Memory' in D. Miller (ed.), Home Possessions, Oxford: Berg.

Marcus, G. (1995) 'The Modernist Sensibility in Recent Ethnographic Writing and the Cinematic Metaphor of Montage' in L. Devereaux and R. Hillman (eds), Fields of Vision, Berkeley: University of California Press.

Marks, L. (2000) The Skin of the Film, Durham and London: Duke University Press.

Mars, G. (2004) 'Refocusing with Applied Anthropology', guest editorial in Anthropology Today (20)1: 1–2.

Martinez, A. (2000) (ed.) Taller de las cuatro estaciones, Madrid: Alas de Colibri Ediciones.

Martinez, W. (1994) 'Deconstructing the "Viewer": from ethnography of the visual to the visual critique of the occult' in P. Crawford and S. Hafsteinsson (eds), The Construction of the Viewer: Media Ethnography and the Anthropology of Audiences, NAFA 3, Højbjerg, Denmark: Intervention Press.

—— (2004) 'Tim Asch, Otherness and Film Reception' in E.D. Lewis (ed.), Timothy Asch and Ethnographic Film, London: Routledge.

Marvin, G. (1988) Bullfight, Oxford: Basil Blackwell.

Mason, B. and B. Dicks (2001) 'Going beyond the code', Social Science Computer Review 19(4): 445–57.

McGuigan, J. (1997) Cultural Methodologies, London: Sage.

McLuhan, M. (1964) Understanding Media: The Extensions of Man, New York: McGraw Hill Book Company.

Mead. M. (1995 [1975]) 'Visual Anthropology in a Discipline of Words' in P. Hockings (ed.), Principles of Visual Anthropology, The Hague: Mouton.

—— (2000 [1953]) 'The Study of Culture at a Distance' in M. Mead and R. Métraux (eds), The Study of Culture at a Distance, Oxford: Berghahn.

Melhuus, M. (2002) 'Issues of Relevance: anthropology and the challenges of cross-cultural comparison' in A. Gingrich and R. Fox (eds), Anthropology, By Comparison, London: Routledge.

Miller, D. (1998) Material Cultures, London: Routledge.

—— (2001a) 'Behind Closed Doors' in D. Miller (ed.), *Home Possessions*, Oxford: Berg.

—— (2001b) 'Possessions' in D. Miller (ed.), *Home Possessions*, Oxford: Berg.

—— (2001c) *Home Possessions*, Oxford: Berg.

Mills, D. (2002) 'British Anthropology at the end of the Empire: the rise and fall of the Colonial Social Science Research Council 1944–1962', *Revue d'histoire des sciences humaines* 6: 161–88.

—— (2003) 'Professionalizing or popularizing anthropology?: A brief history of anthropology's scholarly associations in the UK', *Anthropology Today* 19(5): 8–13.

—— (2005) 'Dinner at Claridges? Anthropology and the "Captains of Industry" 1947–1955' in S. Pink (ed.), *Applications of Anthropology*, Oxford: Berghahn.

Moore, H. (1994) *A Passion for Difference*, Oxford: Polity Press.

—— (1999a) 'Anthropology at the Turn of the Century' in H. Moore (ed.), *Anthropological Theory Today*, Oxford: Polity Press.

—— (1999b) 'Whatever Happened to Women and Men' in H. Moore (ed.), *Anthropological Theory Today*, Oxford: Polity Press.

Moores, S. (1993) *Interpreting Audiences: The Ethnography of Media Consumption*, London: Sage.

Morley, D. (1992) *Television, Audiences and Cultural Studies*, London: Routledge.

Morphy, H. (1996) 'More than Mere Facts: Repositioning Spencer and Gillen in the History of Anthropology' in S.R. Morton and D.J. Mulvaney (eds), *Exploring Central Australia: Society, Environment and the Horn Expedition*, Chipping Norton: Surrey Beatty and Sons.

—— and M. Banks (1997) 'Introduction: rethinking visual anthropology' in M. Banks and H. Morphy, *Rethinking Visual Anthropology*, New Haven CT and London: Yale University Press.

Nichols, B. (1991) 'Pornography, Ethnography, and the Discourses of Power' in B. Nichols, *Representing Reality*, Bloomington: Indiana University Press.

—— (2004) 'What Really Happened: a reassessment of *The Ax Fight*' in E.D. Lewis (ed.), *Timothy Asch and Ethnographic Film*, London: Routledge.

Nolan, R. (2003) *Anthropology in Practice: Building a Career Outside the Academy*, Boulder CO, London: Lynne Rienner Publishers.

Oakley, A. (1985 [1974]) *The Sociology of Housework*, Oxford: Basil Blackwell.

Okely, J. (1994) 'Vicarious and Sensory Knowledge of Chronology and Change: ageing in rural France' in K. Hastrup and P. Hervik (eds), *Social Experience and Anthropological Knowledge*, London: Routledge.

Orobitg, G. (2004) 'Photography in the Field: word and image in ethnographic research' in S. Pink, L. Kürti and A. Afonso (eds), *Working Images*, London: Routledge.

Pauwels, L. (2000) 'Taking the Visual Turn in Research and Scholarly Communication', *Visual Sociology* 15: 7–146.

Pink, S. (1997) *Women and Bullfighting: Gender, Sex and the Consumption of Tradition*, Oxford: Berg.

—— (1999) 'A Woman, a Camera and the World of Bullfighting: visual culture, experience and the production of anthropological knowledge', *Visual Anthropology* 13: 71–86.

—— (2001a) *Doing Visual Ethnography: Images, Media and Representation in Research*, London: Sage.

—— (2001b) 'More Visualising, more Methodologies: on video, reflexivity and qualitative research', *The Sociological Review* 49(4): 586–99.

—— (2003) 'Representing the Sensory Home: ethnographic experience and ethnographic hypermedia' in G. Bloustien (ed.), *En-visioning Ethnography: Exploring the Complexity of the Visual Methods in Ethnographic Research*, Social Analysis 47(3): 46–63.

—— (2004a) *Home Truths: Changing Gender in the Sensory Home*, Oxford: Berg.

—— (2004b) 'Conversing Anthropologically: hypermedia as anthropological text' in S. Pink, L. Kürti and A. Afonso (eds), *Working Images*, London: Routledge.

—— (2004c) (ed.) *Applied Visual Anthropology*, a guest edited issue of *Visual Anthropology Review* 20(1).

—— (2004d) 'In and Out of the Academy: video ethnography of the home' in S. Pink (ed.), *Applied Visual Anthropology*, a guest edited issue of *Visual Anthropology Review* 20(1): 82–8.

—— (2005) 'Introduction: applications of anthropology' in S. Pink (ed.), *Applications of Anthropology*, Oxford: Berghahn.

—— (forthcoming) *Visual Interventions*, Oxford: Berghahn.

—— L. Kürti and A.I. Afonso (eds) (2004) *Working Images*, London: Routledge.

Pinney, C. (1992) 'The Parallel Histories of Anthropology and Photography' in E. Edwards (ed.), *Anthropology and Photography*, New Haven CT: Yale University Press.

Pitt-Rivers, J. (1963) *The People of the Sierra*, Chicago and London: Chicago University Press.

Prins, H. (2002) 'Visual Media and the Primitivist Perplex: colonial fantasies, indigenous imagination, and advocacy in North America' in F. Ginsburg, L. Abu-Lughod and B. Larkin (eds), *Media Worlds: Anthropology on New Terrain*, Berkeley: University of California Press

—— and J. Ruby (2001–02) 'North American Contributions to the History of Visual Anthropology' in H. Prins and J. Ruby (eds), *The Origins of Visual Anthropology*, a special issue of *Visual Anthropology Review* 17(2): 3–12.

Ramos, M.J. (2004) 'Drawing the Lines: the limitations of intercultural *ekphrasis*' in S. Pink, L. Kürti and A.I. Afonso (eds), *Working Images*, London: Routledge.

Read, R. (2005) 'Scopic Regimes and the Observational Approach: ethnographic filmmaking in a Czech institution' *Visual Anthropology* 18(1): 47–64.

Rice, T. (2004) 'Soundselves: an acoustemology of sound and self in the Edinburgh Royal Infirmary', *Anthropology Today* 24(4): 4–9.

Roberts, S. (2005) 'The Pure and the Impure?: applying anthropology and doing ethnography in a commercial setting' in S. Pink (ed.), *Applications of Anthropology: Professional Anthropology in the Twenty-First Century*, Oxford: Berghahn.

Rony, F. (1996) *The Third Eye: Race, Cinema, and Ethnographic Spectacle*, Durham NC: Duke University Press.

Rose, G. (2001) *Visual Methodologies*, London: Sage.

Ruby, J. (1980) 'Franz Boas and Early Camera Study of Behaviour' *The Kinesis Report* 3(1): 6–11.

—— (2000a) *Picturing Culture: Explorations of Film and Anthropology*, Chicago: University of Chicago Press.

—— (2000b) 'Some Oak Park Stories: Experimental Ethnographic Videos', Paper presented at Visible Evidence Conference, Oxford.

—— (2001) 'From Ethnographic Film to Hypertext Ethnography', Unpublished commentary.

—— (2001–02) 'The Professionalization of Visual Anthropology in the United States: the 1960s and 1970s' in H. Prins and J. Ruby (eds), *The Origins of Visual Anthropology*, a special issue of *Visual Anthropology Review* 17(2): 5–13.

—— and R. Chalfen (1974) 'The Teaching Of Visual Anthropology At Temple', *The Society For The Anthropology Of Visual Communication Newsletter* 5(3): 5–7.

Rusted, B. (2004) 'Editor's introduction: visual studies, digital imaging and new media' *Visual Studies* 19(1): 2–5.

Seaman, G. and H. Williams (1992) 'Hypermedia in Ethnography' in P. Crawford and D. Turton (eds), *Film as Ethnography*, Manchester: University of Manchester Press.

Seremetakis, L. (1994a) 'The Memory of the Senses: historical perception, commensal exchange, and modernity' in L. Taylor (ed.), *Visualizing Theory*, London: Routledge.

—— (1994b) 'Intersection, Benjamin, Bloch, Braudel and Beyond' in L. Seremetakis (ed.), *The Senses Still: Perception and Memory as Material Culture in Modernity*, Chicago: University of Chicago.

Sharp, L. (2003) Guest Editor's note in L.A. Sharp (ed.), *Margaret Mead's Legacy: Continuing Conversations*, a guest edited issue of *The Scholar and Feminist On-line* 1(2). Available online: <www.barnard.edu/sfonline/mead/sharp.htm> (accessed 12 November 2004).

Sillitoe, P. (2003) 'Time to be professional?', guest editorial in *Anthropology Today* 19(1): 1–2.

Silva, E. (2000) *The Politics of Consumption @ Home*, PAVIS Papers in Social and Cultural Research, No. 1. Milton Keynes: Faculty of Social Sciences, Open University.

—— and S. Pink (2004) 'In the Net: anthropology and photography' in S. Pink, L. Kürti and A.I. Afonso (eds), *Working Images*, London: Routledge.

Sperschneider, W. and K. Bagger (2003) 'Ethnographic Fieldwork Under Industrial Constraints: toward design-in-context' *International Journal of Human-Computer Interaction* 15(1): 41–50. Available online: <www.leaonline.com/doi/abs/10.1207%2FS15327590IJHC1501_04?cookieSet=1> (accessed 12 November 2004).

——, M. Kjaersgaard and G. Petersen (2001) 'Design Anthropology: When Opposites Attract', poster submitted to the First Danish HCI Symposium. Available online: <www.nwow.alexandra.dk/publikationer/Design_Anthropology.pdf> (accessed 12 August 2004).

Stadhams, D. (2004) 'LOOK TO LEARN: a role for visual ethnography in the elimination of poverty' in S. Pink (ed.), *Applied Visual Anthropology*, a guest edited issue of *Visual Anthropology Review* 20(1): 45–58.

Steele, N., and T. Lovejoy (2004) 'Engaging Our Audience through "Photo Stories"' in S. Pink (ed.), *Applied Visual Anthropology*, a guest edited issue of *Visual Anthropology Review* 20(1): 70–81.

Stoller, P. (1989) *The Taste of Ethnographic Things: The Senses in Ethnography*, Philadelphia: University of Philadelphia Press.

—— (1997) *Sensuous Scholarship*, Philadelphia: University of Pennsylvania Press.

Suchman, L. (2000) 'Anthropology as "Brand": Reflections on Corporate Anthropology', published by the Department of Sociology, Lancaster University. Available online: <www.comp.lancs.ac.uk/sociology/soc058ls.html> (accessed 19 July 2004).

Tacchi, J. (1998) 'Radio Texture: Between Self and Others' in D. Miller (ed.) *Material Cultures*, London: Routledge.

Taureg, M. (1983) 'The Development of Standards for Scientific Films in German Ethnography', *Studies in Visual Communication* 9(1): 19–29.

Taussig, M. (1991) 'Tactility and Distraction', *Cultural Anthropology* 6(2): 147–53.

Taylor, L. (1994) (ed.) *Visualizing Theory: Selected Essays from VAR 1990–1994*, London: Routledge.

—— (1998) 'Introduction' to D. MacDougall, *Transcultural Cinema*, Princeton: Princeton University Press.

—— (2003) 'Suspended in Webs of Signification', foreword to R. Coover, *Cultures in Webs*, CD-ROM, Watertown MA: Eastgate Systems.

Throop, Jason (2003) 'Articulating Experience', *Anthropological Theory* 3(2): 219–41.

Tongue, N., J. Wheeler and L.J. Price (2000 [1993]) 'At the Edge … : Visual Anthropology and HIV prevention' in P.J. Higgins and J.A. Paredes (eds), *Classics of Practising Anthropology 1978–1988*, Oklahoma City OK: Society for Applied Anthropology.

Turner, T. (2002) 'Representation, Politics, and Cultural Imagination in Indigenous Video: general points and Kayapo examples in indigenous media' in F. Ginsburg, L. Abu-Lughod and B. Larkin (eds), *Media Worlds: Anthropology on New Terrain*, California: University of California Press.

Turner, V. (1986) 'Dewey, Dilthey and Drama: an essay in the anthropology of experience' in V. Turner and E. Bruner (eds), *The Anthropology of Experience*, Urbana: University of Illinois Press.

—— and E. Bruner (1986) (eds) *The Anthropology of Experience*, Urbana: University of Illinois Press.

Tyler, S. (1987) *The Unspeakable*, Madison: University of Wisconsin Press.

van Leeuwen, T. and C. Jewitt (2000) (eds) *Handbook of Visual Analysis*, London: Sage.

van Willigen, J. (2002) *Applied Anthropology: An Introduction*, Westport CT, London: Bergin and Garvey.

Wasson, C. (2000) 'Ethnography in the Field of Design', *Human Organization* 59(4): 377–88.

Wenger, E., R. McDermott and W. Snyder (2002) *Cultivating Communities of Practice: A Guide to Managing Knowledge*, Boston: Harvard Business School Press.

White, S. (2003) *Participatory Video: Images that Transform and Empower*, London: Sage.

Wright, C. (1998) 'The Third Subject: perspectives on visual anthropology', *Anthropology Today* 14(4): 16–22.

Wright, S. (2005) 'Machetes into a Jungle? A history of anthropology in policy and practice, 1981–1996' in S. Pink (ed.), *Applications of Anthropology*, Oxford: Berghahn.

Young, M.W. (1998) *Malinowski's Kiriwana: Fieldwork Photography 1915–1918*, Chicago and London: University of Chicago Press.

Zeitlyn, D. (2001) 'Reading in the Modern World: Anthropological Perspectives on Writing and the Virtual World', *CSAC Monographs Online* No. 17. Available online: <http://csac.anthropology.ac.uk/CSACMonog/RRRweb/> (accessed 13 August 2003).

Filmography

A Buen Común (2000) *Mujeres Invisibles*. Distributor information online. Available online: <www.lboro.ac.uk/departments/ss/workingimages/abstracts/anamartinezfilm.htm> (accessed 12 November 2004).

Cool, J. (1994) *Home Economics*, CVA, University of Southern California.

Engelbrecht, B. (2000) *Building Season in Tiebele*. Distributor: IWF, Goettingen, Germany.

Flaherty, R. (1922) *Nanook of the North*. New York: Revillion Freres.

MacDougall, D. and J. MacDougall (1979) *Lorang's Way*. Distributor: Documentary Educational Resources, Watertown MA.

Mourao, C. (2000) *The Lady of Chandor*. Lisbon, Portugal: SP Films.

Read, R. (2000) *Domov*. Distributor, Granada Centre for Visual Anthropology, University of Manchester.

CD-ROMs

Biella, P., N. Changon and G. Seaman (1997) *Yanomamö Interactive: The Ax Fight* (book and CD-ROM), Wadsworth: Thompson Learning.

Coover, R. (2003) *Cultures in Webs* CD-ROM, Watertown: Eastgate Systems.

Hubbard, G., A. Cook, S. Tester and M. Downs (2003) *Sexual Expression in Institutional Care Settings: An Interactive Multi-media CD-ROM*, Stirling: University of Stirling, Department of Applied Social Science.

Mohr, J. (2003) *A Photographer's Journey*, Association Mémories de Photographes. Available online: <www.memoiresdephotos.ch> (accessed 12 November 2004).

Ruby, J. (2004) *The Taylor Family*, CD-ROM, Distributor: Documentary Educational Resources, Watertown MA.

Steiger, R. (2000) *En Route*, CD-ROM. Distributed with *Visual Sociology* 15.

Index

Printed in Great Britain
by Amazon